Found Object Art

Dorothy Spencer

Schiffer Publishing Ltd

4880 Lower Valley Road, Atglen, PA 19310 USA

Dedication

This book is dedicated in loving memory to Frieda Fehrenbacher, a very old and dear friend, who took me to my first flea market. Frieda was a major junker who appreciated the value of a found/discarded/thrift store find as much, if not more so, than anything bright and new. She was an inspiration and delight to anyone who was lucky enough to have shared the junking experience with her. I was fortunate to have known Frieda for as long as I did.

Library of Congress Cataloging-in-Publication Data

Spencer, Dorothy.
Found object art / Dorothy Spencer.
p. cm.
ISBN 0-7643-1437-8
1. Found objects (Art)--Catalogs. 2. Artists--United States--Interviews. I. Title.
N7433.7 .S68 2002
709.73'09'045--dc21
2001003761

Designed by Bonnie M. Hensley
Cover design by Bruce M. Waters
Type set in Bergell LET/ZapfHumanist BT

ISBN: 0-7643-1437-8
Printed in China

Published by Schiffer Publishing Ltd.
4880 Lower Valley Road
Atglen, PA 19310
Phone: (610) 593-1777; Fax: (610) 593-2002
E-mail: Schifferbk@aol.com
Please visit our web site catalog at **www.schifferbooks.com**
We are always looking for people to write books on new and related subjects. If you have an idea for a book, please contact us at the above address.

This book may be purchased from the publisher.
Include $3.95 for shipping.
Please try your bookstore first.
You may write for a free catalog.

In Europe, Schiffer books are distributed by
Bushwood Books
6 Marksbury Avenue
Kew Gardens
Surrey TW9 4JF England
Phone: 44 (0) 20 8392 8585
Fax: 44 (0) 20 8392 9876
E-mail: Bushwd@aol.com
Free postage in the UK. Europe: air mail at cost.

Contents

Acknowledgments

I would like to thank all the artists who have been so supportive of this book; they have responded—especially at the end, in record time—to all of my requests with overwhelming enthusiasm, for which I am grateful.

The subject of recycling and the creation of objects that are both functional and aesthetically innovative has long been an area of personal interest. The vast number of well-wishers I have encountered in the past ten years since I started researching the subject for the original exhibition that ignited all of this—*Recycle, Reuse, Recreate*—has been deeply encouraging. To all who have been so generous with information, contacts, and support (thank you Lou), I express my appreciation.

There are several galleries whose representatives have responded generously with both time and materials. I would like to thank: Arne Anton, American Primitive Gallery, New York City; Julie Bernson, Andover Gallery of Art, Andover, Massachusetts; Meredith Hyatt Moses, Clark Gallery, Lincoln, Massachusetts; Martha Connell, Connell Gallery, Atlanta, Georgia; Mija Riedel, Susan Cummins Gallery, Mill Valley, California; Ann Nathan, Ann Nathan Gallery, Chicago, Illinois; Linda Ross, The Sybaris Gallery, Royal Oak, Michigan; Ruth Snyderman, the Works Gallery, Philadelphia, Pennsylvania.

Finally, I wish to thank my son Jason and all of my friends, especially Ginny Croft and Marge Kline, who have tirelessly encouraged my tenacious belief in the value of recycling as an art form.

—Dorothy Spencer

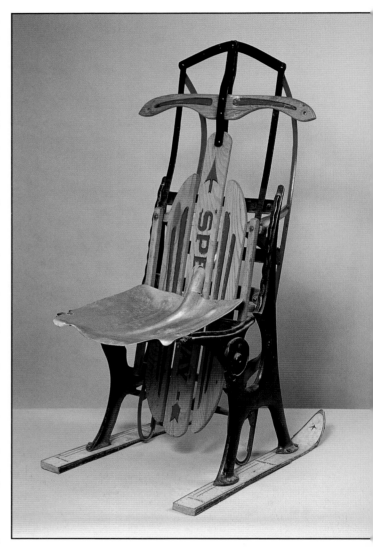

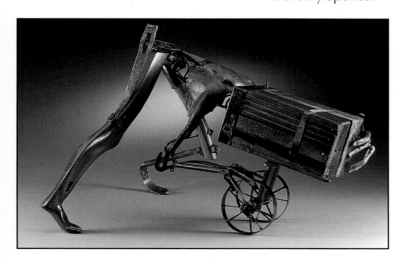

Opposite page:
Decorated Automobile
Artist unknown
Hand-decorated car covered with assorted found objects.
Photo courtesy Peggy Weil

Introduction

"Pollution is just an untapped resource."
—Buckminster Fuller

In 1994, I was fortunate to be awarded a grant in conjunction with The Arts Counsel Inc., New York City, from the Arts America Program of the United States Information Agency (USIA) to curate an exhibition on artists who worked with recycled materials. The exhibition and its accompanying catalog, *Recycle, Reuse, Recreate*, traveled to over fifteen venues throughout Africa before ending .

Although the exhibition came home in 1996, I have continued to research and collect information about artists who use found/discarded materials to create their work—some of which functions, some of which does not. However, the work that I have had the exhilarating opportunity to see has left a profound influence on the way I view life and its everyday detritus.

Although the idea of recycling as a politically correct action is a fairly recent phenomenon, it has not only caused the public to become more aware of the problems that accompany the amount of trash discarded on a daily basis and its need for proper disposal, it has also elevated the work produced by "recycling" artists to a more respectable level in the world of art and craft. Whether these pieces are considered fine art or functional craft/objects, the last decade has seen the growth of exhibitions and other venues to show the work as well as patrons who are now collecting it with a passion.

The artists in this book all possess an awareness that they can create amazing things from what is readily available, along with the fascination and/or challenge of creating something new from something old—these are the common threads that unify them more than anything else. The "why" of choosing to work in this medium, if one can

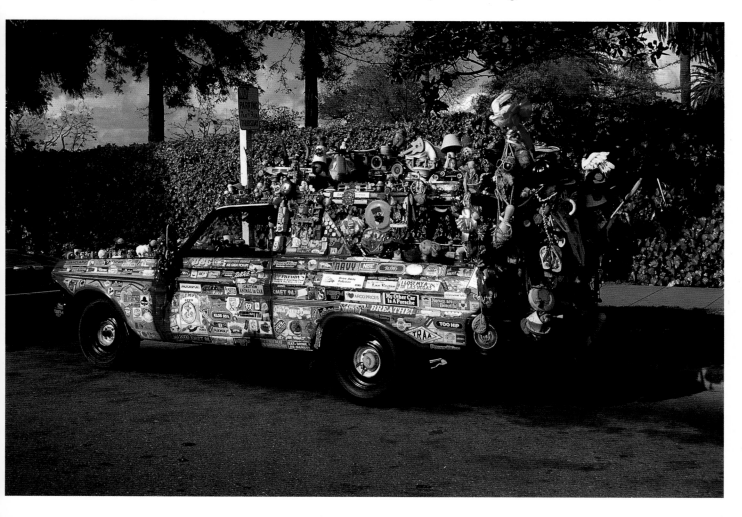

call it a medium, is quite varied—and their statements reflect numerous influences and desires.

For example, the artist Gyöngy Laky talked about having traveled to India on a post-graduate program: "...It was during that year in India that my respect for materials and all their capabilities fully hit home. While in India, I used to shop for tomatoes at the corner vegetable stand. It was the habit of the shopkeeper to make small bags out of children's math homework. People would look through trash for materials to make small bags.

"I had received a letter from the US which I read and threw out. When I bought my tomatoes the next day, I received them in my own letter glued into a small bag. I was so moved by that sense of value."

Other artists relate stories of learning from their families, from generations raised during a Depression that caused them to "make do" or "do without," while others are simply fascinated by the look of a piece of metal once it has been weathered or a piece of wood that has been left on the beach to bake for seasons in the sun. Are the works of these artists political statements or just personal styles of their art-making? It actually doesn't matter. It is each work that speaks so eloquently for itself. The how and why an artist chooses the materials are all part of the creative process that is so individualized.

Frank Miller, a Los Angeles-based artist says: "When I was about eight years old, I had climbed the fence behind my house in search of adventure. I landed in a narrow yard behind some commercial buildings on the next block. There was a lot of junk laying about, including a smashed TV set. This was in 1948 so it wasn't an old TV—just broken. I was absolutely awed when I looked inside the broken cabinet, where I discovered this beautiful network of wires, tubes, and all kinds of intriguing shapes and colors. I studied it for a long time and wondered how this could be thrown away. It seemed to have too much value to be just tossed out like that. I knew it couldn't function as a TV anymore but it still had an energy, a life, and a potential to go on to become something new. I have never forgotten this experience. Over the years, its memory has returned to me many times. I also began, as time went by, to notice this same life and potential in many things that have been thrown away. This is my art today, found objects. Junk anywhere that can be refashioned into an expression of one's thoughts, feelings, opinions, and spirits which is art. My art."

The work reflects the rich variety of visual creativity found in every form of art today. We do not have a national style: diversity is the American image. The hand-crafted forms now being developed relate to technical

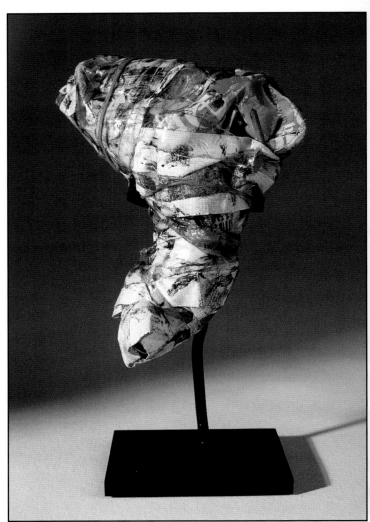

Untitled, ca. 1975
Philadelphia Wireman
Products of the anonymous artist known only as the Philadelphia Wireman, miniature sculptures such as the one shown here were found on the streets of Philadelphia during the mid-1970s. All of the pieces are made from wire combined with discarded bits of city life. Photo courtesy the Janet Fleisher Gallery, Philadelphia, Pennsylvania

evolution and also to a wide range of international cultural and political influences, both historical and contemporary. Many artists are creating new interpretations of ancient techniques and styles, giving fresh expression to longstanding fine art, craft, and design traditions. They are, in a sense, visionaries.

As Tom Patterson has so profoundly stated in his catalogue, *Ashe: Improvisation & Recycling in African-American Visionary Art*, "It's unfortunate that the word 'visionary' is tossed around with so little discrimination. It's applied freely to canny corporate executives, charismatic politicians, brash rock stars and any number of other individuals who have managed to capture the public's attention during their requisite 15 minutes of fame."

Despite its appropriation by the mass media as one of our favored fuzzy buzzwords, I've chosen to use "visionary" here because in its most precise sense—according to one or more of its several dictionary definitions—it is so strikingly applicable to the artists represented in this book. As an adjective it means: "characterized by foresight or vision, in the sense of unusual competence in discernment or perception; [it also refers to anyone or anything] that has a fantastical or dream-like nature, or that is otherwise given to apparitions, prophecies or revelations." As a noun, it means: "seer, prophet or dreamer." These, of course, are the same characteristics by which every traditional culture identifies its wise men and women, its shamans, sorcerers, diviners and healers.

Although the work of these visionary artists/designers/craftspeople is highly idiosyncratic, there is that indisputable link that unites them. They are all strong believers in the commonplace and its ability to be made uncommon. Junk is a handy artistic resource. It's cheap, plentiful, and rich with associations: where did it come from? What was it used for? Why was it thrown away? What can I do with it? These are the connections that make it possible to transform the mundane into the sublime. These are people who are natural collectors. They sift through the second-hand world, often finding rejected objects that suggest possibilities through form or meaning.

This book contains a variety of artists and their respective objects. It's a real mixed bag. There are pieces that are basically fine art oriented, including both two-dimensional and sculptural pieces created primarily for their aesthetic value. There are pieces that have been designed for personal adornment, including jewelry as well as clothing. Although the materials often make the statement, the pieces are innovative and quite elegant in the manner in which they have been created. There are the pieces that were made for a specific use. These are functional and include furniture and lighting. Then there are those objects that are basically vessels yet whose media are all encompassing, with shapes ranging from the very traditional to the most abstract.

The artists and artisans whose work is shown here are representative of a new breed, but one with a rich inheritance that dates back through more than a century of innovations in design and the creative aesthetic. The legacy of an artistic spirit of ingenuity, cultural democracy, and self reliance is also evident. The ethos of these artisans is the unifying moral and artistic force of craft and the reconnection of that force with the everyday world.

A Sense of History

Found art is not new. At the turn of the twentieth century, paint, clay, bronze, and marble were the accepted artistic mediums. The idea of using actual objects in painting or sculpture was considered radical, even heretical, for an established artist. But in the first decade of the twentieth century, a new art form called *Cubism* broke down many conceptual and visual barriers. Pioneered by Pablo Picasso from Spain and Georges Braque from France, Cubism attempted to overturn the prevailing artistic prejudices by projecting a faceted, fragmented, and relativistic view of the modern world.

Picasso and Braque experimented with trompe l'oeil effects in their paintings of the early 1900s. The next step was to incorporate actual objects—mirrors, newspapers, cigarette packs, and playing cards all found their way into these works of art, blurring the distinction between the

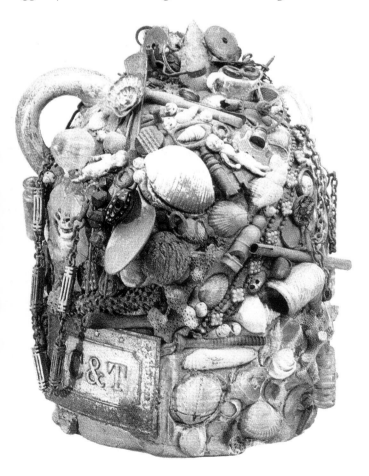

Spirit Jug, ca. 1930
Artist unknown
"Spirit jugs" or "Memory vessels" are part of an African-American tradition of decorating gravesites with everyday objects, thought to be for use in their previous owner's afterlife. Twentieth century jugs have been made by a variety of people, reflecting their personal lives and the society in which they lived. This vessel is made from glazed stoneware, metal, seashells, and various found objects.
Private collection. Photo by Lynn Rosenthal

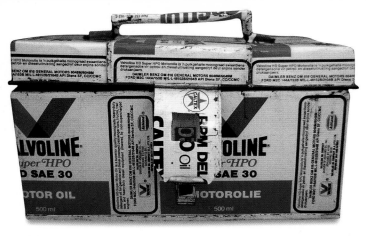

Briefcase, ca. 1980
Artist unknown
Many Third World and unschooled artisans earn their living by turning industrial waste into objects to sell at street markets. This small case is constructed from discarded Valvoline oil cans.
Photo courtesy Dorothy Spencer

formalized world of painting and the changing and moving modern world.

And, despite the serious ramifications of Picasso's new art and ideas, his work had its playful side. Among his most celebrated creations is a sculpture that is simply titled, *Bull's Head*. It was made from a bicycle seat and a pair of handlebars. Picasso wrote of the piece: "One day, in a rubbish heap, I found an old bicycle seat, lying beside a rusted handlebar…and my mind instantly linked them together. I assembled these two objects…that everyone recognized as a bull's head. The metamorphosis was accomplished, and I wish another metamorphosis would occur in the reverse sense. If my bull's head were thrown in a junk heap, perhaps one day some boy would say, 'Here's something that would make a good handlebar for my bicycle.'"

On the eve of the first World War, an artistic movement was born which attempted to demonstrate that all human values—aesthetic, moral, and social—were deemed inconsequential when compared to the ultimate horror of war. This nihilistic manifesto was dubbed "Dada" after the French word for hobbyhorse. Dada poetry was "found poetry," random words drawn from a hat and assembled into bizarre sequences. It was not a big leap to "found art" and in this respect, junk and Dada produced a marriage made in heaven.

The most innovative of the Dada iconoclasts was Marcel Duchamp, a man for whom junk took on an almost spiritual significance. Duchamp delighted in rescuing objects from their normal and nearly invisible everyday roles, and combining or highlighting them to reveal a second and more provocative life. For Duchamp, common objects placed together in uncommon pairings could suggest new meanings, or better yet, baffle and hopefully outrage the public. *Bicycle Wheel* (1913) was a bicycle wheel mounted upside down on a simple white kitchen stool. The separate objects lost whatever functional value they might have possessed, but they gained a new—aesthetic—purpose.

By the end of Duchamp's time, junk had become a respectable artistic medium: the only question was how to employ it in new and unusual ways. Artists like Alexander Calder fashioned the fantastical out of the ordinary: a candelabra assembled from an olive oil can; a table bell made out of wire and broken glass; a lamp devised from cake molds; an entire circus—from animals to acrobats—all from old wire and bits and pieces of found things.

By the middle of the century, artist Robert Rauschenberg had become interested in the expressive possibilities of junk as artistic medium, as another kind of paint. Why not use found objects as an expressive artistic tool? Ladders, clocks, ventilation ducts, pillows, beds in their entirety—all turned up in Rauschenberg's attempts to bring artwork and the real world a little closer. These

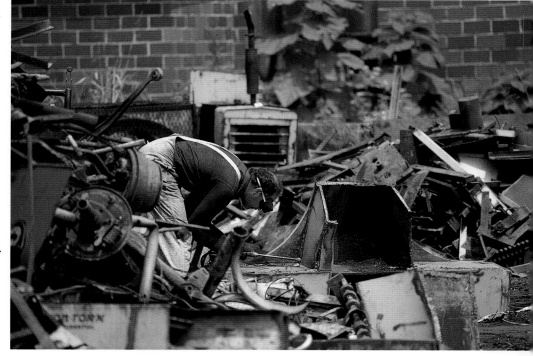

Gordon Chandler of Carrollton, Georgia collecting materials for his artworks at the ACME scrapyard.
Photo courtesy Ed Lewis

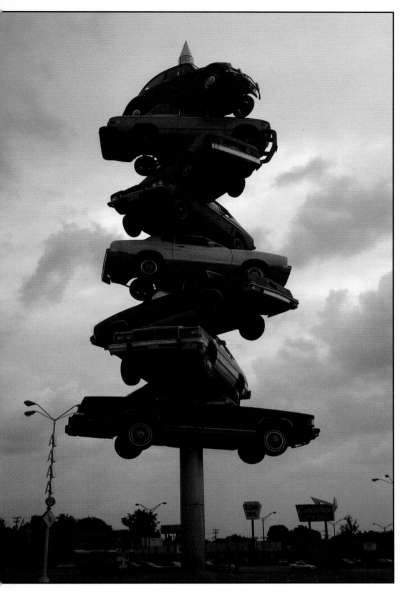

Spindle, 1989
Dustin Shuler
The automobile, television and computer are the three technological wonders of the twentieth century that have most profoundly influenced our culture. In recognition of this trend, artist Dustin Shuler has chosen the automobile as the subject of his work. In *Spindle*, for example, which is on display at a shopping center in Cicero, Illinois, Shuler has lifted the automobile out of its ordinary context, relocating it in an unexpected setting that causes the viewer to look again at this common object and question its priority and importance in our daily lives.

combination sculpture/paintings were called "combines," and Rauschenberg's philosophy was that "A pair of socks is no less suitable to make a painting with than wood, nails, turpentine, and fabric."

In the early 1960s, John Chamberlain attempted to duplicate the results being achieved by the abstract expressionist painters of his time, but his palette was the auto junkyard, his paint predominantly auto body parts. He rearranged squashed fenders, broken doors, twisted bumpers, and dented hoods.

Joseph Beuys, one of the instigators of the German "Fluxus" movement, utilized all manner of discarded electrical equipment, hunks of felt, old ship generators, wire, beat-up Volkswagen vans, autopsy tables, giant batteries, and so forth to promote the idea that the scientific and the mystical are not far removed.

California artist Edward Keinholtz united the worlds of junk art, pop art, and stage design to create weird and often horrifying tableaus commenting on modern life.

Jean Tinguely, a member of the "Movement Movement," took seriously Pablo Picasso's dictum that junk transformed into art should have the opportunity to return to junk once more. Tinguely's masterpiece, *Homage to New York*, was a giant construction of junk—wheels, gears, motors, belts, and chains—rigged up in the garden of New York's Museum of Modern Art in 1960. According to viewers and art historians alike, "It was a suicidal machine…which annihilated itself with much sound and fury."

By the 1970s, the work of David Hammons, a New York sculptor living and working in Harlem, had caught the attention of art critics as well as that of the fine art public. Hammons creates his art from urban refuse and the detritus of African American life, incorporating everything from chicken bones to basketball hoops to hair clippings. The recipient of a MacArthur Foundation Fellowship, Hammons finds the construction of outsider art and African American folk art fascinating "because it points to an esthetic, a way of using and doing things, of creating something beautiful from the nothing that is given, from the leftovers." By making art from found materials, Hammons says, he attempts to put himself on the same plane as the historically marginal, opening himself up to their canons of beauty and perseverance, which sometimes translate as transformational magic (from Kellie Jones, *David Hammons: Rousing the Rubble,* Cambridge, Massachusetts: The MIT Press, 1991).

It is the notion of outsiders, the idea of people who are out of touch with the world of museums, publications, and galleries who nevertheless make art, which provides the other important legacy that many of the artists in this book subscribe to. Encompassing the self-taught or merely somewhat isolated artist, this tradition has existed in America since the country's earliest days, continuing to contemporary times. Variously known as folk, tramp, vi-

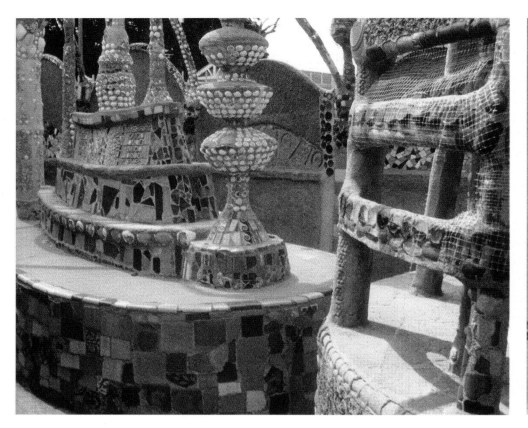
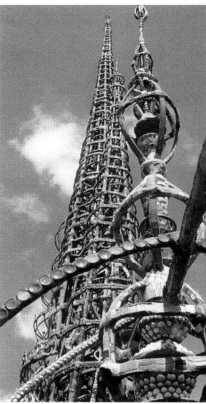

The Watts Towers, ca. 1954
Simon Rodia
Consisting of nine major sculptures constructed of structural steel, covered with mortar, and studded with a mosaic of tile pieces, The Watts Towers are the work of one man: Simon Rodia. Born in Italy, Rodia immigrated to the United States in the 1890s. In 1921, he purchased a triangular-shaped lot in Los Angeles and began to construct his masterpiece. For thirty-three years, Rodia worked single-handedly to build his towers without benefit of machine equipment, scaffolding, bolts, rivets, welds, or drawing boards. Besides his own ingenuity, he used a tile setter's simple tools and a window washer's belt and buckle. Today, the structure is administered by the Los Angeles Cultural Affairs Department.

sionary, or naive art, work by artists identified as outsiders has been recognized historically as the art of the common man. Embracing countless different styles and forms, the objects produced in this vein include spirit trees created by settlers from Africa; intricately woven purses, picture frames, crosses, and the like fashioned by prisoners (especially during the 1920s through the 1950s); yard and house installations, such as Simon Rodia's Watts Towers in Los Angeles; and public sculptures like those found in a Cicero, Illinois shopping center. Works of this nature are now attracting the attention of folklorists, scholars, and historians.

This is not simply art struggling to have a social conscience, however. The volume of debris salvaged by these inspired recyclers may be negligible compared with that destined for the landfills, but the growing trend toward reclamation is not. For these artifacts, rescued and reformed, have been endowed with a new, sometimes even tangible value.

What many of the artists represented in this book share are personal vision and a design sense that have been affected by the contemporary environment and its materials. Regardless of the long-standing tradition of making art from found materials, those who created the pieces shown here follow a subtly different agenda. In this age of ecological awareness and concern, incorporating discarded objects in works of art has become something of a fetish. Thus, a sort of "scavenger mania" as well as environmental themes course through many of the pieces in this book. In the past, art created from found materials tended to exploit the sculptural form, graphic reassociations, or other decorative elements of the castoffs from which it was made. In other words, its concerns were strictly visual. The pieces in this book, however, focus as much on functional qualities as on visual ones.

Remnants forgotten, cast off—wood, old pieces of fabric, chicken wire, eating utensils, toys, bits of iron and tin, broken TV sets—the list is as long as the number and kinds of items that are discarded daily. But this is also the stuff of which art is made. Many of the new composites are not only functional; sometimes they are even evocative of the original use of the materials from which they are con-

structed. In other instances, the original function of the items used is so muted as to be rendered inert.

This book offers readers an opportunity to witness the skill and inventiveness with which creative people make art from the heretofore worthless. At the core of this creativity is an ability to see analogies, relationships, and alternate uses. The book concentrates on the works of some extraordinary individuals who share several key characteristics that set them apart from many others who have been similarly categorized. They all make frequent and regular use of discarded objects and other found materials in their work. Many are self-taught, in the sense that they arrived at their distinctive approaches to artmaking without the guidance of professional artists, art instructors, or prescribed curricula. Many others have degrees that range from college level to post-graduate to doctoral in fields as diverse as education, science, and industrial design.

Found objects contain a value of time and labor production relating to their past history and to their current manifestation. The pieces created from them are related to technical evolution and also to a wide international range of cultural and political influences that are both historical and contemporary. These pieces have been made by artists who are creating new interpretations of ancient techniques and styles, giving fresh expression to longstanding fine art, craft, and design traditions. The works, like their makers, reflect the rich variety of visual creativity apparent in every form of art today. Yet, despite differences in identities, motives, and circumstances, those who fashion new forms from old ones experience conceptual processes that are strikingly similar. Each work in this book involves a transformation that is not mechanical, but rather one that is creative.

Found objects incorporated in works such as those included here have an intrinsic value that can perhaps be measured in terms of their initial purpose and the labor involved in their original production. Certainly all of the artists in this book have expressed a fascination with these found materials and the challenges that come not only from reclaiming what has been cast aside, but also from creating something totally new and fresh from such refuse. They are, in this sense, visionaries indeed.

Objects rescued, reformed, and redefined as artifacts have been endowed with a new, sometimes tangible, value. Their transformations compel viewers to reconsider what is usually seen as precious and to look afresh at objects that normally disappear into the tedium of the everyday. If one purpose of human artistic expression is to locate and affirm universal values, then these inspired recyclings could not be more eloquent or more relevant.

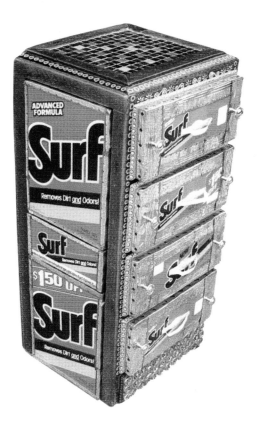

Chest Of Drawers, 1990
Jon Bok
Furniture from laundry detergent boxes, found wood bottle caps, and assorted found materials.
Courtesy Gallery of Functional Art, Los Angeles, California

Desert Painting with Sardine Can and Bottle Cap Frame, ca. 1975
Artist unknown
The elaborately decorative frame of this piece is created from sardine cans and bottle caps; the painting is on cast-off plywood.

I Have Seen Many Things
Simon Sparrow
41" x 66" x 5"
Assemblage from found materials.
Courtesy Carl Hammer Gallery, Chicago, Illinois

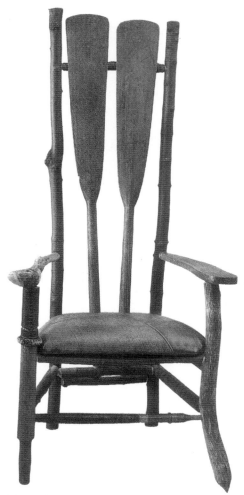

Summer Memories, 1993
Daniel Mack
Chair from old fishing boat oars, driftwood and fishing rod—the
elements of a summer vacation.
Courtesy of the artist

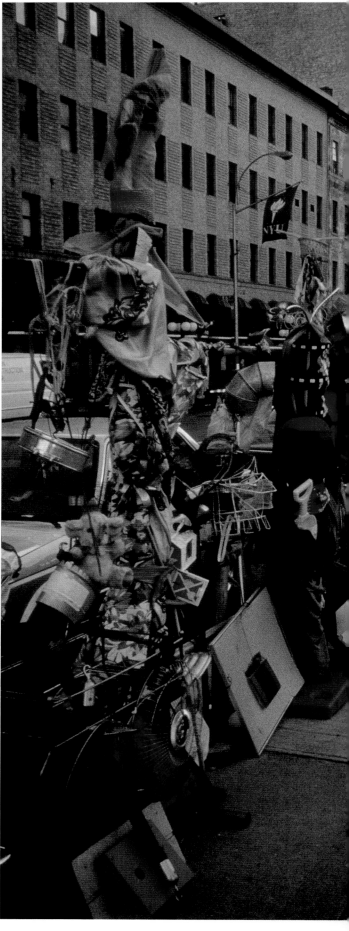

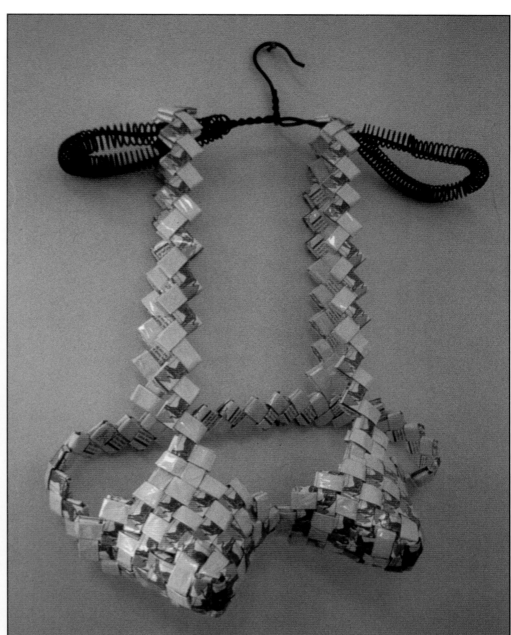

Bra, ca. 1930
Artist unknown
Bra made from woven cigarette packs by prison inmate.

**Street Installation of
Found Materials
Assembled at Astor
Place in New York City**,
1996
Curtis Cuffie

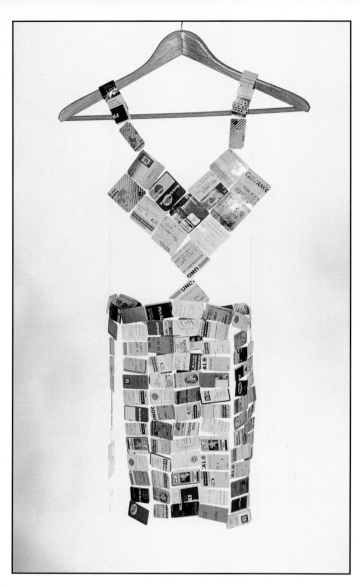

Home Ec.
Peggy Weil
Apron made from credit cards.

Chest Of Drawers, 1998
Reconstructions by Dorothy Spencer
Found wood, yardsticks, hockey
sticks, wood from old advertising
crates.

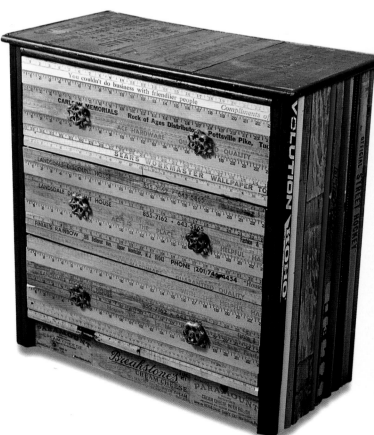

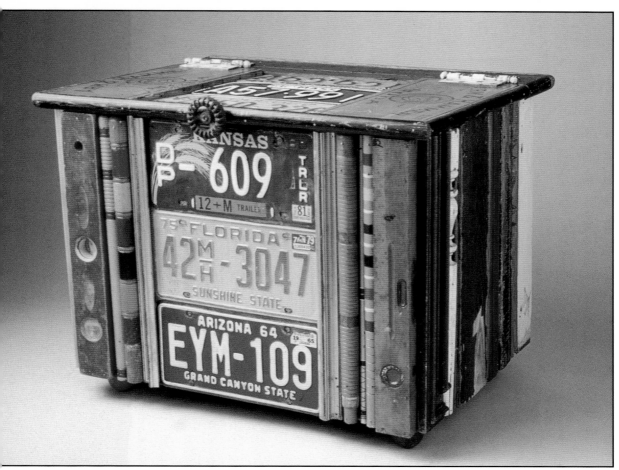

Blanket Chest, 1999
Reconstructions by
Dorothy Spencer
Found wood, license
plates, croquet
mallets, wooden
levels, and other
discarded objects.

Basket
Artist unknown
Woven subway tokens from the Paris
metro.

Umbrella Stand, ca. 1920s-1940s
29" high
Made from broken shards of pottery,
found objects, small toys
*Courtesy American Primitive Gallery, New
York City*

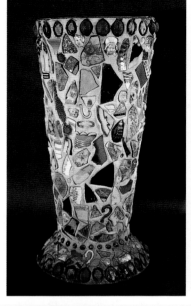

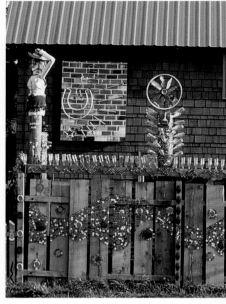

Lounge Chair, 2000
35" x 30" x 84"
Driftwood, woven necktie upholstery

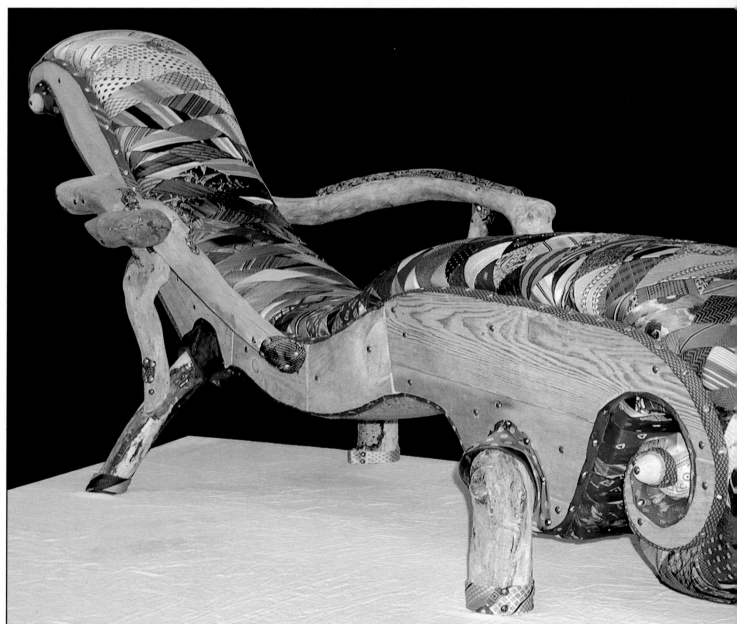

Dick And Jane's Spot—North Fence

Located in the heart of Washington state, Dick Elliott and Jane Orelman have created an art site that is predominantly of their own work, but is also a collection of the works of over thirty-five different artists. In the summer of 1994, Dick and Jane's Spot was nominated as a "Great American Public Place" in a search conducted by Urban Initiatives of New York City.

"Our modern day cultural totem is the power pole. Like life, many art pieces come and go, changing and decaying. The Spot is ever evolving. Beginning in 1980, always expressing the mystery of life, never being finished, just being, until the day it becomes a parking lot." —Dick and Jane

Table with Compartment, 1997
37" x 18" x 20"
Driftwood, copper

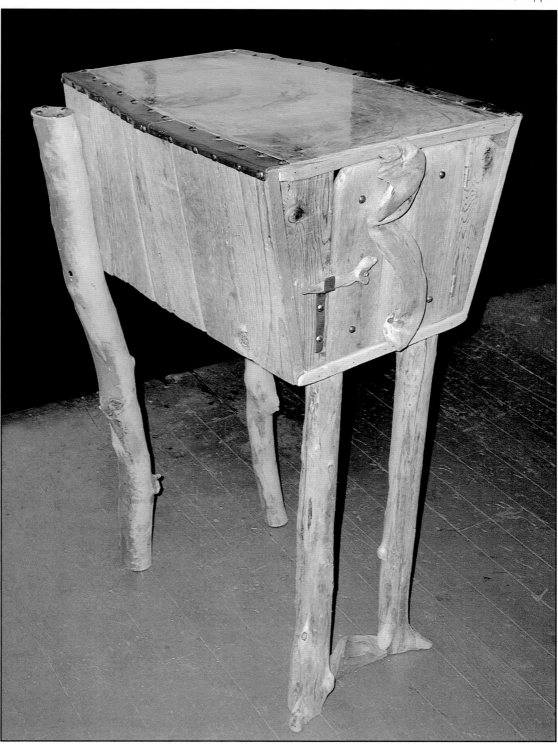

The Artists

"The excitement begins way before we design a piece, seeking out and sorting through salvage yards we hear of through word of mouth. A very good day begins this way. Standing alone with acres of unwanted items, from old shoe soles to a child's rusted toy, makes us feel a distant kinship to these items, the lives of these people and a time gone by. In designing a piece, we try to convey a sense of this nostalgia.

"Often, these ordinary discarded pieces become transformed into the sacred. An old bucket becomes a container for a light. A rusted valve cap becomes a torso for a doll. A child's toy iron becomes a shrine. We accumulate found objects until the time is right to re-invent these objects into their next lives. The challenge of working with recycled materials is for the viewer to see the found object in a new light, beauty and uniqueness— not just an old piece of 'junk'."

Nancy Anderson and Carolyn Douglas live in Boulder, Colorado.

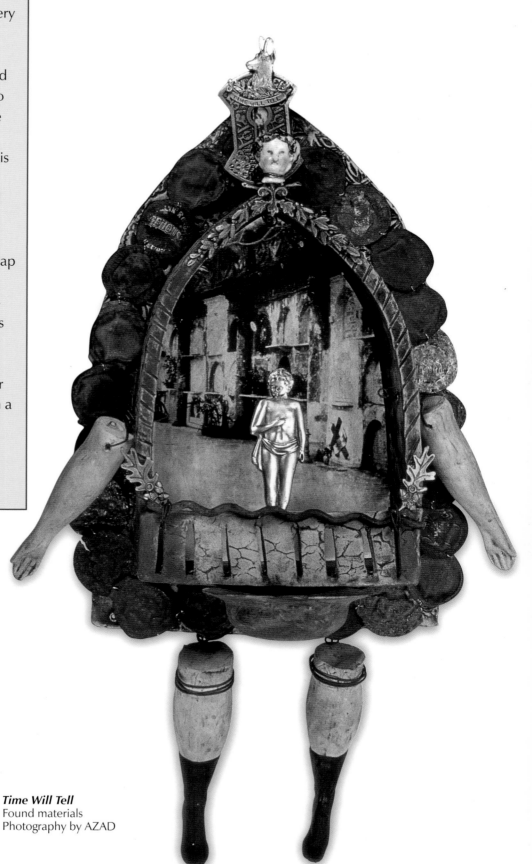

Time Will Tell
Found materials
Photography by AZAD

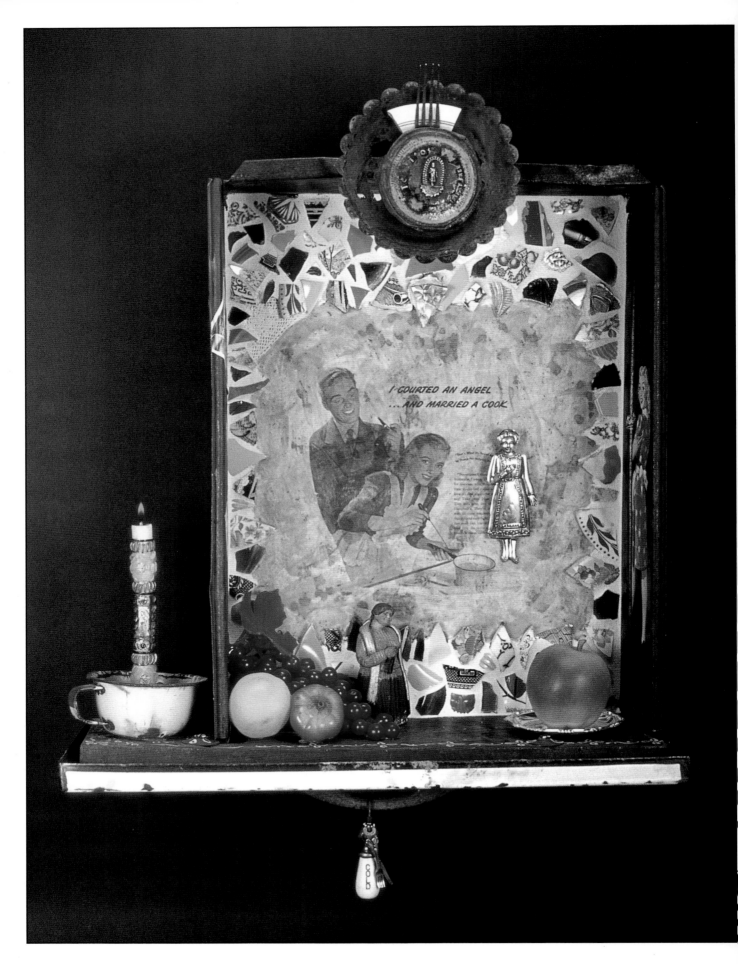

I COURTED AN ANGEL
...AND MARRIED A COOK

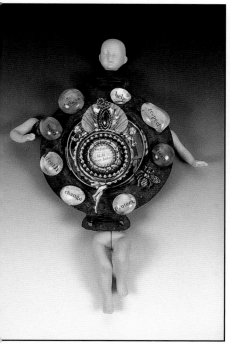

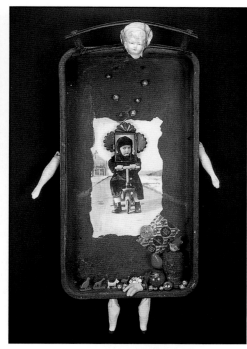

Core Memory
Found materials
Photography by AZAD

Before It's Too Late
Found materials
Photography by AZAD

Guardian Angel
Found materials
Photography by AZAD

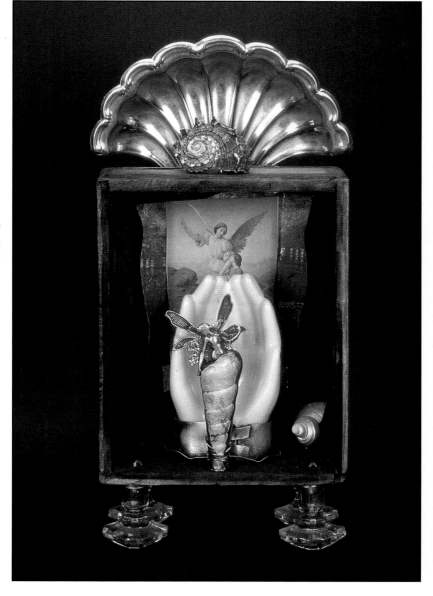

Opposite page:
Courted an Angel and Married a Cook
Found materials
Photography by AZAD

21

"My work as an artist has always been connected with an affinity towards the found object. I have become an enthusiastic collector of mass-produced, consumer goods from the '30s, '40s, and '50s.

"During the '70s, site specific installations that existed for the duration of an exhibition formed the main body of work produced. They were arrangements of collected objects, such as a wall of cameras or a grid of fiestaware in the grass. As these were not permanent pieces, they became more of an event with subsequent documentation.

"In the mid '80s, light, then function became notable elements in my work. The pieces became unified objects in the form of a lamp or light sculpture. These works were mainly rearranged lamp components. Later, with the help and collaboration of several glass artists, hand blown glass elements were incorporated.

"The recent work still utilizes light as an element but is no longer the main focus. The arrangement of collected objects is again the primary concern, this time in the form of a permanent object of art. These works incorporate three points of view. One being simply visual, one of cultural commentary, and the other best described as one of humor or whimsy. Though the work reflects a healthy respect for technology, innovation, and the mass-produced object, there is also concern about attitudes of extreme consumerism and the planned and unplanned obsolescence of things produced. The elements used in this work range from household items to industrial salvage, consumer items and the tools that produced them. By using objects that have ceased to serve their original purpose as components in a functional sculpture, I am able to draw upon their nostalgic/historical context as elements in a dialogue. The essential ideas in each work are revealed through the relationship of elements in it."

Harry Anderson currently resides in Philadelphia, Pennsylvania.

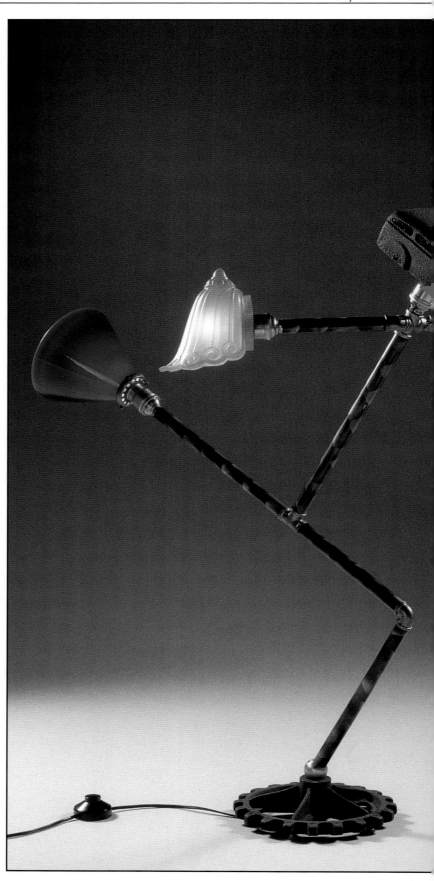

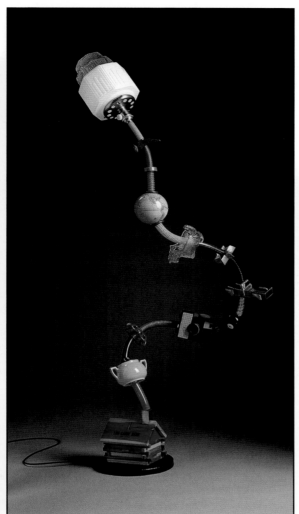

Twister, 1995
52" high
Mixed media
Photography by Michael Ahearn
*Courtesy Snyderman Gallery, Philadelphia,
Pennsylvania*

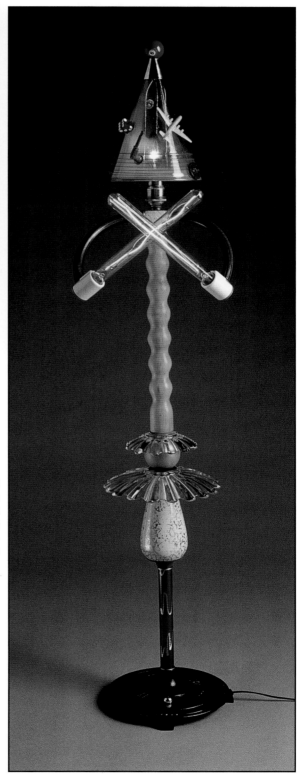

X-Ann, 1995
65" high
Mixed media
Photography by Michael Ahearn
*Courtesy Snyderman Gallery,
Philadelphia, Pennsylvania*

I Roll, 1998
39" high
Mixed media
Photography by Michael Ahearn
Courtesy Snyderman Gallery, Philadelphia, Pennsylvania

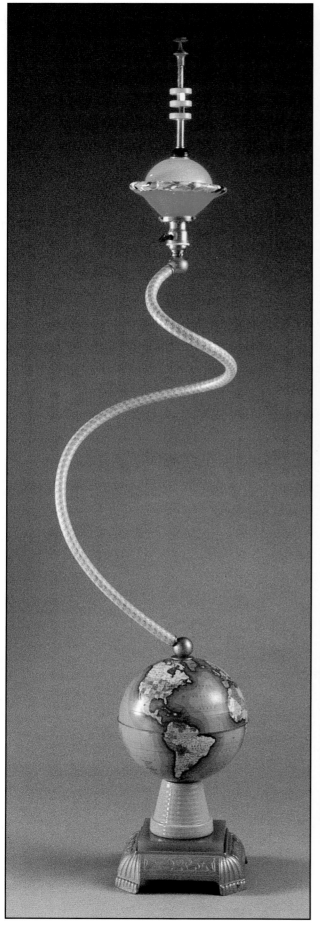

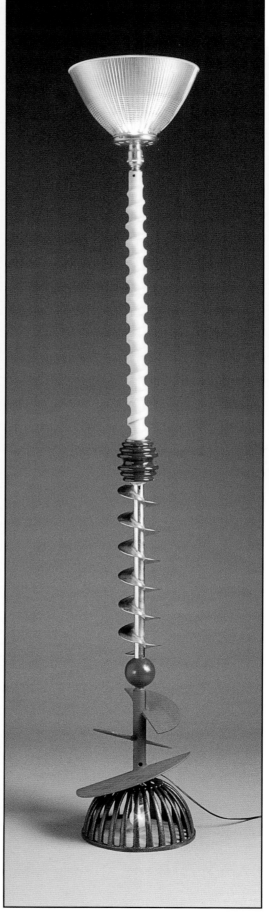

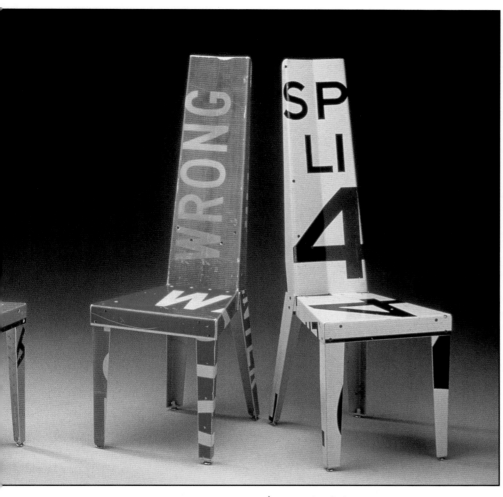

Transit Chairs, 1997
48" x 16" x 21"
Re-used traffic signs, hardware
Photo by Dean Powell

"This series of industrial strength work is designed to celebrate raw American street aesthetic by way of useful items for living. The scrap street signs, bottle caps, and wine corks used in their production transform the urban detritus most of us live with into objects of elegant significance. Conversely, the valuable materials have been metaphorically transmuted to become common. These pieces proudly acknowledge their Pop and Postmodern footing while appreciating the crude beauty of the urban environment."

Recycled street signs have been Bally's *raison d'etre* for some time. "I like the idea of using these environmentally friendly materials in a way that makes them seem precious." His **Transit Furniture** series uses scrap street signs that boldly proclaim their timely message. In addition to the furniture, the signs are used to create numerous innovative bowls, serving platters, eating and serving utensils, and weightlifting paraphernalia. His **Rep Forms** create a conceptual blue of cyclic confusion. Dumbbells are designed to sculpt the body, which has in turn sculpted the dumbbells. The materials used for the Rep Forms are appropriate for an "inner-city gym." They are the gritty remains of once legible traffic signage and, through lathe-finishing, acquire a raw elegance.

Boris Bally lives and works in Providence, Rhode Island.

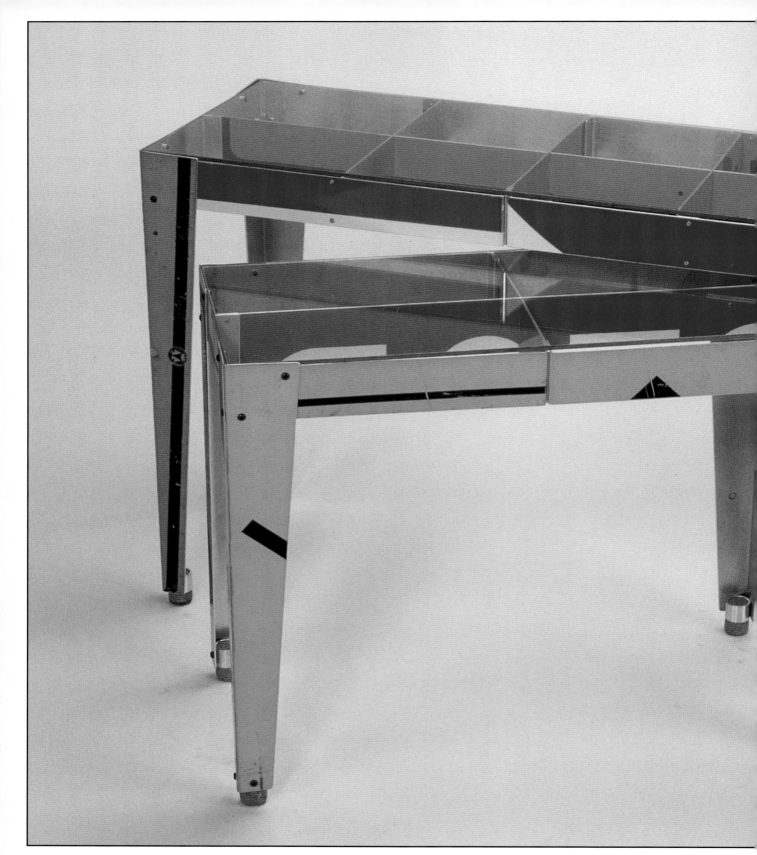

Long and Short Tables, 1999
long size: 25 1/2" x 14 x 36"
short size: 22" x 13" x 26 1/2"
Re-used traffic signs, glass, copper rivets, fasteners
Photo by John Redmond

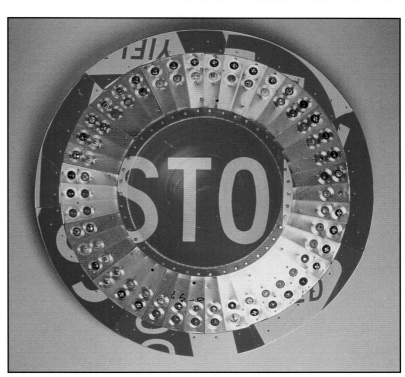

Bottlecap Dahlia Bowl,
1997
38 1/2" diameter x 3 1/2"
Recycled traffic signs,
bottlecaps, copper
Photo by Dean Powell

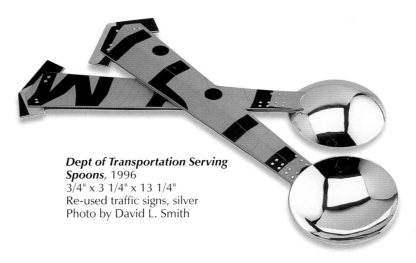

Dept of Transportation Serving
Spoons, 1996
3/4" x 3 1/4" x 13 1/4"
Re-used traffic signs, silver
Photo by David L. Smith

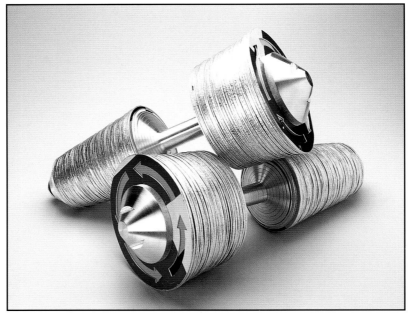

Rep Forms: Dumbbell
Set, 1996
22" x 9" x 9"
Re-used traffic signs,
aluminum
Photo by David L.
Smith

"My work springs from an interest in both fiber and collecting. While patchwork is by its nature a collection of different fabrics, I strive to carry the process a step further by incorporating "found object" materials. In this way, the quilts become a sort of fiber collage. Traditional American patchwork was made from the salvageable portions of worn out clothes and scraps left from cutting new clothes. Continuing this tradition, but in a very different design format, I combine new fabrics with old fabrics, such as printed feed sacks, linen children's books, old lace, canvas money bags, and commemorative handkerchiefs.

"I consider quilts an art form, which, like poetry, becomes much more than the sum of its parts. While paintings or ceramics require a blending of materials, scraps of fabric, like words, retain their original character, while achieving new meaning by virtue of their juxtaposition."

Teresa Barkley has been making quilts since she was five years old. She lives in Maplewood, New Jersey with her husband, the painter Donald McLaughlin, and their two children.

Denim Quilt, 1972
94" x 77"
This quilt is composed of 396 4-inch squares of denim decorated with appliqué, embroidery, and patches. The patches include old army patches, Girl Scout patches, souvenir patches, and commercially embroidered patches for businesses.
Photo by Stuart Bakal.

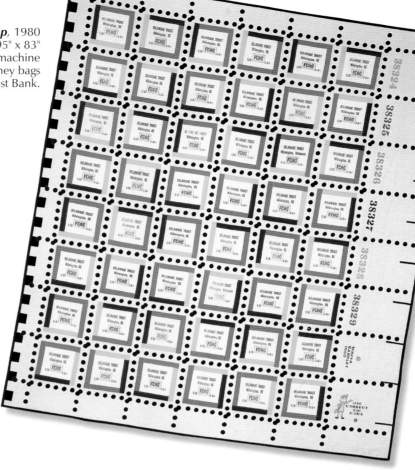

The Delaware Trust Stamp, 1980
95" x 83"
Machine pieced, hand appliquéd, machine quilted, and hand painted money bags from the Delaware Trust Bank.

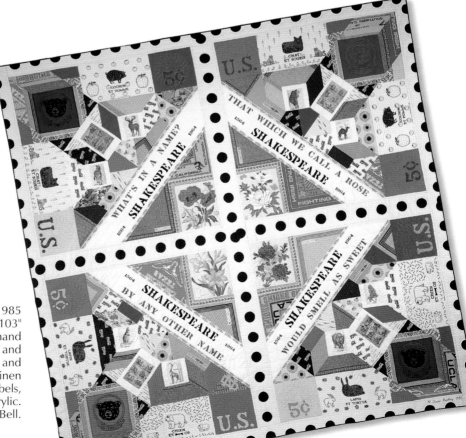

Shakespeare, 1985
103" x 103"
Machine pieced, hand appliquéd, hand quilted, and hand painted from cotton and blends, linen book pages, linen tea towels, clothing labels, acrylic.
Photo by Karen Bell.

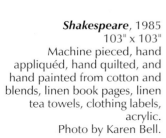

Tea Will Make It Better, 1996
61" x 71"
Machine pieced, hand appliquéd, and machine quilted from cotton, rayon, tea towel, damask napkins, tablecloth, tea co and muslin sacks sold with tea inside.
Photo by Karen Bell.

Labels Quilt, 1974
95 1/2" x 69 1/2"
Three thousand clothing labels hand sewn to machine-quilted squares.

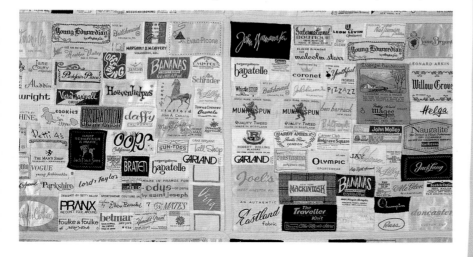

Jim Bauer

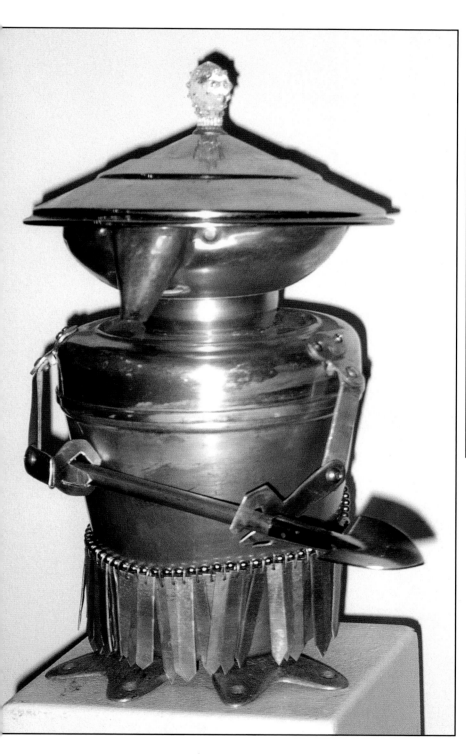

Jim Bauer is a self-taught artist who constructs coffee pot figures and robotic assemblages, using his skills as a former mechanic to build his sculptures. He scavenges old kitchen pots, implements, and other familiar objects, which he combines to reinvent the human form. Most of the sculptural figures feature special effects created by internal lighting. If science fiction evolved in the kitchen, then these figures would certainly be at home there.

The recycled materials Bauer uses are often gathered from the flea markets he once roamed as a junk dealer. In particular, he has a feel for aluminum, an affinity he developed while employed for many years at an aluminum factory. While Bauer also makes lamps from his found materials, it is his animated aluminum pots that best attest to his keen imagination; his eyes see, for example, a set of measuring spoons as fingers, a clock as a stomach, a teapot as a head and so on. Utilizing old and discarded kitchen detritus like Jell-O molds, funnels, and sieves, Bauer's pieces are dichotomies of futurism and nostalgia.

Jim Bauer lives in Alameda, California.

Non-Ferrous Fiberman With Shoes
12" x 9" x 7"
Aluminum cookware
Courtesy American Primitive Gallery, New York City

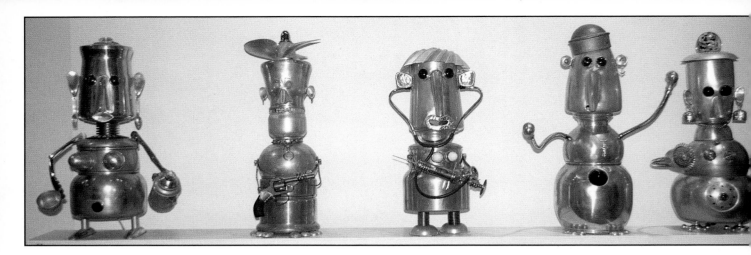

Coffee Pot People Parade
Aluminum cookware
Courtesy American Primitive Gallery, New York City

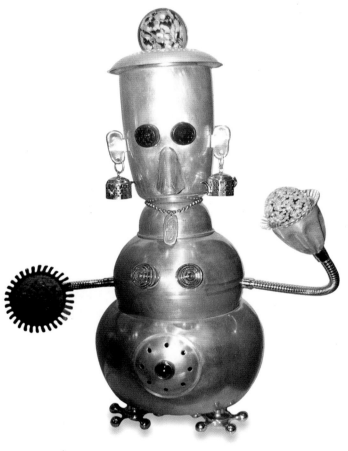

Electronic Pot Lady
Aluminum cookware, electronic pieces, glassware
Courtesy American Primitive Gallery, New York City

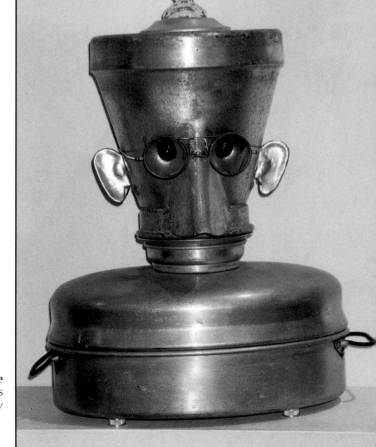

Aluminum Bust With Light Up Eyes and Head Piece
Coffee pot, toaster, aluminum cookware parts, electronic pieces
Courtesy American Primitive Gallery, New York City

"I see recycling as a life style. Not only do I make art out of castaways but dumpster-dive for just about everything I use in my home. The only exception is meat, dairy, and eggs.

"I live in Seattle, Washington. I moved to the Northwest in 1978 from Greenwich, Connecticut. People out here in the Northwest know of Greenwich and are surprised when they find out I am from there, especially when I am hoisting up some dusty furnace duct from the dumpster. I ride a bike a lot and often by the time I arrive home from a bike ride, the bike is as wide as a stuffed shopping cart full of junk. Sometimes the best times of utilizing junk is the process of getting it home.

"Actually, all this recycling started back in Greenwich. I remember it well. There's the 'Rummage Room,' a thrift shop in Old Greenwich, Connecticut that is run by the First Congregational Church. It's still on Southbeach Avenue across from the bank. One day, after I deposited some money in the bank (I had a paper route in the 7th grade during the end of the Nixon administration), I went into the Rummage Room and found a cool maroon sweater for 50 cents. Prior to that, I wore everything new. I took a deep interest in second-hand clothing. My father was delighted with his daughter's new interest—his teenaged daughter not interested in Bloomingdales!

"At the same time, my sister, Yvonne, went into

New York to see a quilt show at the Museum of American Folk Art. She returned home with a catalog that I drooled over. Many beautiful quilts made out of scrap fabric. I wanted to make one, too. So one collection day, on my paper route, I asked all my customers for fabric scraps. I made 13 quilts.

"Today, making art out of cast-aways is a game—a puzzle. I am useless when it comes to home improvement or computers, but this lifestyle makes up for that void."

Whether emulating New England churchyard gravestones, quilts, flags, or various types of tramp art, Beecher draws upon many aspects of American culture to make her point: simple is beautiful, we can get by with less, the handmade is the key to salvation in an increasingly materialistic, throw-away society.

"Function is an oblique link between folk art and Beecher but none of her constructions are in any way usable. The quilts and flags operate as commemorative backgrounds for her over-the-top, obsessive material indulgences. Appropriately flat and two-dimensional, they proffer an image-ground that accumulates within each piece. As the social referents of the recycled materials are unraveled by the viewer (Coke cans, chewing tobacco tins, BIC lighters, olive oil cans), the meaning of each piece emerges as a fusion of fragment, detail and the whole." (from an article by Matthew Kangas, in *Metalsmith*, Spring 1996)

Flip-Top Quilt Study, 1997
24" x 24"
Flip-tops, soda cans, tin, other found objects.
Collection of Harborview Medical Center, Seattle, Washington

Star Quilt, 1990
49" x 50"
Soda and beer cans, bottle caps, woven and
"quilted" with wire.

Rainbow Quilt, 1994
48" x 48"
Plastic disposable lighters, "Copenhagen"
chewing tobacco lids
Collection of City of Seattle Water Department

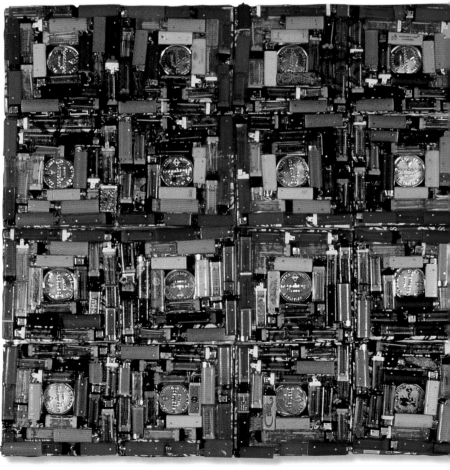

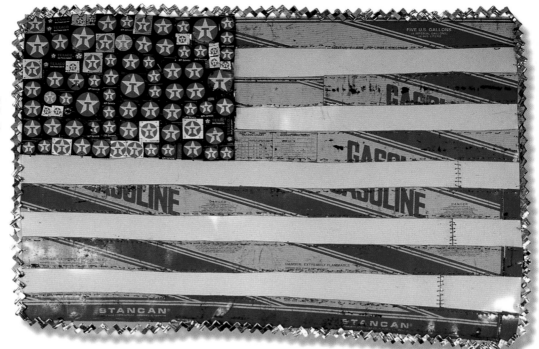

American Flag IX, 1990
24" x 37"
Tin, gas cans, motor oil logos

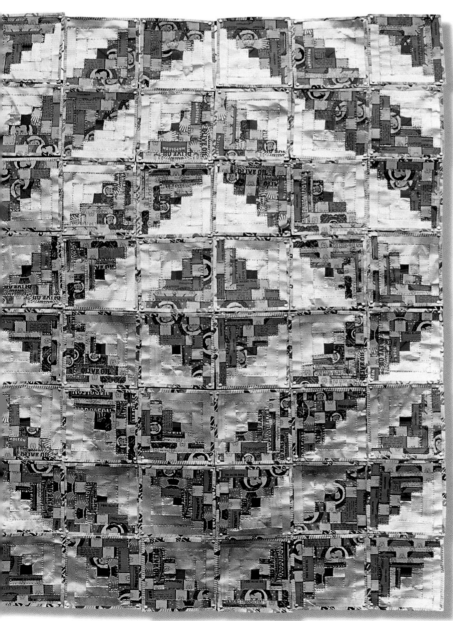

Napoleon Olive Oil Quilt
Aluminum, tin, and auto tail light
fragments quilted together with wire

"Conceptually, my work is a reflection of my need to make order out of chaos and give meaning to the incoherent. What is of primary interest to me is the physical process of making art and the recognition of my inherent desire to make things, and to learn and be inspired to make new things.

"My personal motivation is derived from subject matter such as history, society, politics, religion, family, and perceptions of individuality. Also important to me is making art that addresses issues and raises questions about the act of collecting and acquisition and about arranging and organizing the world in which I live. My work is characterized by the humorous, unpredictable, and provocative use of ordinary materials, and my process is continually fueled by an interest in reorganizing, reclaiming, and recycling the abundance of discarded, rejected, and overlooked materials of our society.

"I am drawn to scrap heaps, junkyards, old barns, attics, and basements. I use familiar objects such as books, bottles, kitchen scales, globes, science equipment, and old tools to evoke meanings layered with humor and irony as well as with more serious intent. I will often make a piece with only the material gathered on a single collecting trip, a sort of trophy of that particular occasion, and title it after the street name or building address where a significant part of the piece was found. I use materials without radically altering their appearance and reorganize objects to be oddly juxtaposed. I make tightly packed groupings with objects that have similar characteristics, which for me creates a feeling of security and well being similar to the feeling one may have when looking at the shelves of a well-stocked pantry. In the end I strive to create a unique form that transcends the smaller parts for the whole and ultimately evokes new meaning.

"The strength of my work is not achieved through the use of fashionable style or by association with current trends. I see the individuality of my work as its strength. Its individuality is achieved by characteristics of economy, simplicity, and honesty."

Doug Bell lives in Andover, Massachusetts.

Ballerina, 2000
78" x 100" x 40"
Open front dresser with torso, electric light, ballerina figurine spinning on turntable floor

Stack, 1998
12" x 11" x 18"
Mixed media

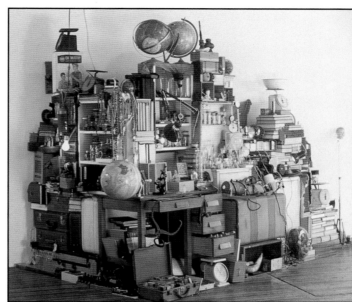

HallSpace Stack, 2000
Mixed media

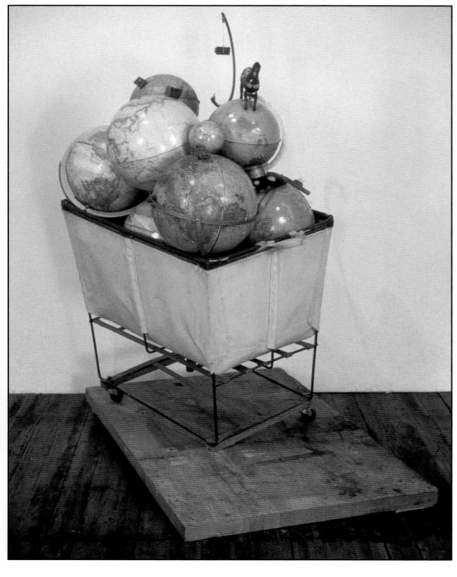

Globe Stack, 2000
49" x 24" x 48"
Laundry cart, wood flooring, globes with toy
train, plane, car, submarine and pony

"I am excited by trash transformation—art alchemy. I'm thrilled by the challenge of fishing in the trash stream in the US (it's really a trash tsunami). Removing things from dumpsters and fashioning new uses is a spiritual experience for me—refuse resurrection requires all my creative abilities to break away from past uses to see new life in old objects.

"In Philadelphia we have a group of salvage artists called the Dumpster Divers, where we throw out ideas of reuse and recreation. Our motto is 'Ejectamentum nummi nostrum—Your trash is our cash.'

"Recently, South Carolina has begun an annual national design gathering with the collection name of 'Ripple Effect.' At the core of this program is our belief that Art can lead the way for society's reuse imperative. The 'Ripple Effect' is creativity, spreading throughout our culture, addressing the limits of our resources by using our imaginations in limitless ways. Everyday, treasures are put out by the curb—we just have to go find them."

Neil Benson lives in Philadelphia, Pennsylvania.

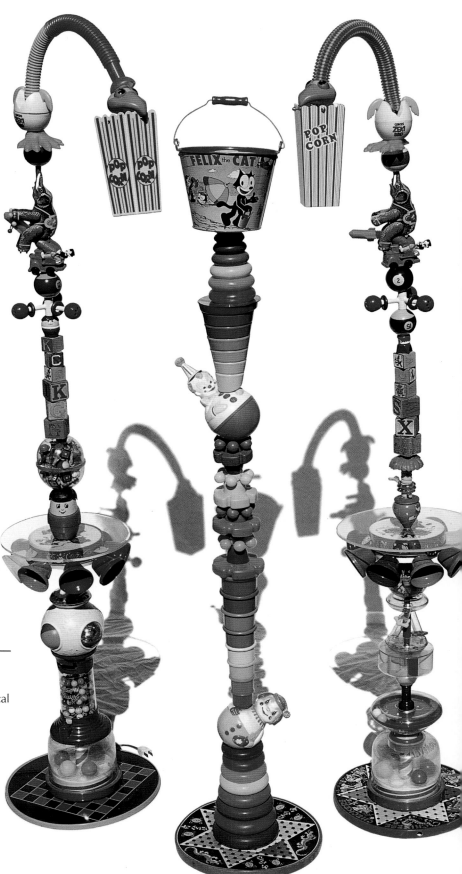

Totem Lamps
Plastic and tin toys, game boards, pool balls, electrical components

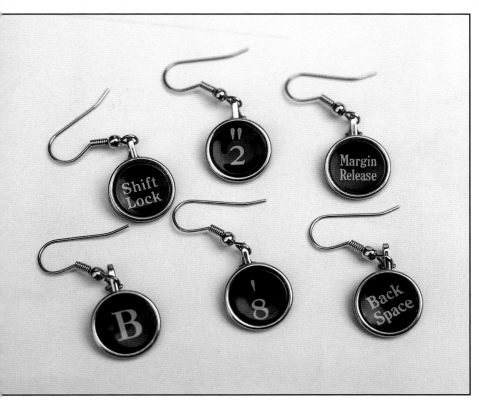

Typewriter Key Earrings
Old typewriter keys, sterling silver

Fork Lifts and **Crowns**
Tin cans, bottle caps, and other found objects

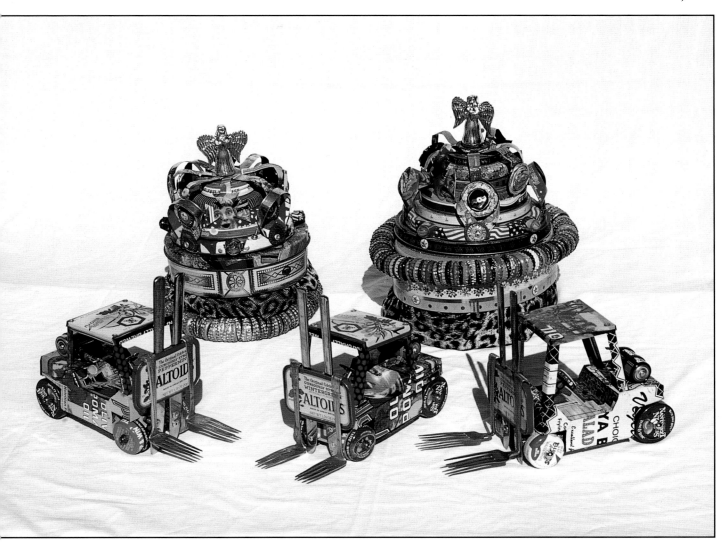

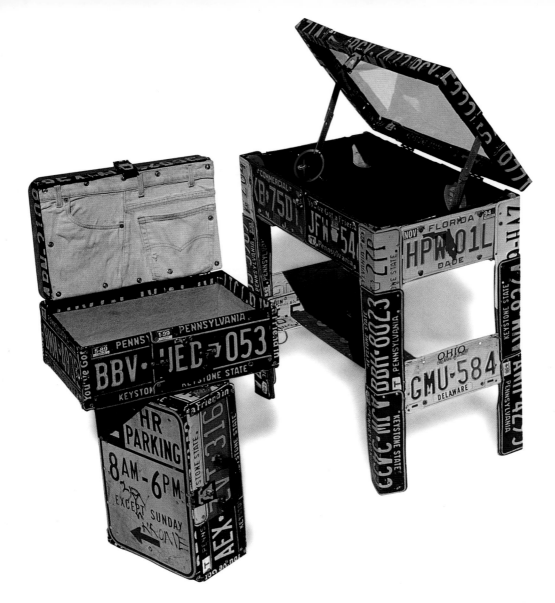

Carry Cases and Table
License plates and found tin

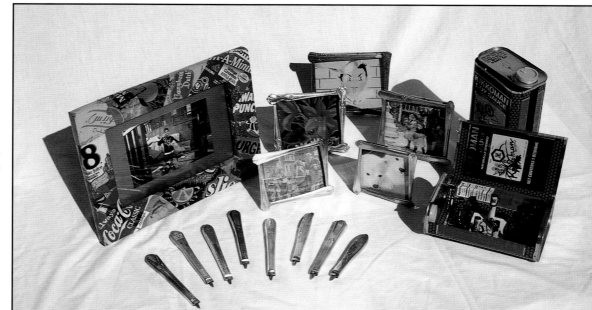

Picture Frames and Pens
Tin cans and flatware

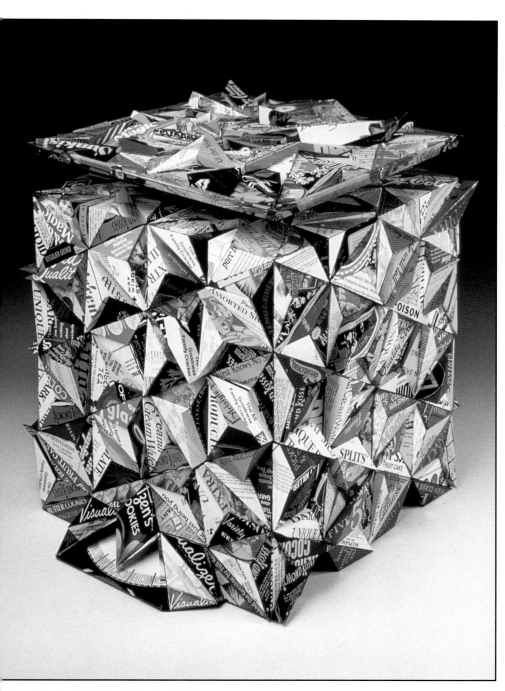

Witnessing the Weight of Words, 1996
20" x 18" x 18"
Pre-printed steel with motorized dial
Courtesy the Sybaris Gallery, Royal Oak, Michigan

"As a recycling evangelist, I use the images printed on post consumer material as a source of inspiration and content in my artwork. For example, reproductions of paintings by Seurat and Manet are found on containers of Danish butter cookies. The printed tin material is used in my piece *Frame of Reference: Consuming Good Taste.* Do products using images of art imply that the product tastes good—or that the consumer has good taste? In many of my pieces, art reproductions and other images on tin cans serve as reflections of the ironic role of art in our consumer society.

"The colors, the patterns, and the words from post consumer materials contribute important content. In another example [of her work], *The Deceiver and the Deceived* includes 140 images of women taken from tin food containers. Each of the fans on the pedestal shows women in various stereotyped roles. Who is the deceiver and who are the deceived in our society when women are portrayed as 'pure, alluring, refreshing, and delicious, good as home-made?'

"The words printed on the materials are carefully selected to reinforce the primary themes of each piece. In particular, my interest extends into the psychology of advertising and the use of words loaded with cultural innuendo."

Harriete Estel Berman, a self-described "recycling evangelist," lives in San Mateo, California.

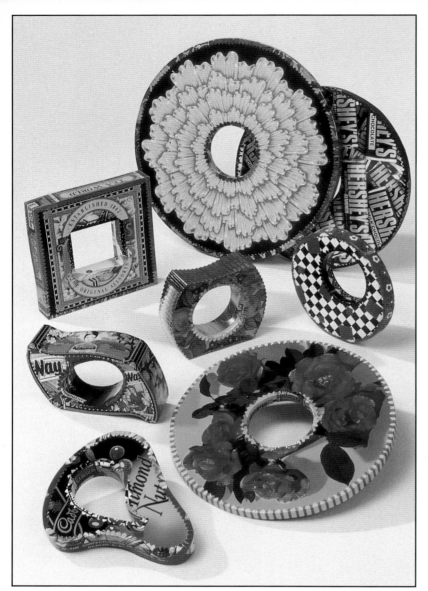

Bracelets, 1999
4.5" diameter x .25 - 1.5" diameter
Pre-printed steel
Courtesy the Sybaris Gallery, Royal Oak, Michigan

Square Yard of Grass, 1998
6" x 36" x 36"
Pre-printed steel, copper base
*Courtesy the Sybaris Gallery,
Royal Oak, Michigan*

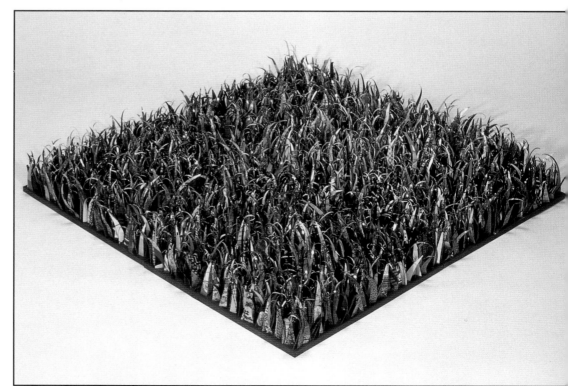

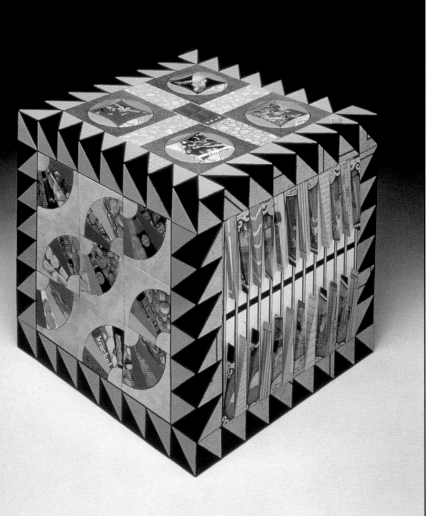

A Pedestal for a Woman to Stand On, 1995
16" x 16" x 16.5"
Pre-printed steel
Courtesy the Sybaris Gallery, Royal Oak, Michigan

*Reality Studded with Thorns
Guards the Front Door from the
Street*, 1997-98
18" x 20" x 5"
Pre-printed steel
*Courtesy the Sybaris Gallery,
Royal Oak, Michigan*

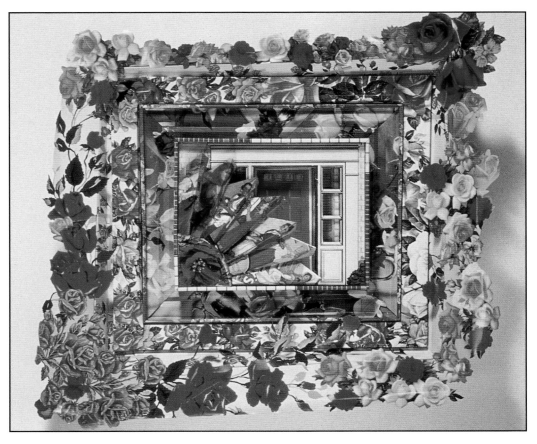

43

"I take all kinds of old buckets, garbage can tops—all kinds of stuff. I've been getting all of this old carpet to make the tongues out of it. That's what I do with that. And all the wires? Most of the time they come from old clothes lines and I tie them on there. Those buckets: I make eyes on them. They have four eyes: some have three—a middle eye. I make them so they can see good: two eyes here and one way up on the top of the head. The third eye sees a whole lot, you know. And I have milk cans tied together. When the wind comes, it sounds like a bell."

Blind since the age of five, Hawkins Bolden has always earned his living cultivating lawns and cleaning the alleys and vacant lots of his Memphis community. As a child, he and his twin brother began making radios, assembling them from discarded parts discovered during his daily rounds. Over the last twenty years he has also been collecting found objects—shoes, chairs, metal pans, ice cube trays, bottles, carpet fabrics, TV trays, pots—which he uses to create standing figures and wind chimes for his yard.

Hawkins Bolden, who was born in 1915, lives in Memphis, Tennessee.

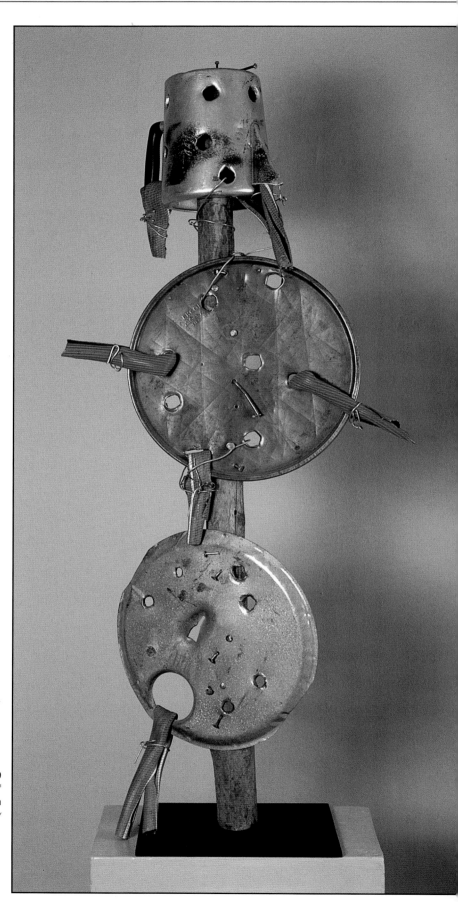

***Untitled - Totem**, 1999*
44" x 20" x 9"
Found metal, rubber hose, tree branch
Courtesy American Primitive Gallery, New York City

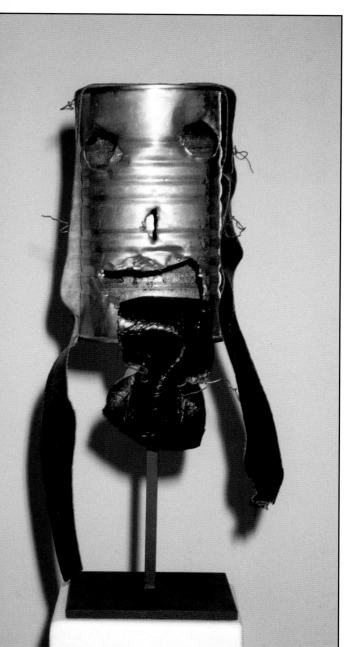

Face - Mask
Old metal and socks
Courtesy American Primitive Gallery, New York City

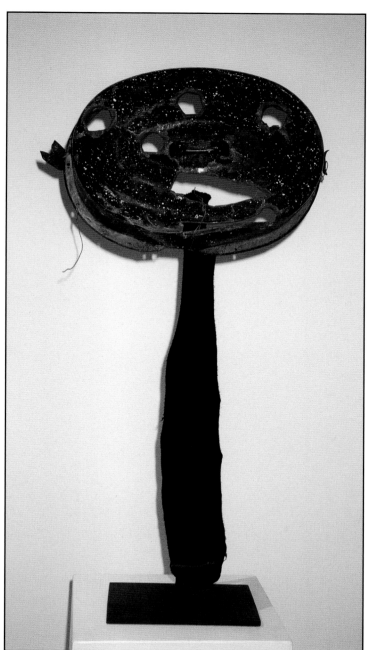

Face - Mask
Tin cans with black leather
Courtesy American Primitive Gallery, New York City

"I have always been charmed by small treasures, ordinary everyday things. What fascinates me is what others disregard, the detritus of the day to day: scraps of colored or patterned paper, old maps and photographs, candy wrappers, bits of bone, board game pieces, broken tail lights, funny rocks. I find this stuff attractive and mysterious. Collecting these odds and ends, these bits of evidence of moments past, I experience a peculiar pleasure, a delight in what is at once both precious and plain. My work is a response to the quality of these things and the associations they evoke—mystery, memory, people, places, and events. It plays with the relationship between the commonplace and rare.

"I prefer a soft tech approach to my work. Collage, assemblage, and fabrication techniques are direct and immediate. They allow me to layer and overlap images and elements or set them side by side. Through this process I can make new associations and visual meanings or enhance those already there. Each piece is made individually, start to finish, so that it is a singular expression of the moment and materials at hand. My jewelry is about remembering and reminding others that ordinary things can be extraordinary."

Ken Bova lives in Bozeman, Montana.

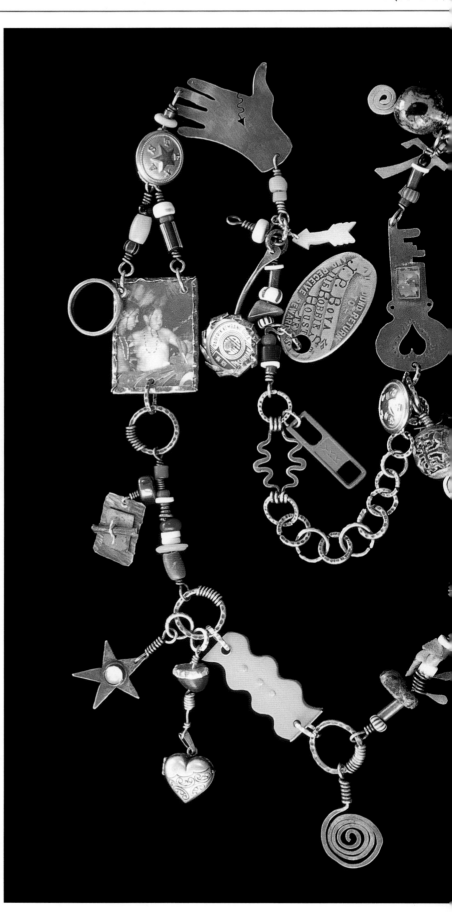

History Lessons in Progress, 1992 - present
Sterling silver and found objects
Courtesy Connell Gallery, Atlanta, Georgia

Opposite page:
Waiting - Brooch, 1998
Wood, bone and other found objects, sterling silver, 14k gold, pearl, citrine
Courtesy Connell Gallery, Atlanta, Georgia

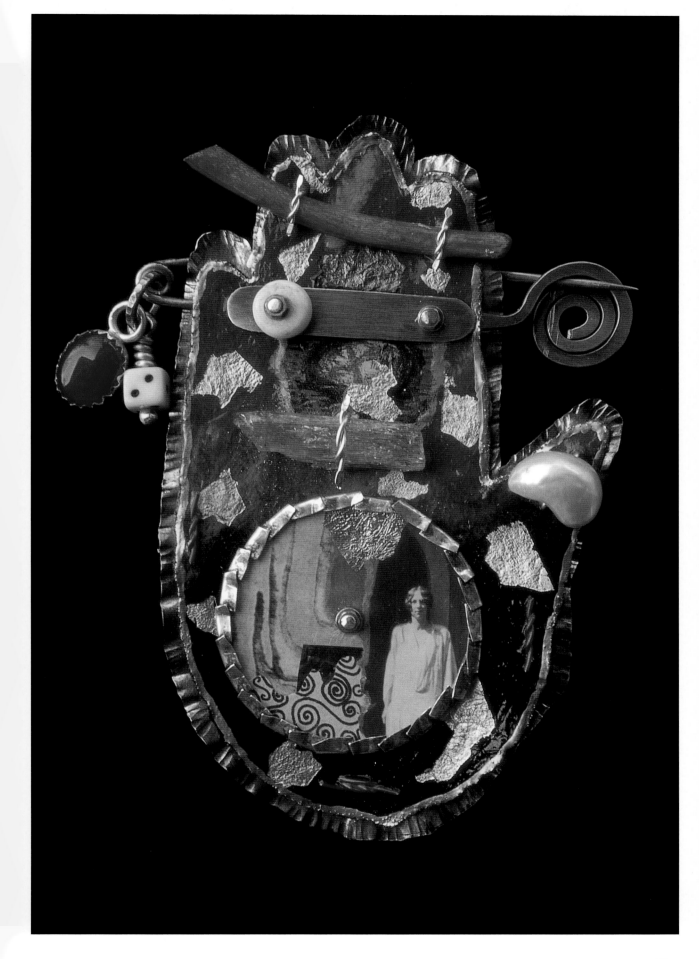

"Growing up in Detroit with my pa being a mechanic and my ma being Catholic, I was the youngest of four sons. The combination of this, along with the fact that my uncles were home builders, left a lasting impression on me. When I entered college, I was sleeping through engineering course by day, working for cash, and tooling on my vehicles half the night. I was able to get by for a few years until the scholarship money ran out.

"There was a point in there some-where when my sight began to change. Piles of left-over car parts started to look different; shapes started to take on new meanings, and when a few things were put side by side, they seemed to almost come alive.

"For the last six years, I have been spending all of my time collecting and building stuff. It has turned into a full-time obsession. I am always stopping to pick up a flattened, rusty, catalytic converter cover or something along those lines. This stuff has value to me because it can tell a story. You just have to take the time to learn how to read it. It's the art of finding the stuff and then figuring out from where it came and pondering the possibilities of how it got there, where it has been, and how many lives it has interacted with, that is what interests me the most. The challenge is not in trying to make the stuff, but being open to it. The resulting sculpture is the by-product of my quest into examining the complex connections in life."

Ritch Branstrom currently lives in Rapid River, Michigan where he is building his homestead from recycled materials.

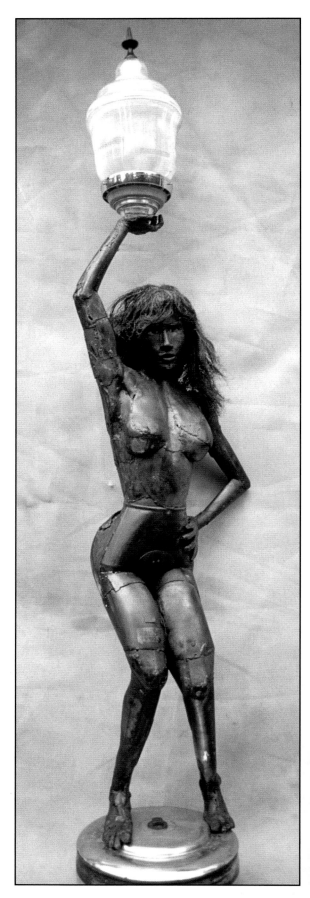

Night Light
10' x 27"

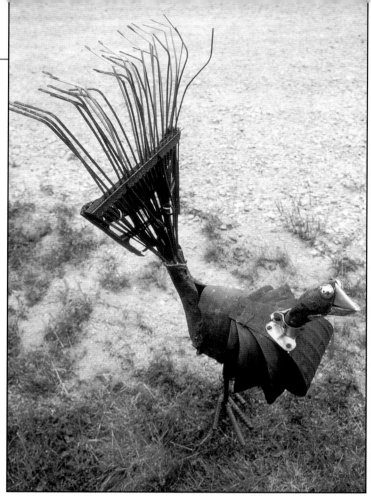

Yard Bird
30" x 16"

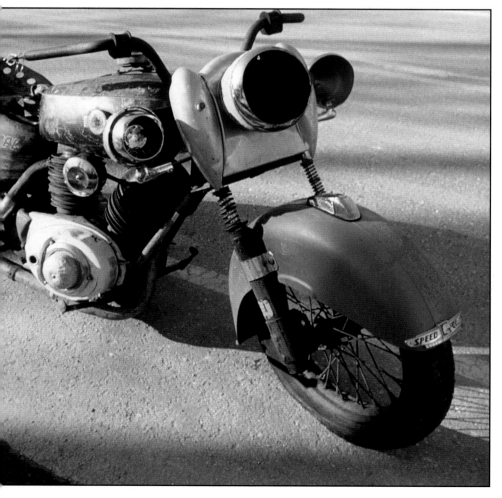

Ad Hoc Hog
Life size +

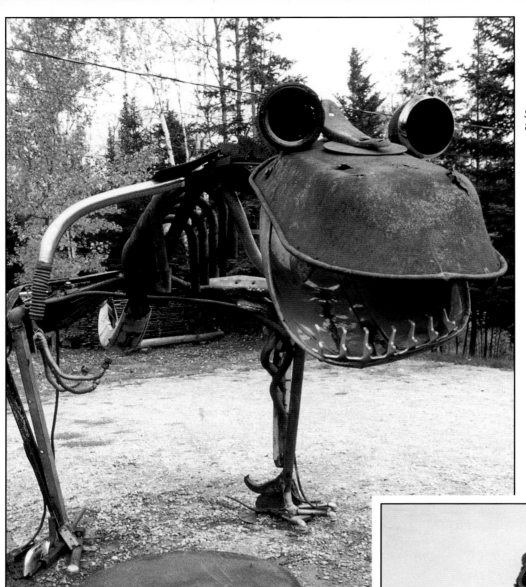

Spot (Dynamic Dinosaur)
8' x 4' x 17'

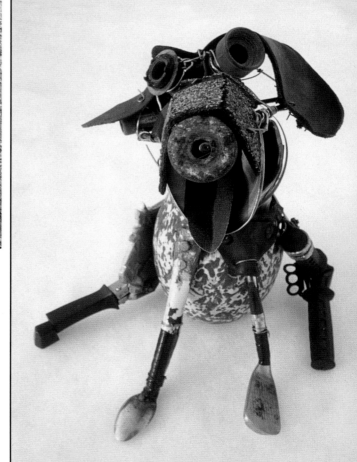

Happy Dog
18" high

"There are three strategies that are consistently employed throughout my work: the use of photographic images, the use of text, and the incorporation of found objects. I use photographic images to create a dialogue between apparent reality and the symbolic and the illusionary. Although often staged or appropriated from historical sources, the photographic images provide a certain measure of proof—a psychic verification. Often times the meaning of the work exists at the intersection of text and image. Words serve to recontextualize the image and bring them into the contemporary sphere of gender politics or other major themes of interest to me. My most recent work borrows forms of visual display, particularly museum and scientific display and uses these forms to examine issues of identity."

Kathleen Browne lives in Ravenna, Ohio.

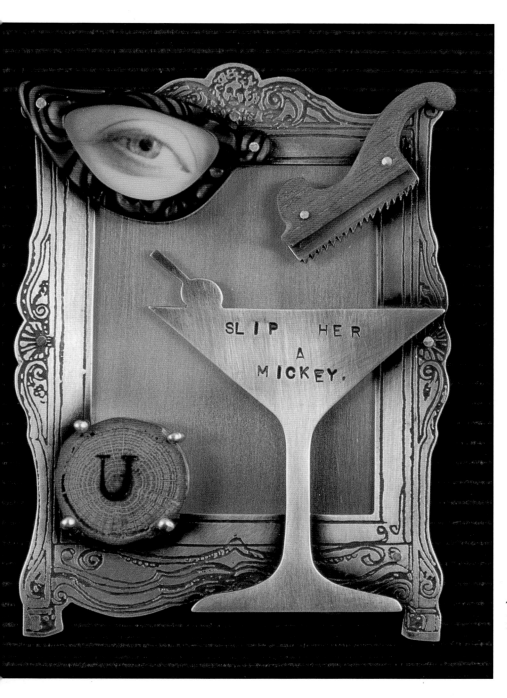

Accusations: I Saw You Slip Her...
3 1/2" x 2 1/2" x 1/2"
Silver, wood, plastic, photo

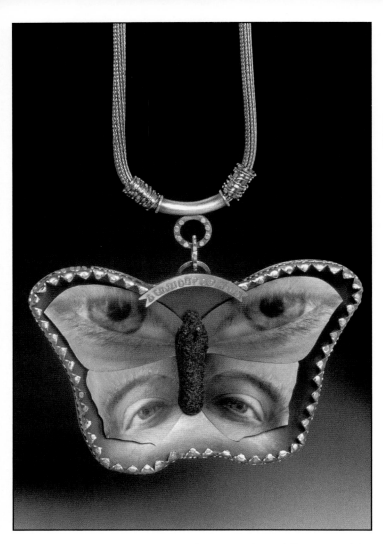

Silent Witness 1, 1998
21" x 4" x 1/2"
Silver, 24k gold, photo, plexi

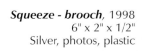

Squeeze - brooch, 1998
6" x 2" x 1/2"
Silver, photos, plastic

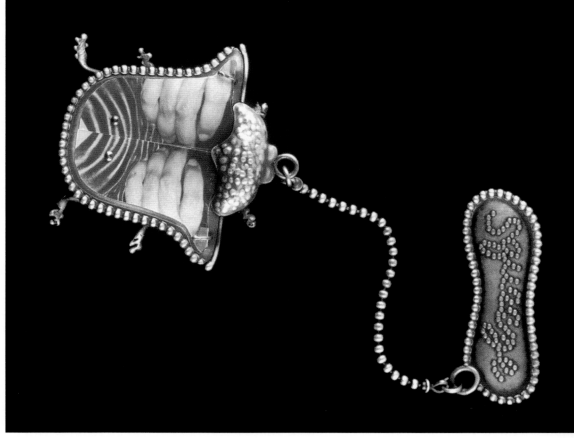

Larry Calkins

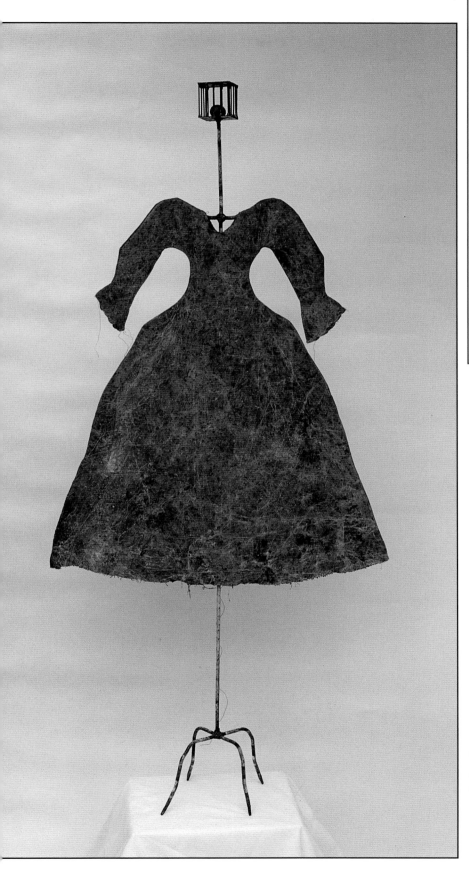

"I was born in Oregon in 1966 and raised in Harian, a small logging community in the Coast Range near Corvallis. Much of my work arises from ties to the small community. My work talks about people and what happened to them. I draw upon my own observations and many stories that are told and retold. Often my work refers to events that impact and change a person's life forever. Such events are marked in the objects that I create, or in reoccurring images and dates. Eventually, they take on the shape and expression of symbols.

"The wood and metal, even the dirt and clay that I use are usually taken from places that have a certain significance. They also tell a story. I see my work as one large piece—an accumulation of places, events, and situations that mark one's road through life."

Hard Scrabble, 1997
50 1/2" x 23" x 6"
Cloth, clay, metal
Courtesy American Primitive Gallery, New York City

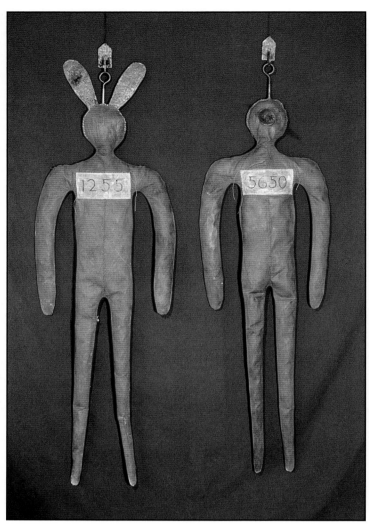

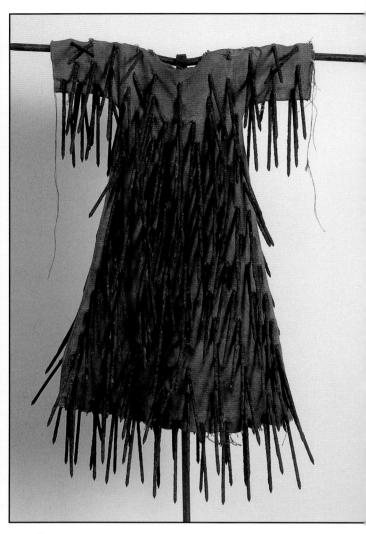

Husband and Wife, 1998
58" x 18" x 3"
Cloth, wax, clay, paint, straw
Courtesy American Primitive Gallery, New York City

Nail Dress, 1995
31" x 15" x 8 1/2"
cloth, clay, metal
Courtesy American Primitive Gallery, New York City

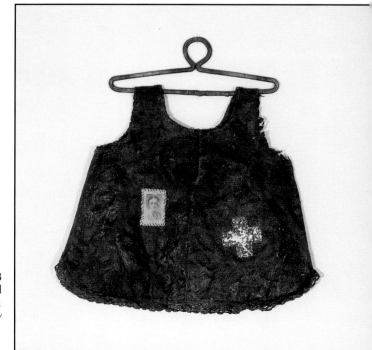

Emily, 1998
cloth, plaster, beeswax, soot, metal
Courtesy American Primitive Gallery,
New York City

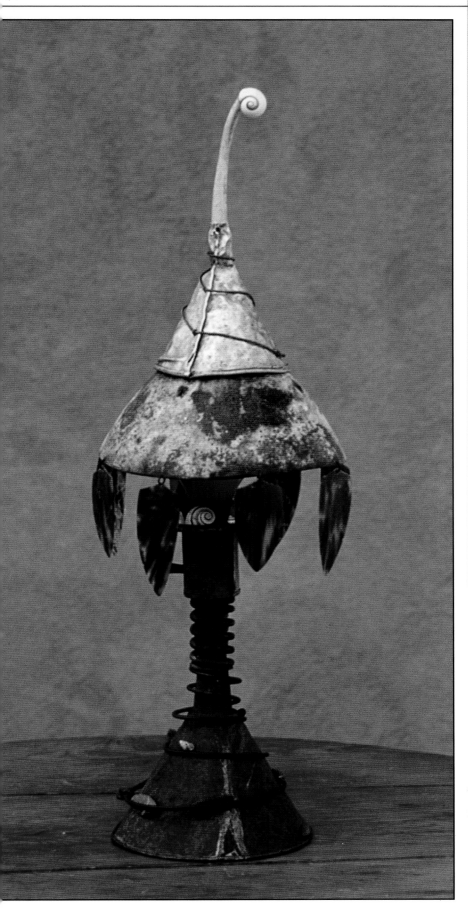

"I find an unlimited source of beautiful materials in junkyards, arroyos, and backyards, many with a rich rust patina achieved only by years in the weather: pieces of great design, history, presence, with stories to tell of the overlapping generations of Industrial Age follies. Something else, now lying, [is] waiting to be rediscovered in a new appreciation. So many pieces will fit together as if they were originally designed to do so. Though they are from completely different industries, now they synchronize with such surprise. I find myself bursting out in laughter at the sudden grace of the moment of junction and discovery. I am so driven by this work, I have amassed tons of rust in my yard, all organized by shape. It is a joy to go shopping for the next piece I need on a project.

"I feel a sense of duty to bring home pieces from the dump, especially when I take a load of home waste there. Negative impact: You buy it, use it, throw it away. I will pick it up, reassemble the pieces into art, furniture, lamps, sculpture, and jewelry, and sell it back to you. That is truly recycling."

Kit Carson lives in New River, Arizona.

Spiral Lamp
13" high
Steel, shell, bone, turtle shell

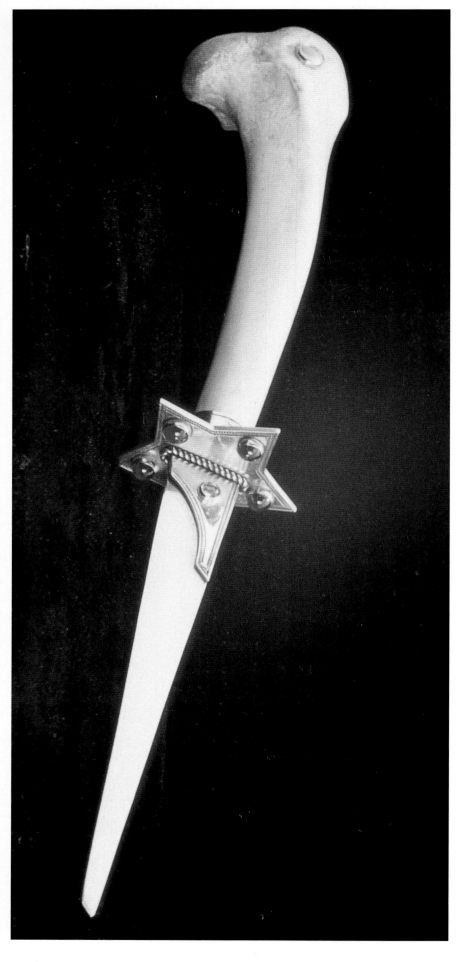

Dagger/Letter Opener
Stainless steel, bone

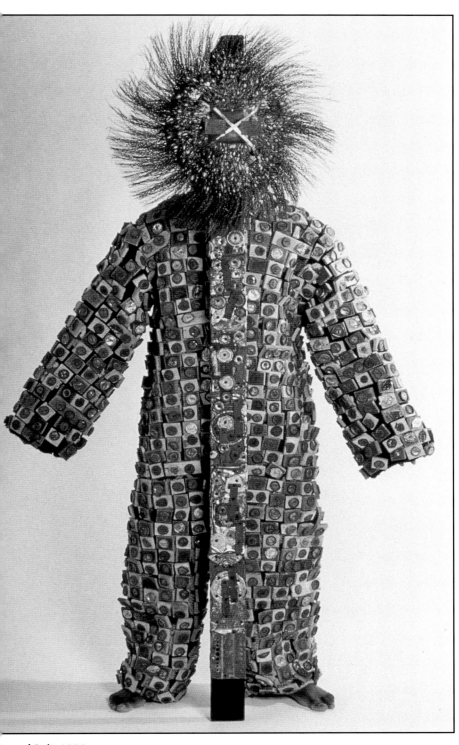

Sound Suit, 1996
Wood, wire, bottlecaps, cotton, afghan
Courtesy the Sybaris Gallery, Royal Oak, Michigan

"The artist's duty is to alleviate any misconceptions his audience might harbor toward his art and to guide them on an exploration of the work. My performance is not just demonstration. Rather, it is a transformation of the individual and a healthy exploration of the possibilities of individuality's consistence and make-up.

"Transformation is a quasi-religious idea, suggesting transfiguration and transubstantiation, involving belief and disbelief. It is also a concept of science fiction utilizing invented materials, objects, and creatures of other worlds, and the fantasy transformations of the human body into other, altered states.

"I believe that the familiar must move towards the fantastic. Allowing the artist to lavish attention on an object can be a way of giving life to inward experiences and emotions. I want to evoke feelings that are un-named, that aren't realized except in dreams."

Nick Cave finds centering and release in the acts of collecting objects from his surroundings and fabricating intuitive works which provoke an emotional response from the viewer. "I am always recycling and redefining who I am, as well." His series of *Sound Suits* are constructed of found/common objects—from bottle caps to twigs to feathers to plastic price tag loops—as well as more traditional fiber arts materials such as sisal and yarn. Transformed by the movement of the wearer, the sounds created by the suits—as bottle caps clank or twigs rustle and materials ripple and wave—expand the viewer's experience of the work.

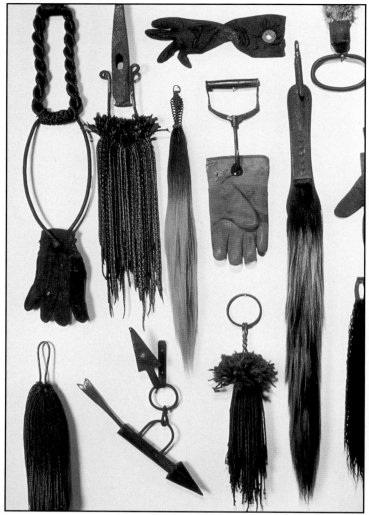

Fetish Objects, 1995
Hair, cloth, metal
Courtesy the Sybaris Gallery, Royal Oak, Michigan

Pocket Painting, 1998
24" x 24"
Paint, cloth, old shirt, dryer lint
Courtesy the Sybaris Gallery, Royal Oak, Michigan

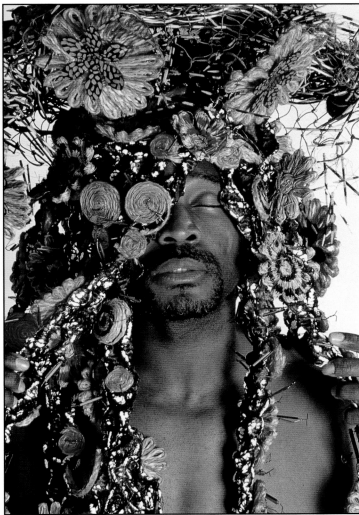

Helmet, 1989
Mixed media, found objects
Courtesy the Sybaris Gallery, Royal Oak, Michigan

Of his approach to making his art, Gordon Chandler says, "I have a very practical bent—I use things of very little value and elevate them. I am influenced by all kinds of information. I think my work is very psychological. I am affected by that when I consider the different layers of meaning in the work, starting with the most literal— the actual physical dimensions and the materials—and on to the spiritual level, where I want moral laws to hold true. My approach is optimism and strength. That is what I want the work to convey."

Salvaged piping and pipe fittings, metal gridwork and gratings, engine casings, exhaust manifolds, huge industrial bolts, springs, and cogs, auto bumpers, and tractor gears—Gordon Chandler combines these materials into innovative configurations that become functional works of art, such as chairs, benches, tables, and urns. From his cache of industrial detritus he has also created a series of imaginative wall sculptures that run from remarkable replicas of deer and moose heads to the most subtly colorful and textured *Quilts,* which are patch worked together reminiscent of your grandma's, save for the fact that they are made from automobile and other industrial salvaging.

Gordon Chandler lives in Carrollton, Georgia.

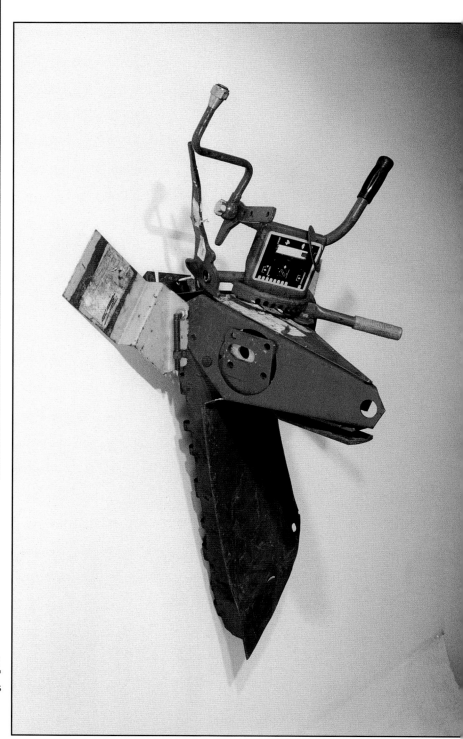

John Deere, 1991
45" x 29" x 21"
From John Deere tractor parts

Wing Chair, 1989
36" x 30" x 40"
Found scrap metal and pipes

Quilt, 1998
75" x 55"
Found steel
*Courtesy Ann Nathan Gallery, Chicago,
Illinois*

61

Blue Chair, 1998
62" x 40" x 30"
Galvanized steel
Courtesy Ann Nathan Gallery, Chicago, Illinois

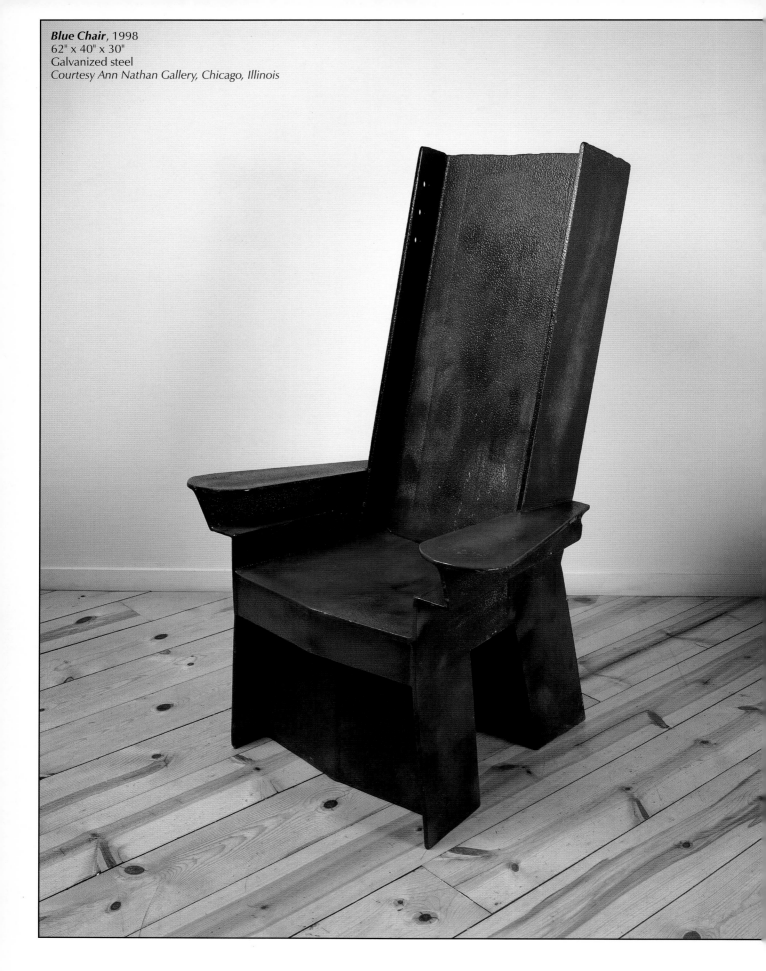

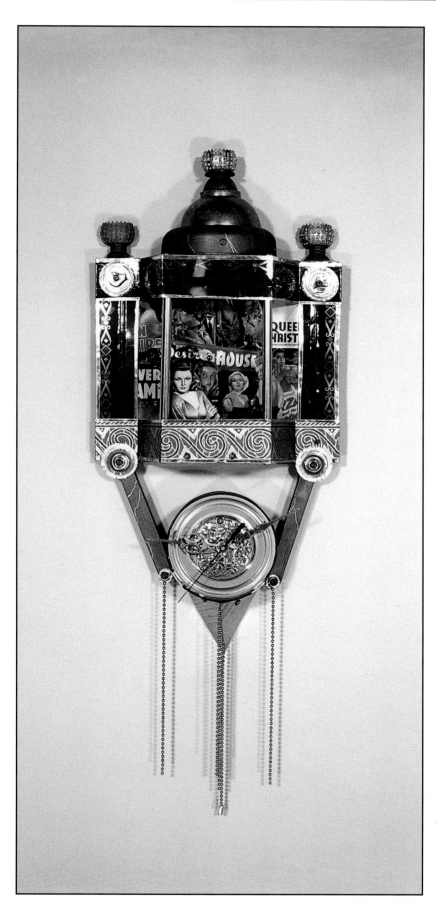

"My work is purely intuitive. I will start with a germ of an idea, maybe a found object will suggest a piece, but as the piece grows different relationships are discovered and the piece will change.

"Working with found objects started as a cheap way to obtain materials. They then became a source of inspiration in themselves. At all times I try to give my work the sense that the parts were manufactured to form the object so that the various pieces transcend what they were.

"The clocks are a conglomerate of ideas I have had over the years. Actual opposed to implied motion, machine sounds emanating from the pieces, the humor, the functionality, the centuries of history, and the near obsession we have for time, are some of the ideas that coalesced to start me working with clocks.

"Having clocks in my pieces also makes my work very 'viewer friendly.' Clocks give an archetypal starting point with which to look at my work. From there the viewers can weave their way deeper into the pieces to find their won relationships and meanings.

"The lamps are similar to the clocks in that they too are viewer friendly. Instead of movement of clock works, there is the glow of the bulb, not only accenting the piece, but changing the mood of the entire room when lit."

Randall Cleaver resides in Philadelphia, Pennsylvania.

Desire House, 1996
15" x 8" x 3"
Tin cans, clock

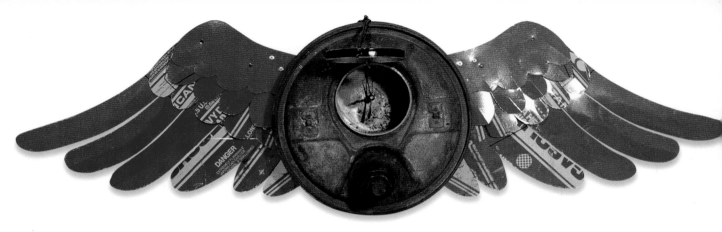

Mothhunter, 2000
13" x 30" x 8"
Tin cans, clock

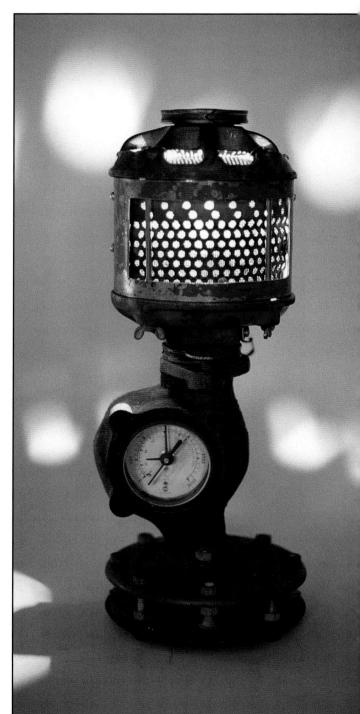

Spotlight, 1998
14" x 6" x 6"
Found objects, lamp, clock

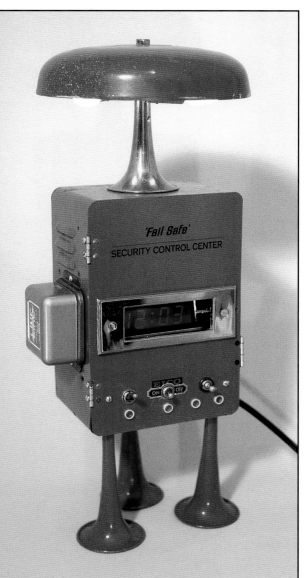

Falesafe, 1998
20" x 8" x 8"
Found objects, clock, lamp

Kikkoman, 1997
13" x 8" x 4"
Tin cans, found objects, clock

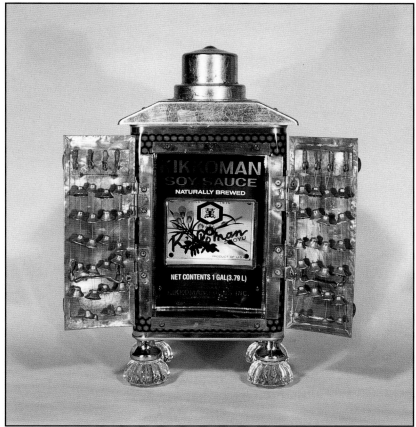

"I work almost exclusively with used materials, discards of a wasteful society. I give them a new life and a chance to be seen in a manner completely foreign to the object's former life.

"Since I was a child, sewing has been an important activity in my life. My Danish immigrant mother brought old world styles, techniques and ideas that differed from what was the norm in the United States in the 50's and 60's. I learned to push the limits of ideas from my older brothers and sister.

"Through the years, I've processed this history and combined it with my own style, techniques and forms that I work with today. The physical form of these objects is created by individual, hand-sewn, cones of zippers. They are sewn together in a honey comb-like structure that is self-supporting. The size and shape of the zipper and its teeth dictate the surface pattern and site of the completed form. The texture and metallic surface of the zipper help to make the very organic forms less so."

Susan Colquitt lives in Marquette, Michigan.

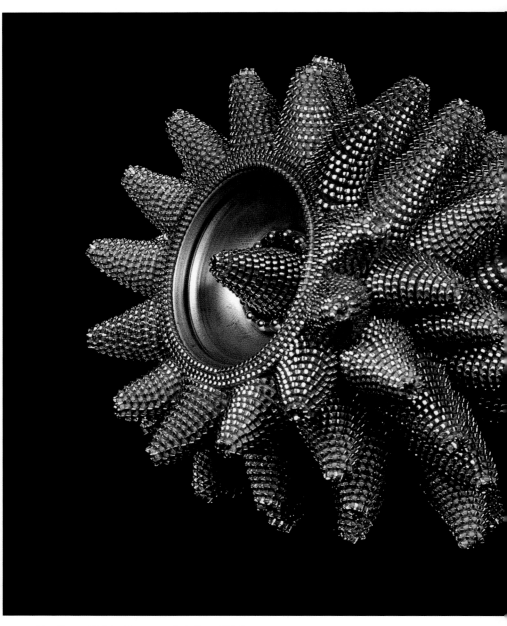

Northern Lights: Summer Solstice, 1998
6" x 7" x 7"
Zippers and found objects.
Courtesy the Sybaris Gallery, Royal Oak, Michigan

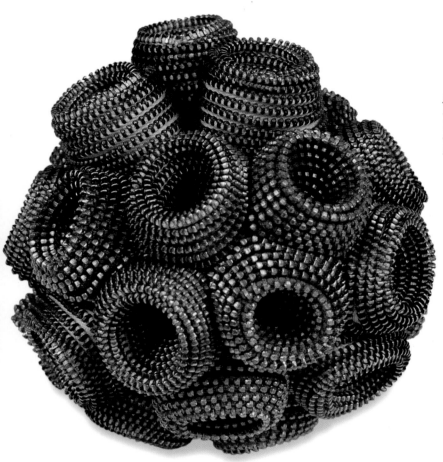

Seafoam Notions, 1995
4 1/4" x 4 1/2" x 4 1/2"
Recycled brass zippers
*Courtesy the Sybaris Gallery,
Royal Oak, Michigan*

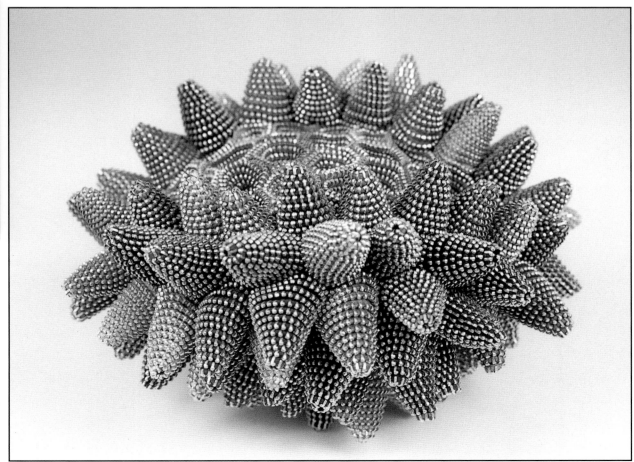

Inflorescent Closures, 1995
4 1/2" x 8" x 7 1/2"
Zippers
*Courtesy the Sybaris
Gallery, Royal Oak,
Michigan*

Forced Closure I, 1993
7" x 7" x 9 1/2"
Reclaimed military zippers
Courtesy the Sybaris Gallery, Royal Oak, Michigan

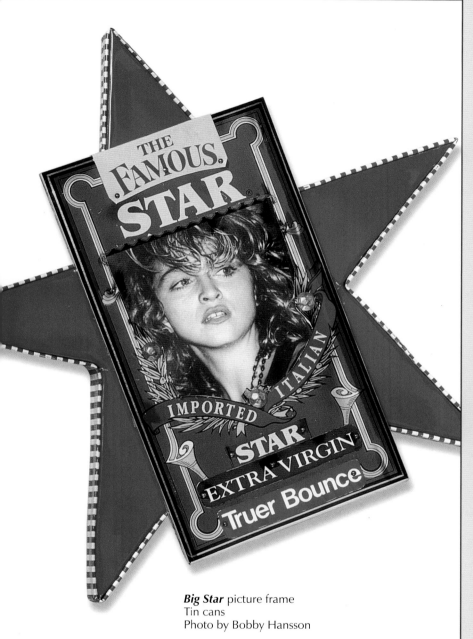

Big Star picture frame
Tin cans
Photo by Bobby Hansson

"Working with old tin cans isn't like working with store-bought stuff. It's similar to making a quilt from grandpa's necktie, grandma's apron, and dad's old work shirt instead of from new materials. Used and rediscovered objects have a history—a patina. They seem to be more poignant than brand-new objects. What I find when I look at them really turns me on. Using found objects just because they're free, or just to be a recycler, eliminates part of the excitement and would be like eating grits without pepper."

I discovered the work of Harvey Crabclaw thanks to Bobby Hansson and his book, *The Fine Art of the Tin Can* (Lark Books, Asheville, North Carolina). In the book, Hansson describes Mr. Crabclaw: "Harvey Crabclaw is an itinerant folk artist whose studio is an exhausted school bus, which he tows across the country, behind an ancient Peterbilt semi-truck tractor. Harvey spends most of his time in New Mexico—his picture frames show the influence of Mexican tinware, cowboy leatherwork, and American Indian patterns.

"This artist's [Harvey Crabclaw] work habits are as unique as his lifestyle. He'll spend a couple of months in New Mexico, working at one of his myriad vocations (including tattooing, sign painting, T-shirt printing, and woodcarving), and when he starts getting restless, he hitches up his rig, which he calls the 'Busted Bus, Tinworks,' and drives."

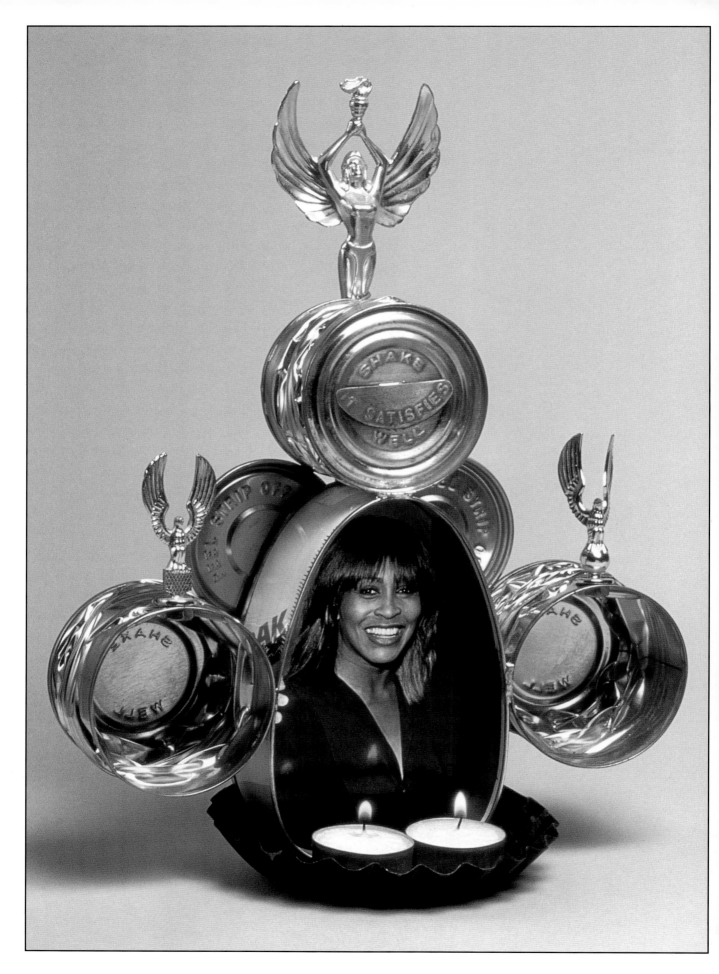

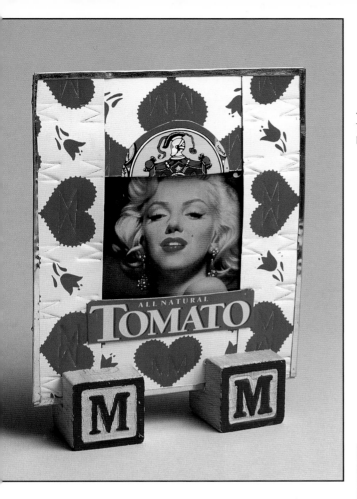

"M.M." picture frame
Tin cans and children's blocks
Photo by Bobby Hansson

Ty Cobb picture frame
Tin cans
Photo by Bobby Hansson

Opposite page:
con Tina Turner
Tin cans, other found objects
Photo by Bobby Hansson

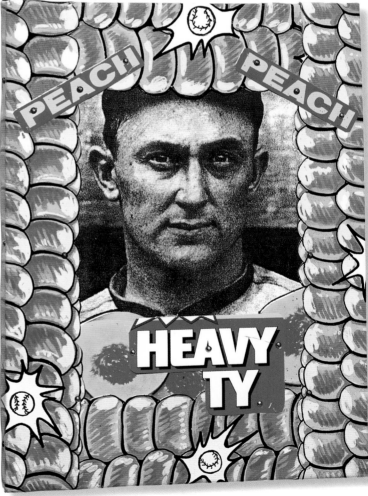

Curtis Cuffie's art has been visible for many years in the streets and attached to fences in New York City's Lower East Side. While living on the streets he has found a following of artists, writers, and passersby who are engaged by his constructions built from the collected objects, fabrics, and messages from street finds that emerge from his nomadic carts. The art he assembles and rearranges over time becomes evolving structures that teeter on chaos yet possess an unmistakable force and quirky ordering of juxtaposed elements. Some pieces are arranged on the sidewalk while others rise as wrapped totems often interconnected to create what appear to be shrines or altars. They flash with reflective elements, wave in the wind from colorful streamers, and appear to be encoded with suggested meanings. He poetically expresses meanings that echo divine inspiration, ideals of universal love, and connection to family in his art. These beliefs may connect with roots in the South where he was born (South Carolina).

Most of Curtis Cuffie's art has been destroyed over the years by the elements, vandalism, garbage collection, and police orders to remove the work due to neighborhood complaints. In addition, Curtis recycles his own work, with elements from one structure reappearing in new formations. In the course of hours, days, or weeks, he will often dismantle pieces into moveable carts that allow him to preserve and recreate pieces with dramatic flourish along the street. His transformation of various materials into vibrant forms is carried out with such theatrical bravado and ease that it suggests a virtual, visual Jimi Hendrix capturing an audience.

The writer Alan Moore observed, "to be making art out of garbage on the streets is a gift of ephemeral magic, and, like weaving a rope out of sand, a meditative action out of principle."

In the tradition of rural southern yard shows, bottle trees, and decorated graves turned urban, Curtis Cuffie created and exhibited his work in the streets of the East Village (New York City) from 1989 to 1997. He now shows with several galleries in Manhattan, where he still resides.

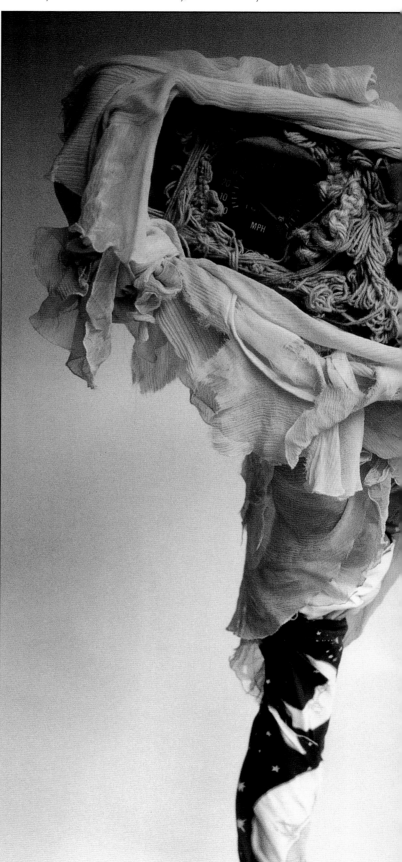

Hoot Owl/Drive Safe, 1994
62" x 19" x 10"
Plastic stand with automobile gauges, yarn, cloth
Courtesy American Primitive Gallery, New York City

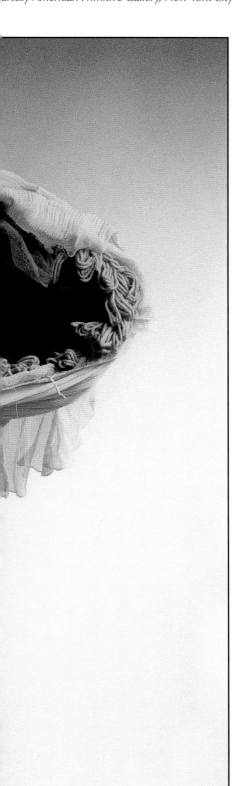

Untitled, 1995
36" high
[mix]ed media - bottle, cloth, wood, bamboo, bone, basket
[Co]urtesy American Primitive Gallery, New York City

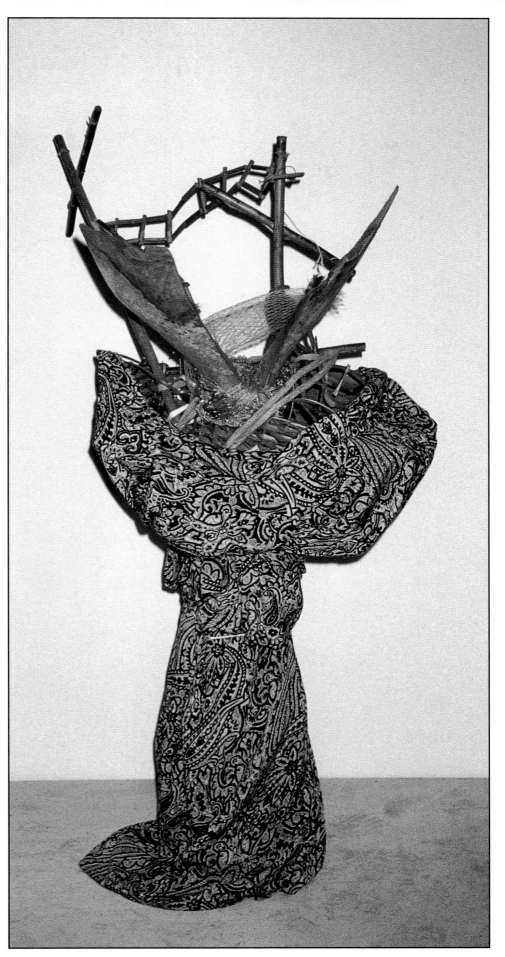

"The early 20th century craftsmanship of everyday tools of our culture (toothbrushes, cars, radios, kitchenware) inspires my art work every day. It was during this time that the ornate and truly futuristic dreams of designers shone bright.

"As I build Deluxe Rocketships starting with canister vacuum cleaners, thermoses, or flashlights—I see how smaller parts from the whole world of thrift store, garage sales, and flea market finds can be taken apart and bolted together anew almost seamlessly in collages of Buck Rogers' era space travel.

"After fifteen years in the music business as guitar tech and tour manager, I found my passion, inspired by an old Electrolux that my grandmother had given me years before and mistakenly thrown out. I've never had art training except what was delivered to me in public school.

"Before my music career, I had been an auto mechanic, bench electronic tech, and welder, though I don't do any welding in my work. My style dictates that I find just the right components to fit together and be bolted or screwed in to look like they've never been apart.

"It seems the planned obsolescence of general products in our society has increased ten fold in the past ten years and they have lost any kind of enduring style to cheap marketability. And so-called 'Space Age' beauty has nothing to do with H.G. Wells or Isaac Asimov's imaginations and aesthetic hopes of what the future could bring. But I see, and I know. And with my work I am trying to respark that imagination of the older folks. Also, of that child who has never really seen in person a real 3-D Rocketship, so that it may let them possibly see their 21st century world with a historical shadow.

"Looking at pieces I use, and knowing that they may be fifty or one hundred years old, I wish I could meet the person who designed that small part on that sewing machine or that hood ornament, to tell them what I've done with it and how it inspired me."

Jimmy Descant lives in New Orleans, Louisiana.

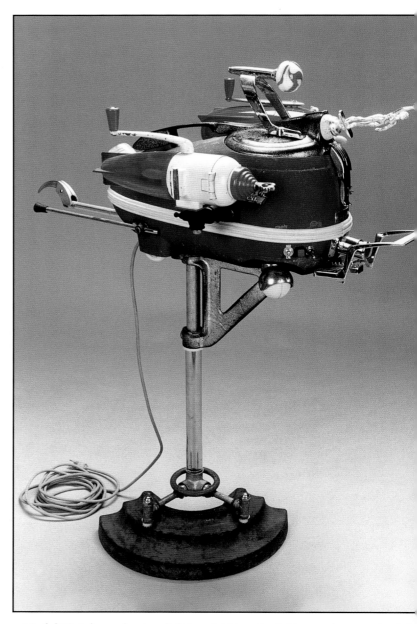

Model VR-4, lower front up lighting, right booster light, rear clear running ligh 90 degree turning radius, rear talon probe, 1997
39" x 17" x 33"
Mixed media
Photo by C. Christopher Mathews

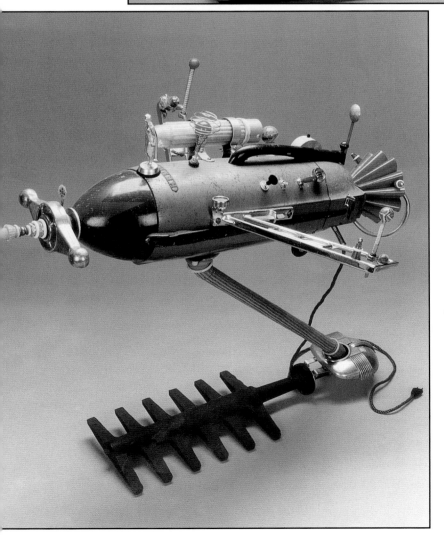

Model VFR Theta, free standing crash model, no lights or motor, 1998
10" x 11" x 5"
Mixed media
Photo by C. Christopher Mathews

Model VR 1, side booster, moonspan and rear lights; top rotating radar, high pitched engine, shaking fuselage, rear take-off flames, 1997
36" x 40" x 31
Mixed media
Photo by C. Christopher Mathews

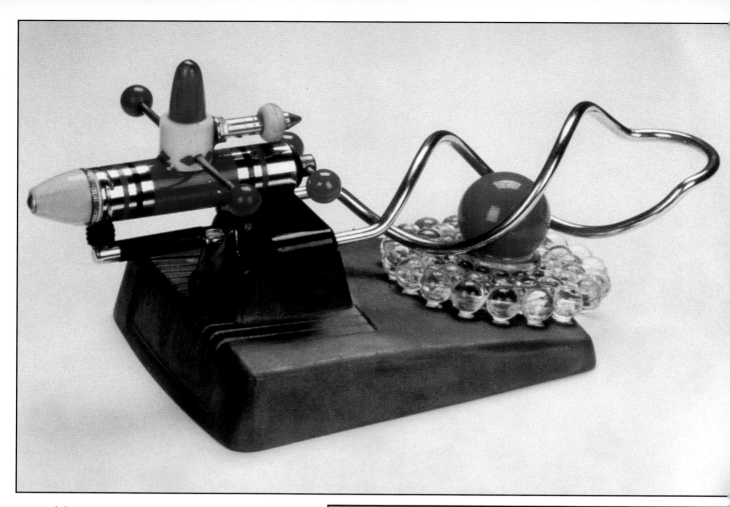

Model VFR Beta, twist front to light, 1997
3 1/2" x 8" x 4"
Mixed media
Photo by C. Christopher Mathews

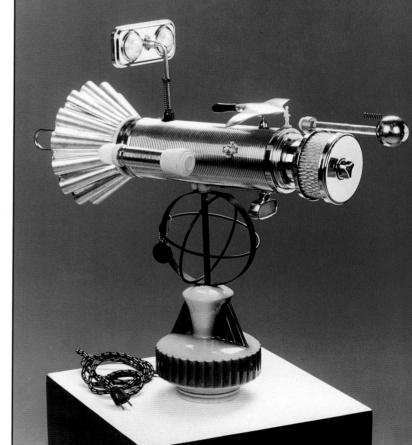

Model VTR 4703, large 60s ribbed thermos, strobing
front filter light, side engines flame lights, 1997
23" x 25" x 9"
Mixed media
Photo by C. Christopher Mathews

"I consider myself a preservationist, taking old things (toys especially) and making them into something new. You could say I get in the way of progress and look to what's being thrown out for the new. I make new things that look old. Consequently I spend a great deal of time hunting for materials. I find stuff all over—in thrift stores, flea markets, scrap yards, dumps."

Dismuke's work, which ranges from assemblages to recreated chairs, grandfather clocks, chests of drawers, and jewelry, is a clever mix of the unusual with the very usual. The objects he creates are sometimes functional, and sometimes even evoke the original function of the materials he uses to make them. Overtly, his work strongly points out that even items of the humblest origins can be rethought to produce extraordinary things.

Poe Dismuke lives in Petaluma, California.

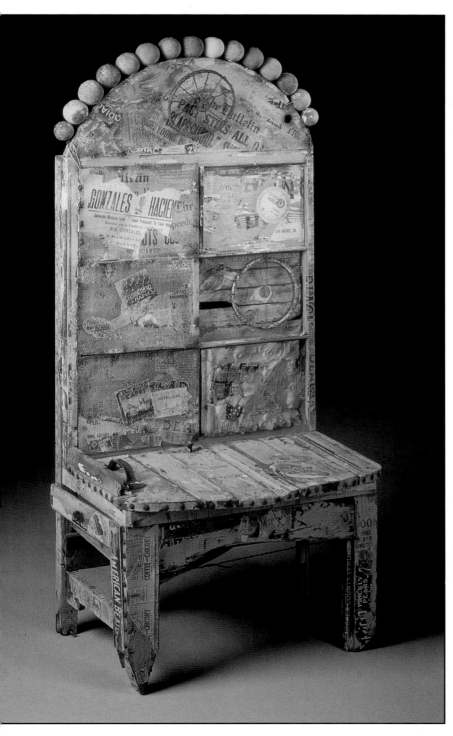

High Chair, 1989
62" x 24 1/2" x 28"
Old wood—doors, hinges, decals, signage

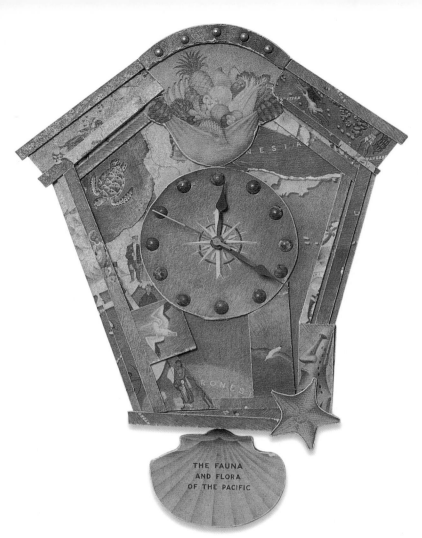

Pacific Islands Clock, 1994
18" x 12"
Cardboard school maps about the flora and fauna of the
Pacific Islands

Toy Duck
Old wood, signage

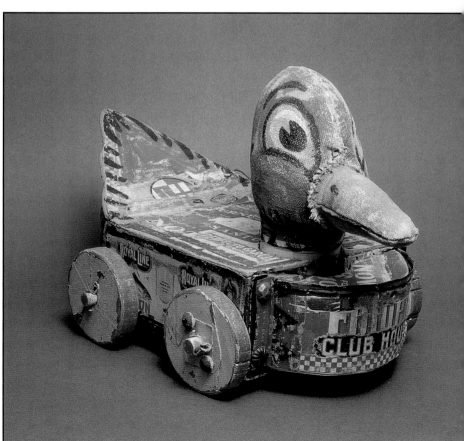

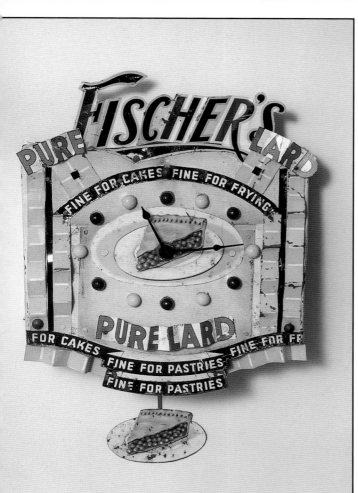

Fischer's Pure Lard Clock, 1994
18" x 12"
Clock works, old signs

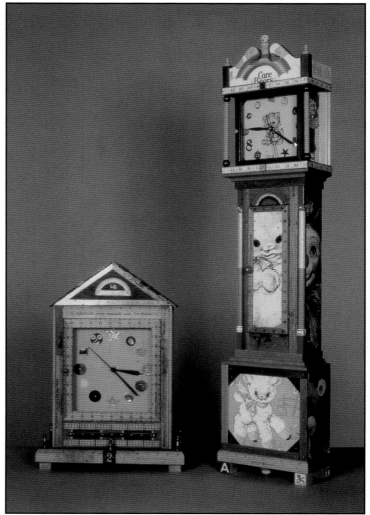

Grandfather Clock and *Mantel Clock*, 1995
Grandfather Clock: 62" x 14" x 12"
Mantel Clock: 24" x 16" x 12"
Clock works, old signs, game boards and other discards

"When I was growing up I was a real alley rat, in the sense that the alley was always a very exciting place because there were broken parts and a few tin cans to take home in my wagon and put in our garage. Then I'd find old paint from the alley and with sticks and brushes repaint things and have my own little fantasy museum."

For over thirty years, Robert Ebendorf has been devising ingenious ways to reemploy what has heretofore been discarded, discovering how to make new materials from the used. Known for jewelry that includes everything and anything he has found, Ebendorf continues inventing such "re-presentations."

The idea behind the objects he makes lies not simply in the intellectual repositioning of familiar objects, but in the physical transformation of the materials he uses—means that, in the end, astonish the viewer. It is exactly this sense of astonishment that gives Ebendorf's pieces their value. It is the profound incongruity of what they are made from and what they are now that so engages the imagination.

Robert Ebendorf lives in Greenville, North Carolina.

Brooch, 1998
Red Dog Beer bottle cap, old broken English china, found gas cap

Brooch, 1998
Broken car window glass, 14k gold, broken bottle glass

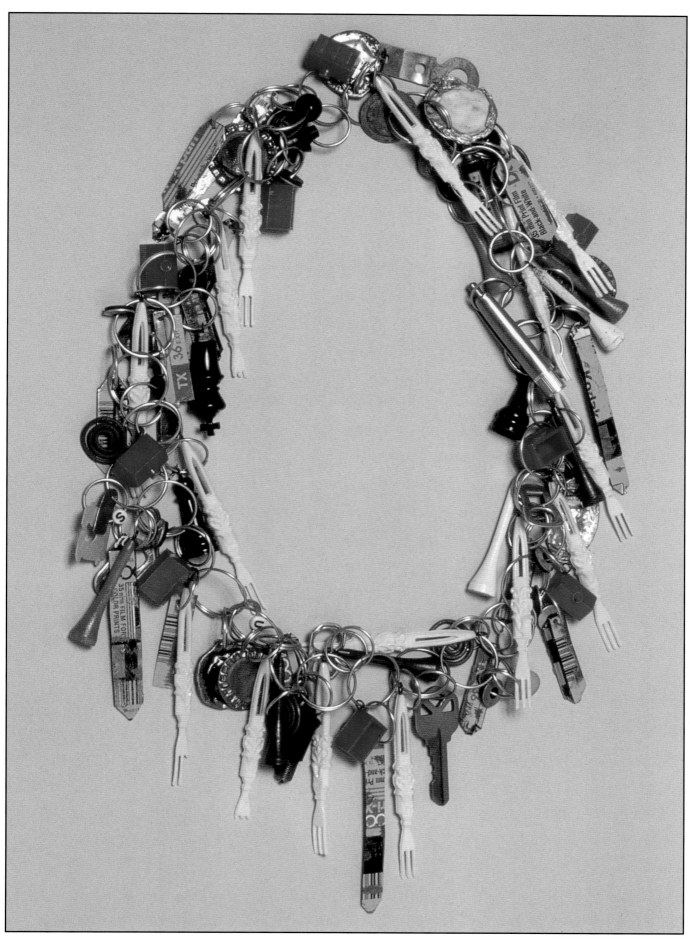

Necklace, 1997
Found objects

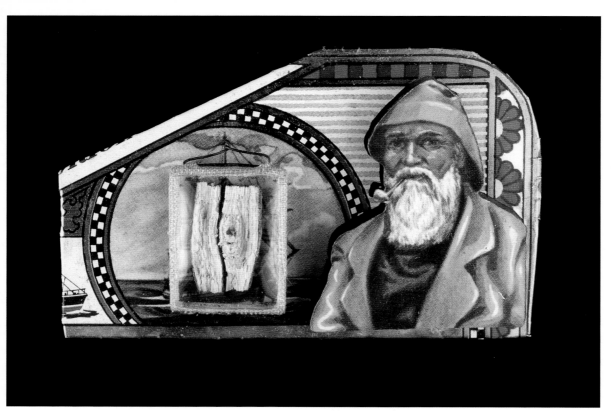

Brooch, 1999
Tin can pull top, old photo, steel shoe cap

Brooch, 2000
Tin can, copper, wood, glass

ant Among Friends, 1995
" x 18"
ut up stamps on board
ourtesy American Primitive Gallery, New York City

Paul Edlin looks at postage stamps differently. He sees the elements of color, shapes, and possibilities in the letters and images. The 67-year-old artist has retired from years of clerical work and has put together an unusual body of art from the most common everyday material that we routinely discard. He incorporates postage stamps and "paints" with bits of colored stamps. For over twenty years, Paul has been experimenting and meticulously cutting, composing, and pasting postage stamps.

The pictures from the early 1980s were intimately scaled with larger stamp images pieced together to make pictorial compositions of birds, animals, and figures, and were sometimes boxed with applied wood strips. Paint was an important part of the early pictures. With his wood slat frames, these pictures achieved a shadow box effect of looking into precious worlds.

As the reclusive artist continued cutting and pasting in his small hotel room studio, he began to enlarge pictures and cut stamps into smaller and smaller pieces. The stamps became obsessive and intricate mosaics. He would often spend months on a single picture, lifting the tiny bits of cut stamps with a pin and create Pointillist-colored images that could be complex pictures with abstracted or naively pictorial compositions.

Paul Edlin lives in New York City.

Loving the Aliens, 1996
18" x 14"
Postage stamp collage on
paperboard
*Courtesy American Primitive
Gallery, New York City*

Abandoned Cars, 1994
19" x 15"
Postage stamp collage on
paperboard
*Courtesy American
Primitive Gallery, New York
City*

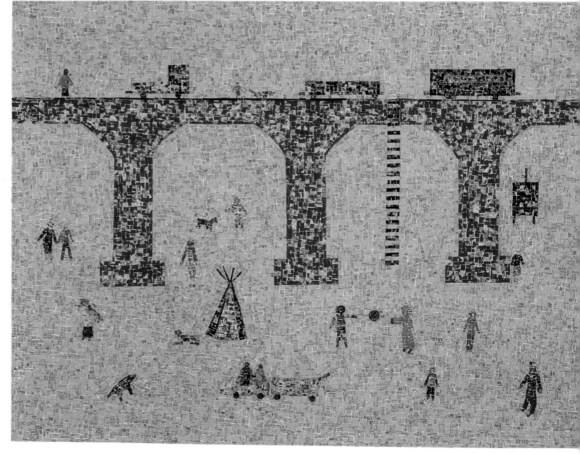

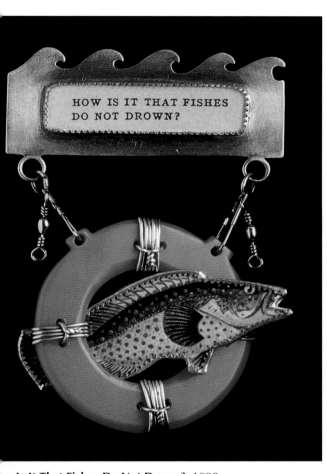

w Is It That Fishes Do Not Drown?, 1998
ooch
/2" x 2 1/2" x 1/4"
rling, found objects
llection of Ken Bova

> HOW IS IT THAT FISHES
> DO NOT DROWN?

"When pressed to define what I do, I always feel strange defining myself as a jeweler. True, I do make jewelry, and so considerations of wearability and mechanics play a part in my design process. This part, however, is in some ways, secondary for me.

"What's most exciting to me is the process of collecting bits and pieces of everyday life—bits of text cut out-of-context from books; definitions from thesauruses and old dictionaries; discards discovered in flea markets—and from this gathered vocabulary of things no longer useful to someone, figuring out how to bring together this bunch of little, separate, ordinary objects, turning them into a whole that's slightly more extraordinary.

"My first jewelry used found photographs, which I set into silver as though they were stones. Combing through flea markets looking for that perfect eye, or a shot of a dog to go into a brooch that said 'Bauhaus' was the challenge. Once I had the right photo, the piece would follow.

"I am fascinated by language and words, and what they imply in the context of a culture, and cross-culturally. What words and images do people use from the daily environment to convey a message, to express what they believe, who they are, what they sell? Over the years it has been as much a part of my process of making objects as actually sitting in my studio to be out of it, looking for inspiration in various cultures, shaking up my notions of what something means; how various people respond to the same words, ideas, customs, objects.

"What has become my favorite way of working, and led to the pieces I am most excited about, began when I discovered a series of 'Little Blue Books' which were printed in the 30's and 40's, and covered subjects that ranged from 'Old Persian Proverbs' to 'American Slang.' As I would read through the often outdated, misogynist, and racist definitions and phrases in these little books, I would see in my mind's eye a piece that would illustrate my own, usually tongue-in-cheek, definition. Work that contains text to me is often the most powerful, and I am always on the lookout for a flea market find of some old book that offers a glimpse into the time in which it was printed.

"By incorporating visual 'nudges,' humor, and moving parts, I hope to take my work past simple adornment towards viewer/wearer participatory objects. Perhaps inspiring a new way to look at some small bits of our everyday lives with a different twist, a slightly altered point of view."

Lisa Fidler lives in Petaluma, California.

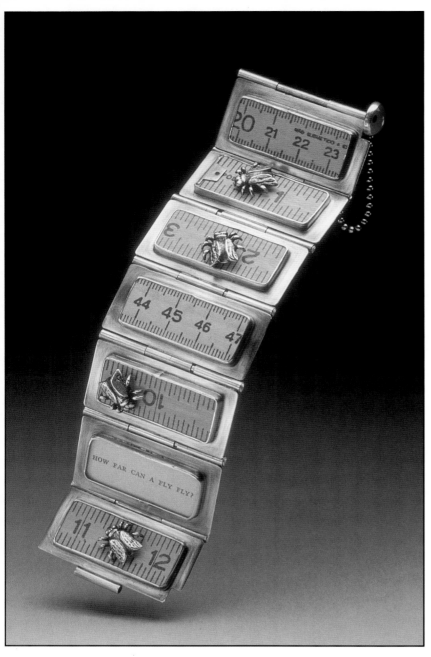

How Far Can a Fly Fly?, 1999
7" x 1 1/2" x 1/3"
Sterling, wood, paper, plastic

Spinning Ouija Brooch, 1996
3 1/2" x 1/3"
Mirror shards, thesaurus pages, sterling
silver, glass, dice, taillight plastic

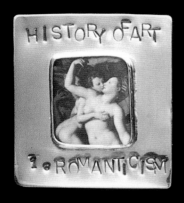

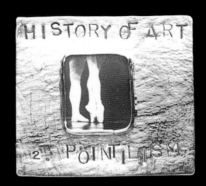

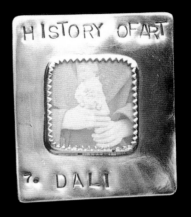

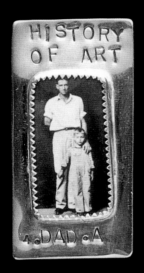

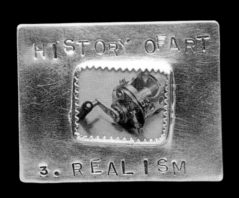

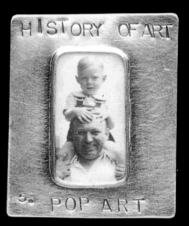

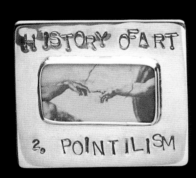

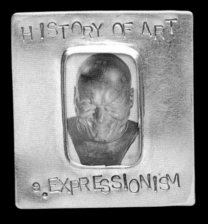

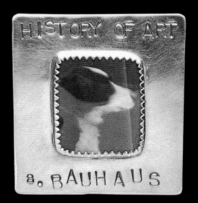

History of Art Pins, 1992
1" x 1 1/4"
Sterling, photos, plexi

"These animated sculptures, activated by wind or hand, are made from scraps of wood, metal, and other discarded materials of a throw-away technological age which places little value on the usefulness of such remnants. However, when you make things by hand, you see such objects differently. An old gelatin mold, pruning shears, broken rake, and faucet handle have inherent form beyond their original function. As these pieces accumulate in my workshop, they suggest ideas I want to express. My rules are simple: make do with what you have, and have fun doing it. Let technology have its day— but before we relegate our hands to being appendages of the computer, remember there is nothing in the world of technology as miraculous as the ability of the mind to direct the hand to express ideas."

Richard Gachot lives in Old Westbury, New York.

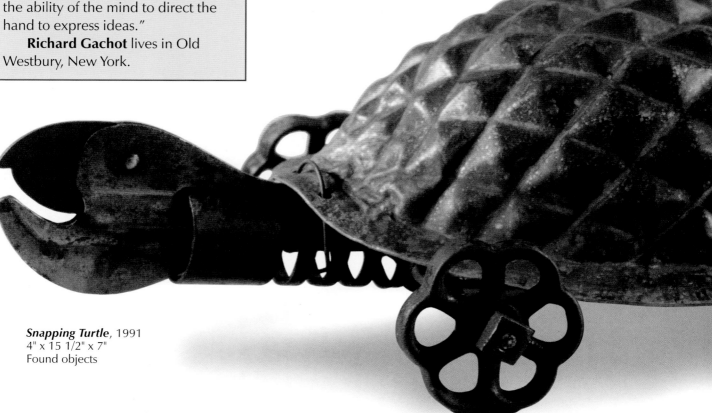

Snapping Turtle, 1991
4" x 15 1/2" x 7"
Found objects

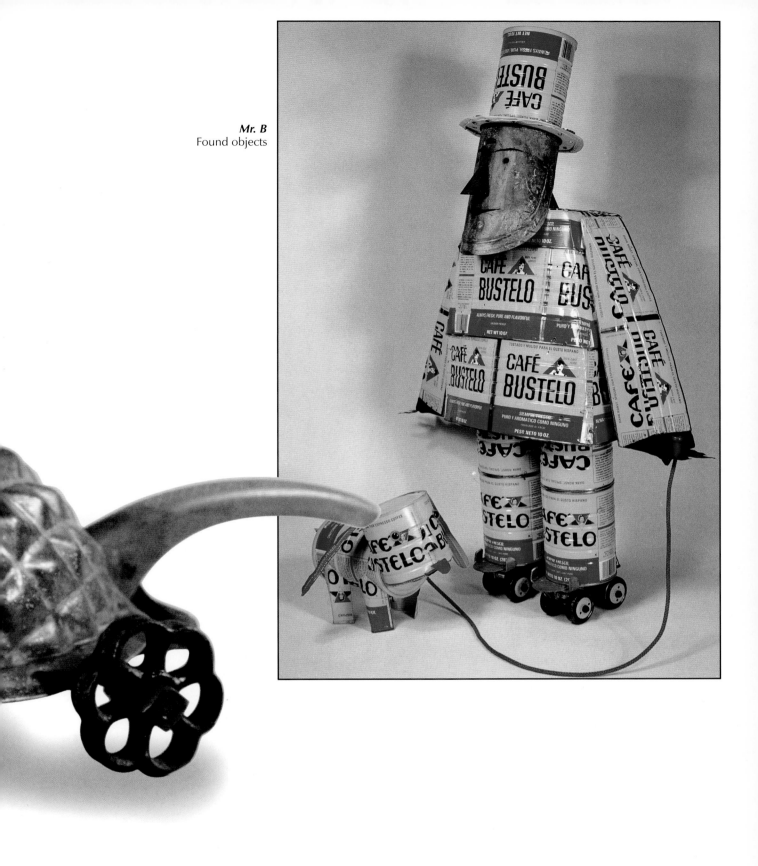

Mr. B
Found objects

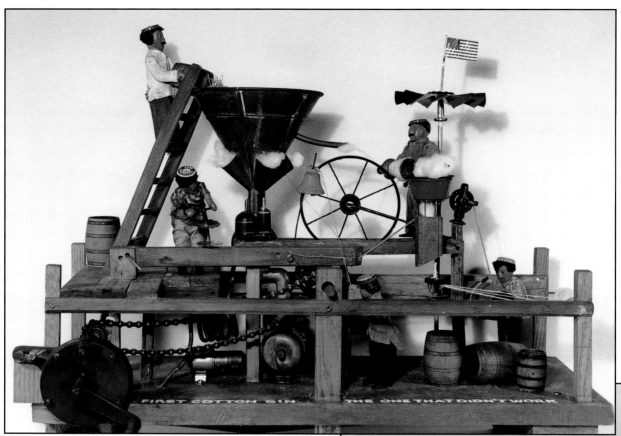

The First Cotton Gin - The One That Didn't Work
Found objects

Mother and Child, 1995
Found objects

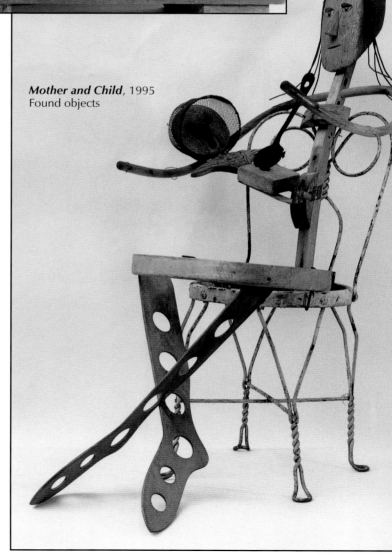

John Garrett

Big Beverage Bark Basket
22" x 22" x 22"
Aluminum soda cans
Courtesy of Connell Gallery, Atlanta, Georgia

"The thing that attracted me to weaving was the way two disparate things join to become one thing stronger than either of the two elements alone." Although John Garrett has strong roots in the crafts tradition, his work does not include the traditional weaver's materials. "My work is about abundance and storage, and those are the concerns of functional crafts." Garrett loves materials, usually those that he has salvaged—baling wire, bits of fabric, rusty fire screens, paper plates—all of which he keeps in check by an equally strong commitment to order.

Like traditional Native American basket makers, Garrett uses materials gathered from the environment. However, his environment is the late twentieth-century/early twenty-first century urban landscape, and because his materials are so representative of contemporary life, their layering and juxtaposition comment on our society.

The technique that has become his signature style involves weaving strands of various substances—vinyl, aluminum, painted metal strips, fabric, yarn, clothesline, and more—through a metal screen to create a sheet that can be bent into a container form. Taking this approach, Garrett simultaneously investigates profusion and containment.

John Garrett resides in Albuquerque, New Mexico.

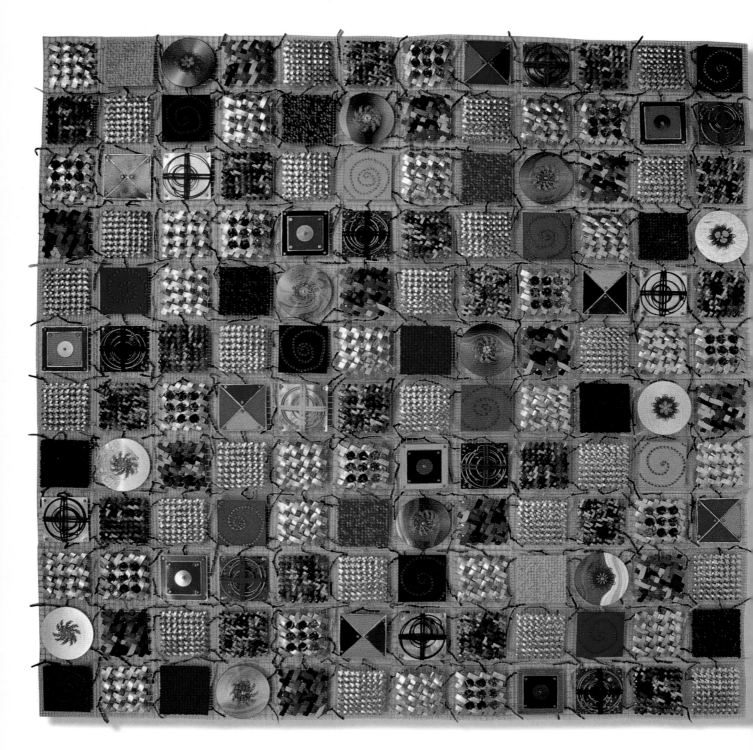

Holiday Quilt
50" x 50"
Found materials
Courtesy of Connell Gallery, Atlanta, Georgia

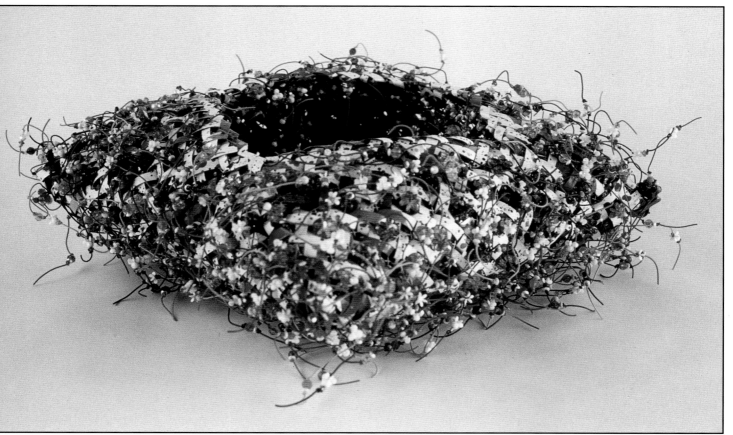

93

"It is in my nature to seek the unusual and find amusement in the discarded. I am seduced by the forms and surfaces of found objects. They enchant me with their elusive histories and the memories they induce.

"In my choice I claim responsibility to communicate my aesthetics, to give my life balance among discarded and displaced materials, to take measure and find order, and in the end, the mysterious beauty of an object may be recycled again and again ..."

Chris Giffin lives in Mt. Vernon, Washington.

Fishy Brooch
3 3/4" x 1 3/4" x 1/2"
Vintage tins, wire, brass bolts
Photo by Rodger Schrieber

Table Clock
12" x 5" x 3"
Vintage tins, brass, clock movements
Photo by Ron Sawyer

Brooch
5 1/2" x 4 3/4" x 1/4"
Old tins, game card, glass, pewter number
Photo by Ron Sawyer

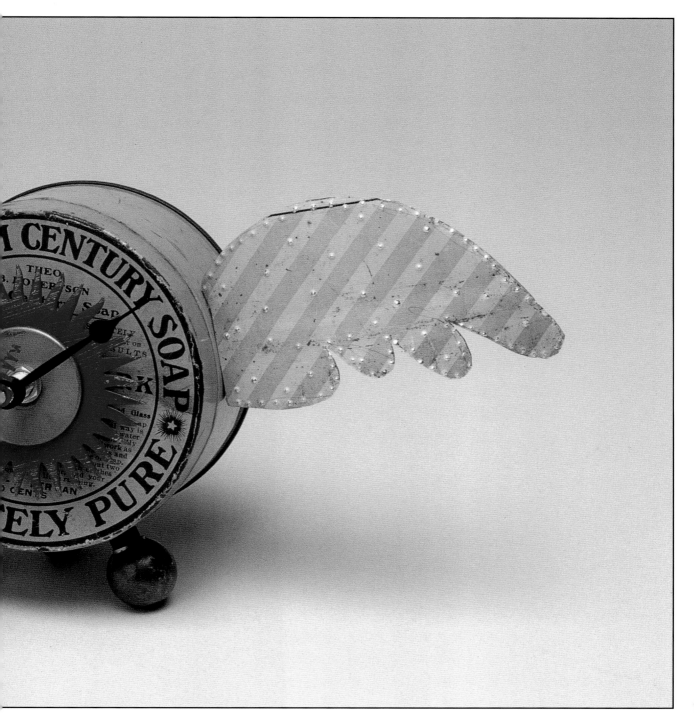

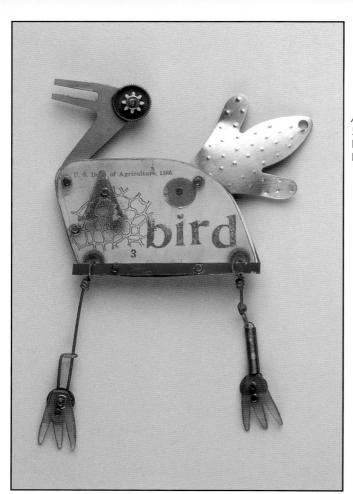

A Bird Brooch
5" x 4" x 1/4"
Fishing lures, old paper, old tins, typewriter parts, horn, wire
Photo by Ron Sawyer

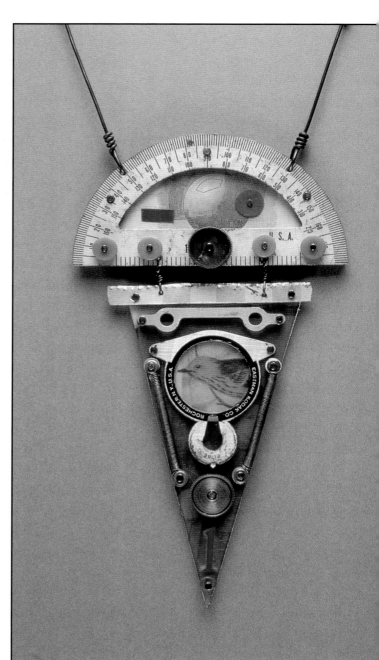

Neckpiece
6 1/2" x 4" x 1/4"
Vintage photo, old paper, typewriter parts, camera
parts, plastic, measure, glass
Photo by Ron Sawyer

Michelle Gleeson

st Belt Beauties.- NJ
rrous rusted metal found in New Jersey, sterling silver, 18k gold,
ose diamond

" I enjoy the notion of 'precious vs. non-precious'—by whose definition? Never mind the lovely contrast of pitted dark surfaces to textured gold and then the addition of color! My *Rust Belt Beauties Series* is just such a good challenge for me to construct and design.

"I started using found aged ferrous metals (rust) six years ago. It's such a thrill to gather found objects from urban areas that then can be recycled into smaller new works/sculptures that one can wear. I am intrigued by the textural contrasts of pitted aged steel combined with the smooth softness of gold and pearls. There is also the contrast between the value of mined goods (i.e. gold and gems) and the cast-off character of rust. What is 'valuable' metal anyway? When I mix 'less than traditional' materials, this allows me to 'push the envelope' in terms of design. For instance, sometimes, in lieu of cut stones traditionally set, I favor gem stone crystals that are 'captured' and free-moving. Thus evolved my *Rust Belt Beauties Series*."

Michelle Gleeson resides in Westlake, Ohio.

Rust Belt Beauties - Philadelphia/Cleveland
Hexaglow pendant
Found metal objects, 22k/18k and Ag bi-metal,
chrysoprase

Minisparklers Earrings/Pendants
Found objects from Philadelphia, 18k and
Ag tri metal/red spinels

Coffeehouse Birdhouse
14" x 20" x 12"
loom parts, chicken coop parts, scrap copper, paper
Courtesy Ann Nathan Gallery, Chicago, Illinois

"I have worked with scrap materials often and prefer them for their unique visual and textural qualities. Found and deteriorating objects commonly display a beauty that cannot be copied by hand. Additionally, most of the materials used in my pieces have their own history, which adds depth to their reuse in this context..

"I have collected these materials over a period of five years from alleyways, dumpsters, abandoned buildings, factories, and warehouses, rehab sites, cars, and junkyards, the side of the road, my grandparents' farm, my own desk drawer, and second-hand stores. I am aware that this scouring for materials is not unlike the scavenging done by real birds to make their homes."

Jeff Goll builds fantastic creatures, as well as birdhouses and doghouses, that very few people could imagine. The building components come from machinery, furniture, food containers, sports equipment, automobiles, other buildings, games, books, clothes, kitchen utensils, and electronics, among other sources. He resides in Durham, North Carolina.

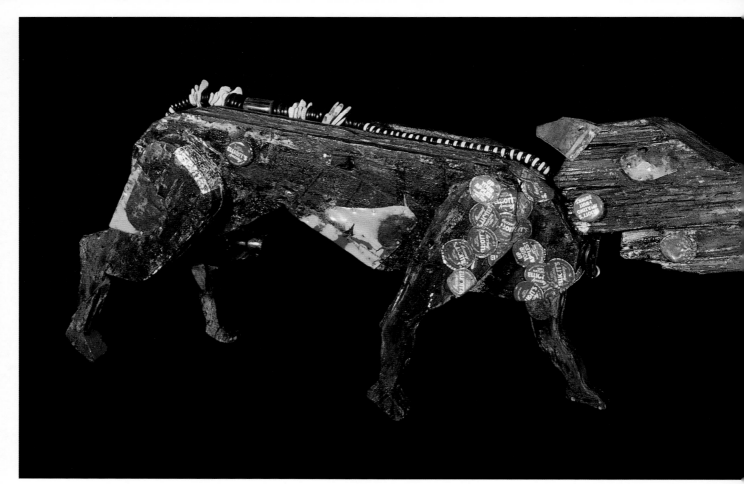

Bottle Cap Dog
30" x 6" x 13"
Wood, bottle caps, steel cans, copper, jewelry
Courtesy Ann Nathan Gallery, Chicago, Illinois

Mother Dog
28" x 10" x 14"
Furniture parts, copper, jewelry, porcelain bath fixtures
Courtesy Ann Nathan Gallery, Chicago, Illinois

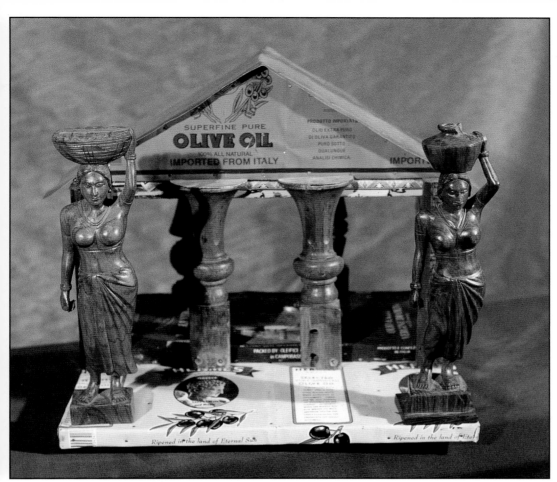

Greek Temple Birdhouse
15" x 15" x 15"
Lamp parts, furniture parts, olive oil cans
Courtesy Ann Nathan Gallery, Chicago, Illinois

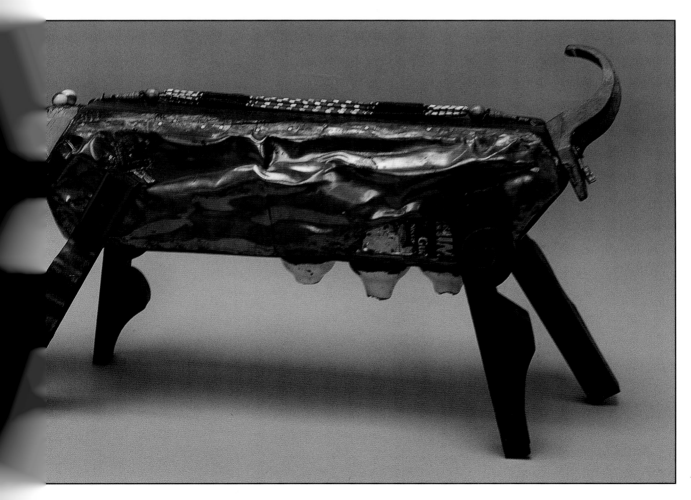

"After absorbing the writing of Jack Kerouac, I was duly inspired, and decided to hitchhike west. Upon reaching San Francisco, the ultimate geographical border of America, I decided I didn't like the city and turned back east. I got as far as Montana where I became first a ranch hand to provide myself a livelihood, an occupation that alternated with life as a cowboy and a carpenter. I eventually bought my own small sheep ranch.

"However, my mind still buzzes at the end of the day, an energy I have channeled into sculpting. My materials come from bits and pieces left over from carpentry, my immediate environment and the ranch itself. If there is one overriding thread that connects my work it is of the land and how humankind interacts with it. I have watched much of the open countryside build up around me. I have expressed my equivocal feelings about raising domesticated animals and protecting them against their natural prey. I understand that living precariously close to the millennium means embracing different realities simultaneously, the magic and irony that I try to express in my work."

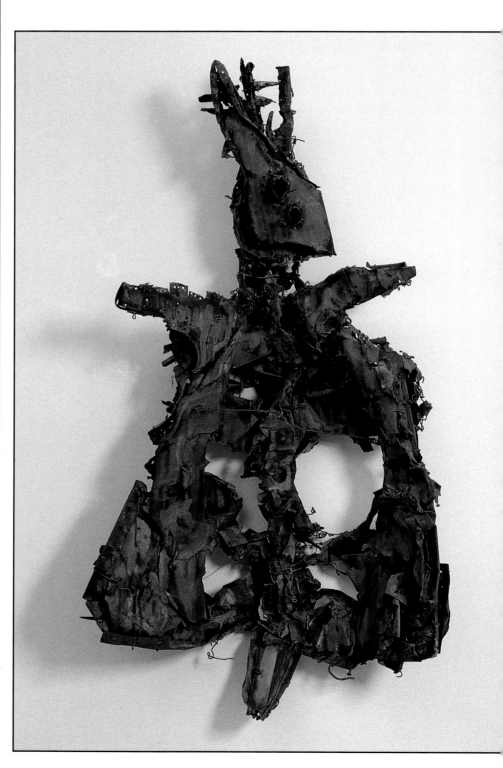

Left with Dry Husk, 1997
46" x 25" x 6"
Metal, mixed media
Courtesy Calvin-Morris Gallery, New York City

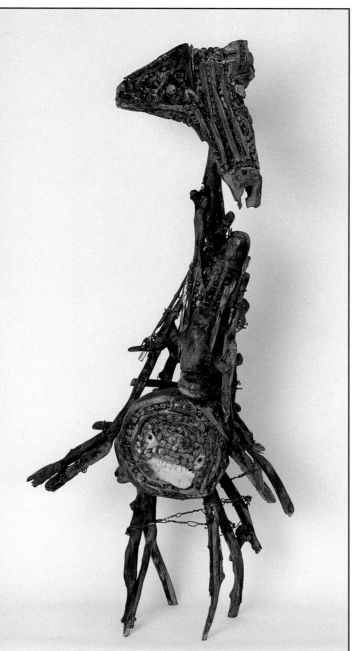

Fetish to Delay the Coyote, 1998
43 1/2" x 18 1/2" x 10"
Mixed media
Courtesy Calvin-Morris Gallery, New York City

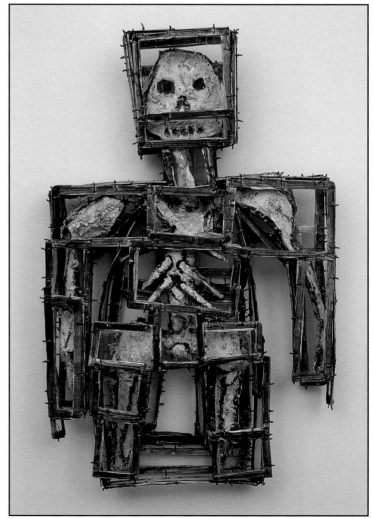

Just Under the Skin, 1999
38" x 23 1/4" x 3 1/2"
Paint, metal, Plexiglas, wood
Courtesy Calvin-Morris Gallery, New York City

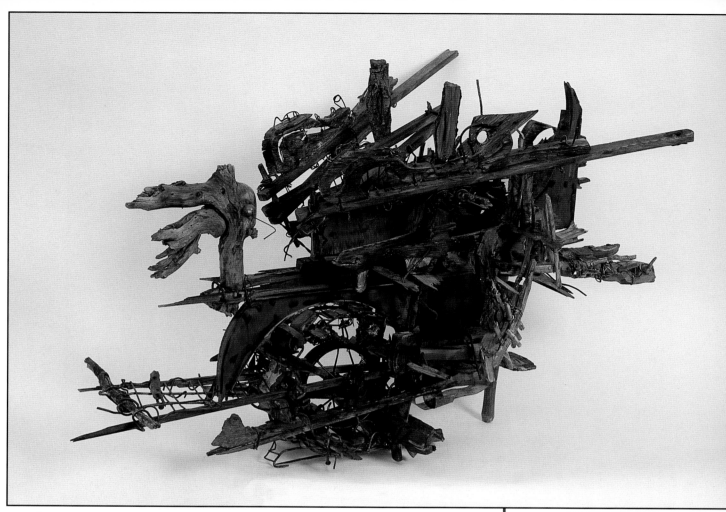

Turkey, 2000
23" x 41" x 16"
Wood, wire, paint
Courtesy Calvin-Morris Gallery, New York City

Clare Graham

Group of Baskets
bottle caps
photo courtesy Michael Tobias

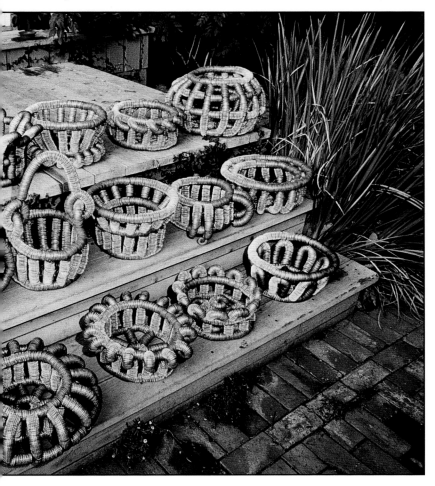

"After going through the usual college and university training in Fine Arts and being pampered with the unreality of material costs through various subsidies, the hard reality of buying ones own art materials put a serious crimp in the scale and ambition of art production after graduation.

"I had always had an interest in the subliminal processes of production and felt myself attuned to the endless repetition in such tasks as weaving, crocheting and building up forms from the simple bit by bit. A form of meditation exists for me in the act of mindless creation when one is totally absorbed by the endless seeming chain of repeated motion.

"The numerical extension of repeated acts of accumulation (lengthening the enjoyable meditation phase) was a definite goal. Traditional art materials proved to be cost prohibitive so I turned to the second hand and recycled markets for units of repeat that could be used. Having been an addict of epic proportions to flea markets and swap meets, I was always drawn to the array of multiples. Yardsticks by the hundreds, scrabble tiles by the thousands, bottle caps by the hundreds of thousands and pop tops off of soft drink cans by the millions.

"Each of the materials has its own integrity that takes manipulation and experimentation before it starts assuming forms it can take. Oft times the forms bear much resemblance to recognized naive or primitive art forms. I have always been a collector of things—rocks and leaves and coins and keys and stamps as a child; dice, dominos, rulers, scrabble tiles, faucet handles, pop tops, ad infinitum as an adult. To give the collections order and form I assemble them into arrays of like materials. This allows me to exit them from my life and save them from the anonymous life of rejected surplus trash."

Clare Graham lives in Los Angeles, California.

Opposite pag[e]
Large Vesse[l]
Bottle caps and pop top piec[es]
Photo courtesy Michael Tobi[as]

Rug
Bottle caps and pop top pieces
Photo courtesy Michael Tobias

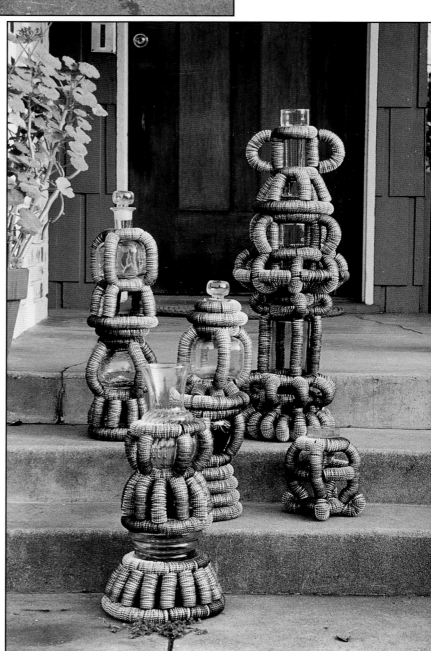

Vessels
Bottle caps and pop top pieces
Photo courtesy Michael Tobias

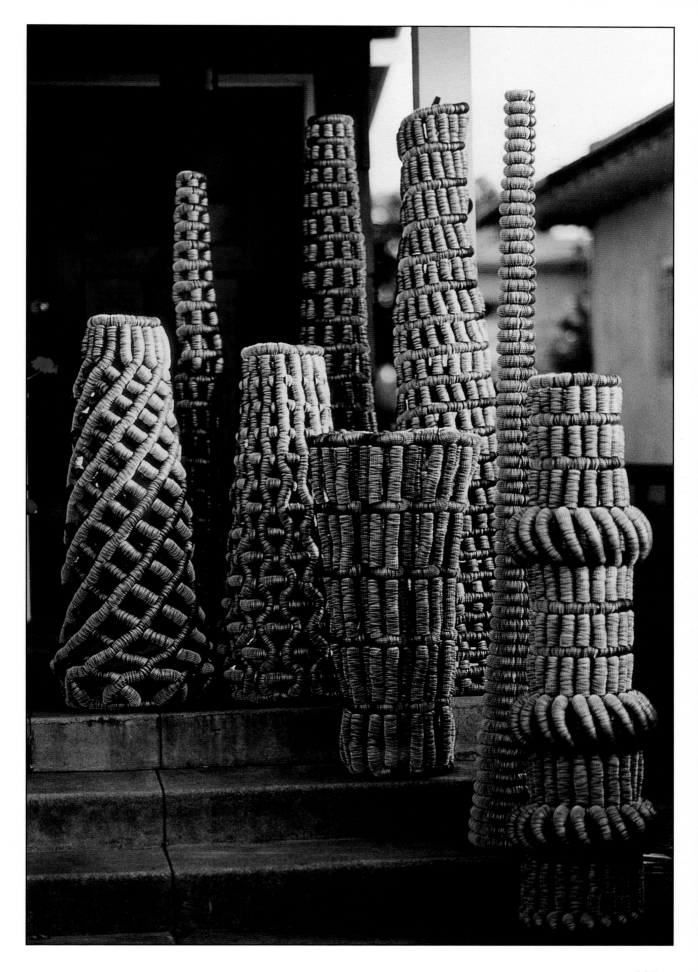

"I've enjoyed making jewelry and wall-hung narratives for the last ten years. Working with tin has provided a palette I feel completely comfortable with. It has given me an opportunity to tell stories in figurative ways using the natural color and graphics of the materials.

"My palette isn't just flat, however. Living by the beach in Los Angeles gives me ample access to found objects. Using these paired with the color combinations in the tin, I can create literal dimension and figurative depth to my pieces. By combining all with sterling silver rivets and other fine metalsmithing tools, this 'junk' rides at a higher level.

"I grew up on the East Coast of the U.S. with the ocean close by and a river running in the backyard. As a kid, the water provided a never-ending adventure for me and my siblings. As a result, fishing poles, sailboats, lassos, or young girls and boys often make their way into my work. The childhood memories enrich my art and my art-making continues to enrich my soul."

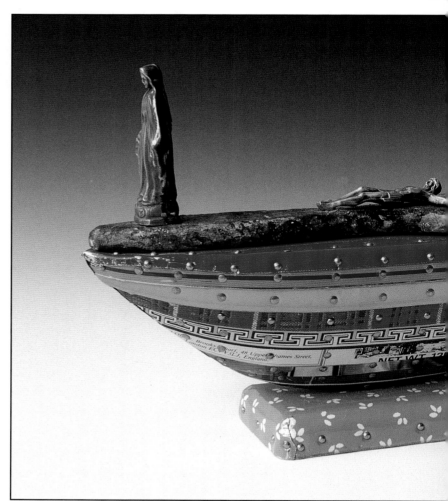

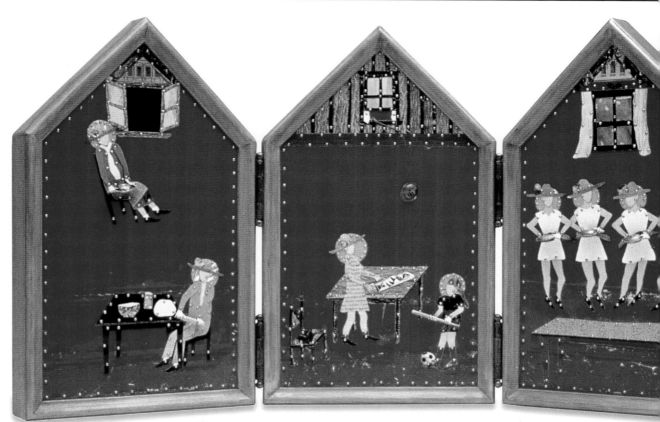

Mary Takes J.C. for a Cruise, 1994
3/8" x 4 7/8" x 1 3/4"
collage from old tins

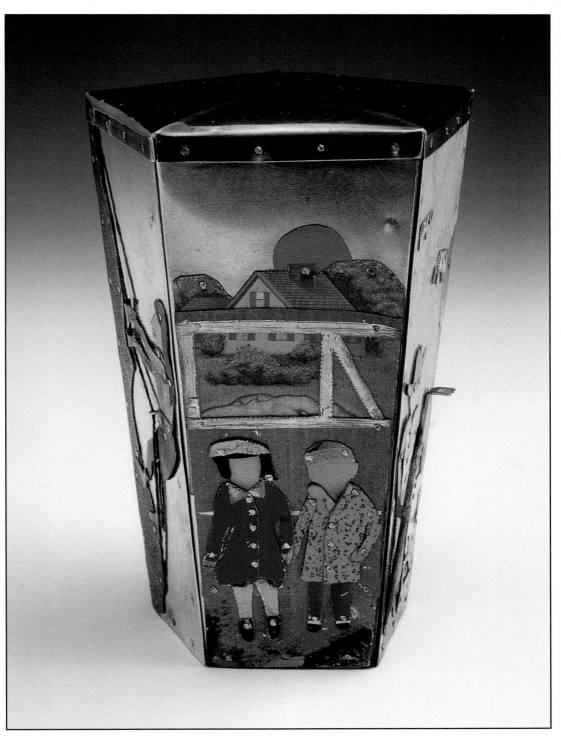

A Cup for Gabe, 1995
Silver and riveted old tins

Eight Important Women, 1995
13/16" x 25 5/16" x 2 3/16"
wood and collaged old tins

The Big Ride, 1996
15 7/8" x 6" x 1 1/16"
Old motor tins and wood collaged

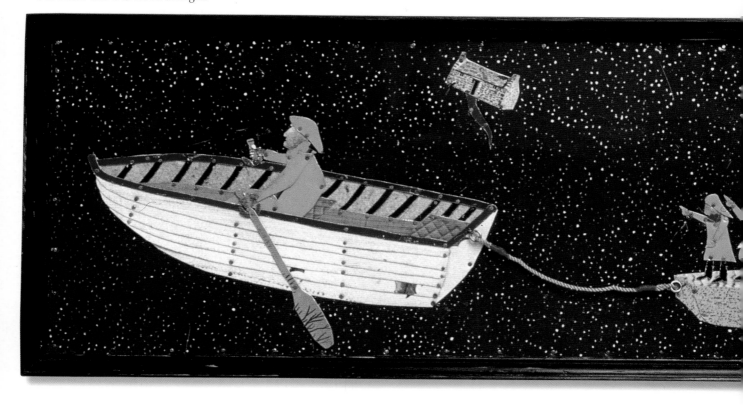

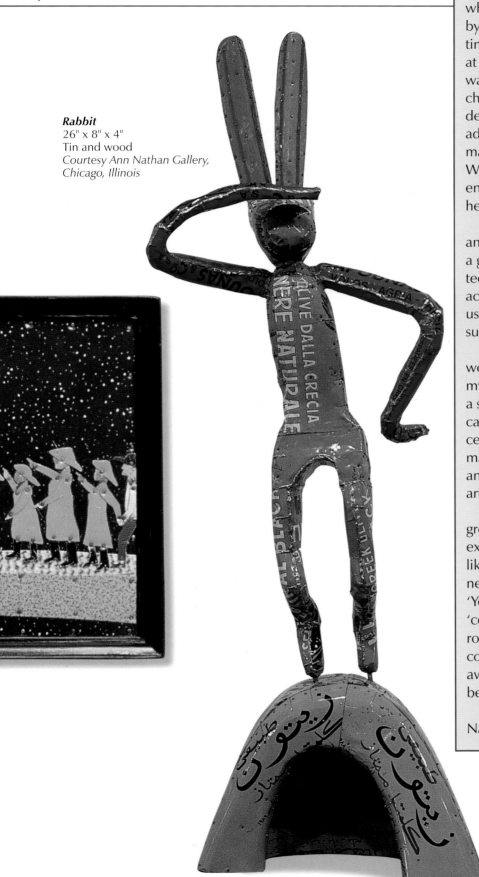

Rabbit
26" x 8" x 4"
Tin and wood
*Courtesy Ann Nathan Gallery,
Chicago, Illinois*

"A great influence on my work was when I saw two *Hairy Who* exhibitions by H. C. Westermann at the Serpentine Gallery in London and then again at the Camden Art Centre in London. I was overwhelmed by what I saw. It changed the direction of my sculptural development literally overnight. In addition, I saw a lot of Calders' animals, including his *Circus* at the Whitney Museum in New York City. I enjoyed his sense of wit and the way he manipulated found materials.

"I have always been interested in and loved animals. (I had wanted to be a game warden in Africa when I was a teenager but was thwarted by the academic requirements.) I began to use animal imagery as the entire subject matter for my sculpture.

"I have always preferred ways of working that enabled me to change my mind at any time in the making of a sculpture. I was never interested in carving, modelling or casting processes. I discovered the allure of found materials through primitive sculpture and the work of many American artists.

"One day I was telling my green grocer that I was about to buy an expensive tin of his olive oil because I liked its beautiful color blue which I needed for a parrot that I was making. 'You don't need to do that,' he said, 'come with me.' He took me to a room filled with large, empty, multicolored tins. 'We normally throw them away but you can have 'em.' He has been giving them to me ever since."

Peter Grieve resides in Prechacq-Navarrerux, France.

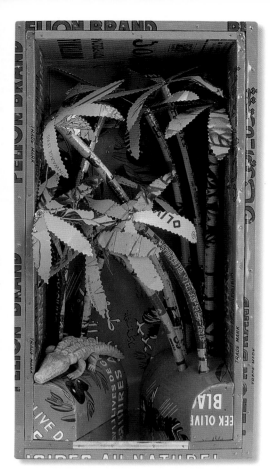

Cooper's Creek, 1990
19" x 10" x 7"
Tin and wood
Courtesy Ann Nathan Gallery, Chicago, Illinois

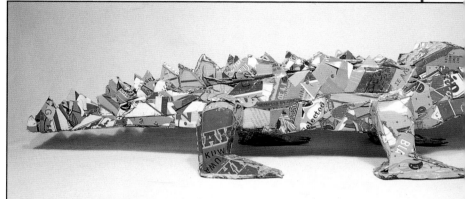

Crocodile, 1992
9 1/2" x 45 1/2" x 15"
Tin and wood
Courtesy Ann Nathan Gallery, Chicago, Illinois

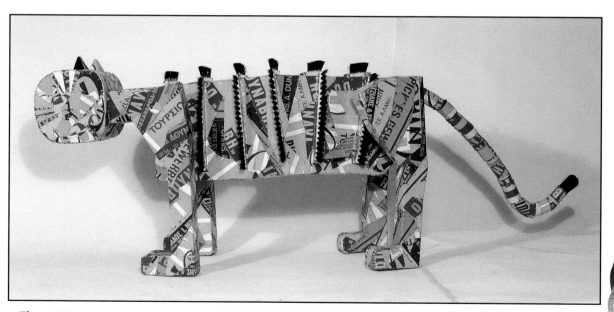

Tiger, 1991
16" x 9" x 42"
Tin and wood
Courtesy Ann Nathan Gallery, Chicago, Illinois

"I've been making furniture, musical instruments, sculpture, and the like out of found objects since 1956. It's a lot about seeing things in different ways—realizing that the most base materials—trash—can be transformed into the most sublime—art. If an ironing board looks like a chair, I turn it into one. It's like destroying and creating something at the same time."

Influenced by the Neo-Dada movement, Hansson began making sculpture, furniture, and musical instruments from found objects while still in college. His works may well be functional, but humor—in the form of visual as well as verbal puns—plays a major role in the objects he produces. He thinks that it is more fun to dig in a dumpster than to wait in line at an art supply store. In addition to operating the Leaping Beaver Tinker Shop in Rising Sun, Maryland—specializing in working with recycled materials—he is also the author of *The Fine Art of the Tin Can* from Lark Books. He lives in Rising Sun, Maryland.

On the Road Again
Old tin cans

Gitana
"geometrically designed for square dance music"
Tin cans and other found materials

Lionel Lunchbox, 1997
8" x 10" x 5"
Tin cans and other found materials

Throne for Snow Queen, 1987
48" x 18" x 30"
Chair from snow skis, wrought-iron chair
frame, shovel and sled

Mugwump Throne
Discarded cedar wood
fencing

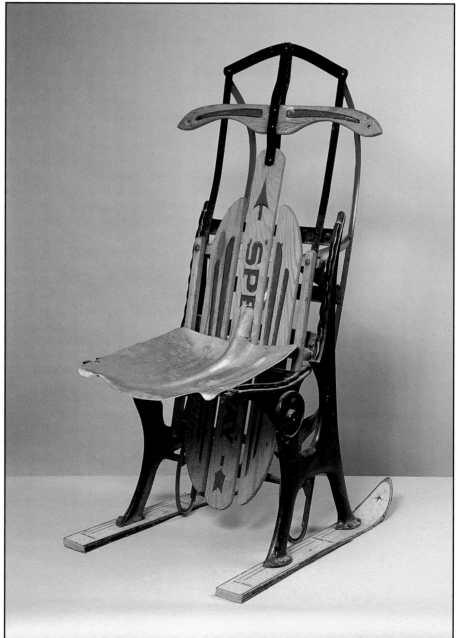

"My approach to art and to life is based on a quote from the agricultural chemist and educator, George Washington Carver: 'Use what you have and do it now.' As an artist who is deeply concerned with environmental issues, I particularly enjoy the adventure of working with unusual materials that have been thrown away. It is a joy to see them transformed into objects that can be appreciated as art rather than society's discards.

"The consistency of my work does not lie in shape or material but in the focus of using trash to make a statement for conservation. Making old inner tubes look like velvet is easy when they are woven with expensive silk ties that have been discarded because they are out of style.

"I began working with braided nylon rope discarded from a yarn factory, then 35mm movie film, outdated 'Previews of Coming Attractions' from a theater. Weaving Japanese newspapers into logs, interchangeable *Temple Blocks* led me to working with the aluminum plates that they printed newspaper with. The material determines the technique and I just follow along."

Polly Harrison lives in Cedartown, Georgia.

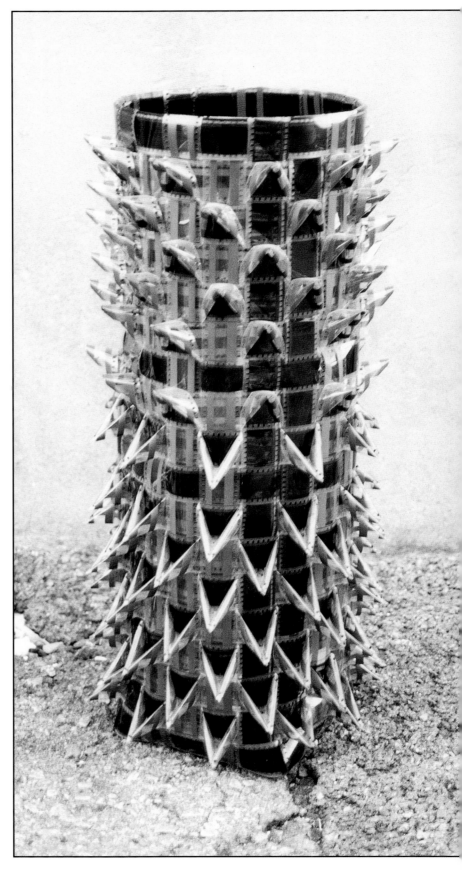

Standing Basket, 1996
42" x 12" x 12"
35 mm movie film

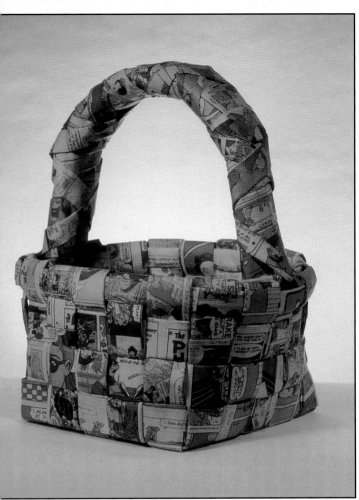

Sunday Comics, 1991
9" x 8" x 12"
Woven newspaper

Basket, 1999
8" x 8" x 16"
Inner tubes and ties

Washington Seminary, 1999
7 1/2" x 15" x 6"
Aluminum, Plexiglas, old photo, pop rivets

Memories of Maureen
4 1/2" x 8" x 8"
Telephone wire, knotless netting, found
objects

"In 1970, when my formal art education began, concepts of the Pop and Minimal movements were prevailing thoughts of the times. Craft media disciplines were thus affected and I was exposed to the idea of expanding traditional boundaries as well as technical knowledge.

"Concentrating my studies in the fiber/fabric area, I explored the idea of using the technical structures with nontraditional materials. My open approach to materials seemed a natural evolvement of my early childhood intrigue with the nature of objects. I was always adapting and adjusting both natural and man-made objects to suit my needs. Because I grew up in a nonindustrial environment, the quantity and availability of mass-produced material became very appealing to me.

"My current interests include the use of everyday objects. Structure, form, and function of materials continue to intrigue me. Currently I use mundane objects with techniques from the textiles discipline to create my jewelry. I strive to create an awareness of personal adornment that exceeds the restrictive boundaries of traditional Western materials and techniques."

Tina Fung Holder was raised in a rural village at the edge of the jungle in Guyana and now lives in Washburn, Wisconsin.

Snaps No. 3 - Neckpiece
snap fasteners, cotton yarn
Courtesy Connell Gallery, Atlanta, Georgia
Photo by Jeff Bayne

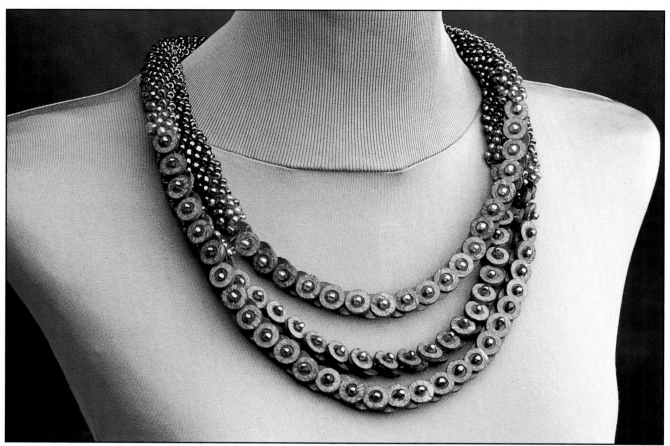

Tri-Ko
65" x 7" x 2"
Coconut buttons, glass beads, cotton crochet
Courtesy Connell Gallery, Atlanta, Georgia
Photo by Jeff Bayne

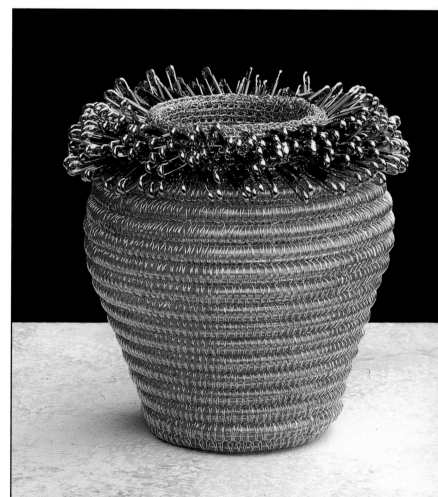

Basket
Safety pins, glass beads, wire, plastic tubing
Courtesy the Sybaris Gallery, Royal Oak, Michigan

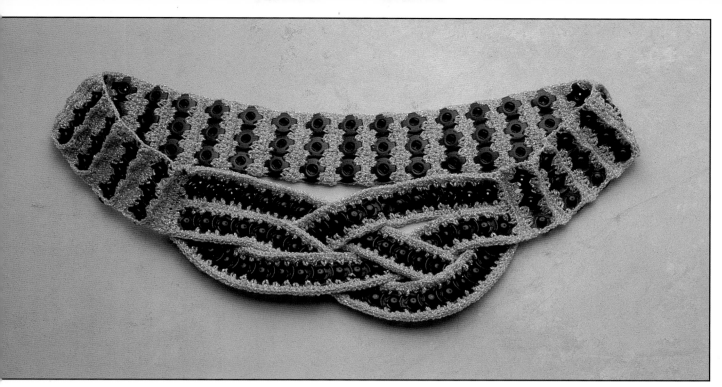

Snaps Belt
Snap fasteners, synthetic yarn, crochet
Courtesy Connell Gallery, Atlanta, Georgia
Photo by Jeff Bayne

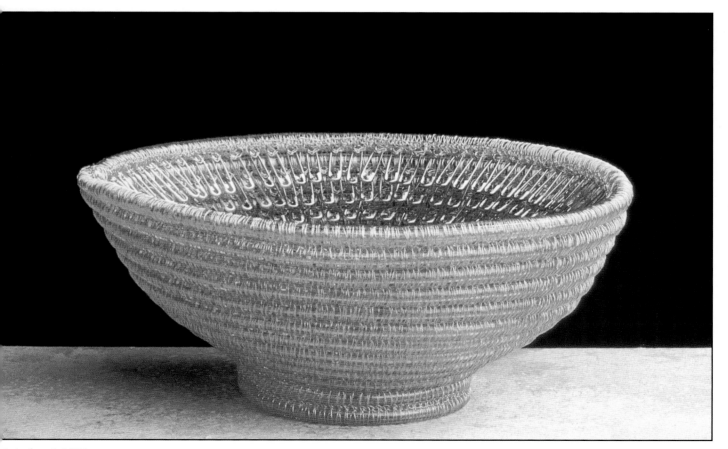

Interiors I, 1988
3" x 7 1/2" x 7 1/2"
Plastic tubing, safety pins, wire
Courtesy the Sybaris Gallery, Royal Oak, Michigan

"I come from a long line of hoarders. My grandmother stashed everything from rickrack salvaged from old aprons to tin pill and Band-Aid boxes and even the matchbooks my granddad brought home with his Lucky Strikes.

"My mother plucked buttons from our worn-out clothes, cramming them in cigar boxes already bulging with greeting cards and ticket stubs from the Broadway previews she frequented in Philadelphia during the 50's and 60's.

"I don't know that they were convinced they'd ever use these things again (although my great-gram turned out some impressive rugs braided from scraps of moth-chewed sweaters over the years). But when you've lived through a Depression and worn underwear made from flour sacks, it seems a waste to throw away perfectly good 'junk' I guess.

"As one generation after another has downsized to basement-less apartments, the next has inherited these hoarded 'treasures.' I haven't the heart to throw them away. Besides, I've inherited my own hoarding and trash-picking gene. For years, I happily carted this burgeoning pile of discards from one basement to the next during my own moves. I'd comb through periodically, admiring these unappreciated reflections of the past when even the button you bought on a 5 and dime sweater or the labels pasted on cigar boxes and tomato cans were little works of art.

"When my meticulous husband wondered about why I kept things I pulled out to look at maybe once every 4 or 5 years, I took it to heart. Since then, I've incorporated my finds in my artwork, melding the objects together into functional and decorative collages that now warrant a prominent spot in everyday living spaces. I love that they stir precious memories of the past for other people, too. Not to mention that they give my scavenging addiction a valued purpose."

Jennifer Reid Holman lives in Philadelphia, Pennsylvania.

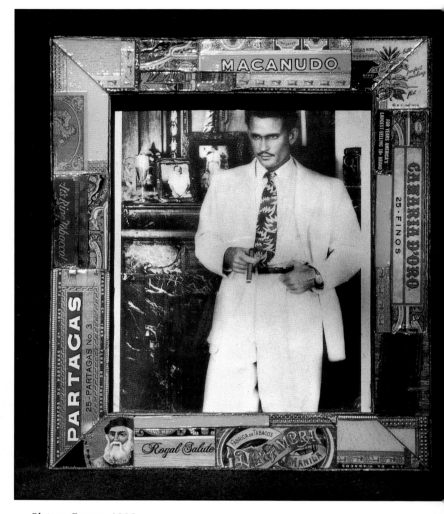

Picture Frame, 1998
5" x 7"
Old cigar boxes

Kitchen Wreath, 1997
24" diameter
Old fabrics, discarded kitchen utensils

Humidor, 1998
9 1/2" x 11 1/2" x 4"
Wood, old cigar boxes

"I place great importance on maintaining the integrity of the materials which I use. Each piece evolves through a process of trial and error, with the shapes and colors of the materials often guiding the development of subject matter. The beauty of found objects, discolored, corroded, and misshapen by the random process of history set this process in motion.

"I find objects along the road and in dumps that are in the process of being reclaimed by the earth. These objects represent humanity to me. They are the materials and products of human ingenuity and machinery that get a new life in my work. The new materials which I use take on the historic cast of these found materials. I work in a very direct way with the materials, riveting and cold connecting them to form the figures who could be the children or other selves of these women. I leave it to the viewer to decide for themselves. For the past few years I have been exploring vessels. Vessels as the container for our muscles, bones, innards, souls. As time wore on the vessels themselves became the subject matter. Sometimes they hold things, sometimes they stand by themselves or with other vessels on a plane. Portraits occasionally become my focus; portraits within vessels, by themselves, made from paper collage and paint, found objects, or a combination of all these. Sometimes faces merge with their environment, objects, or with each other, and personalities emerge."

Judith Hoyt lives in New Paltz, New York.

Woman with Pink Skirt, 2000
34" x 12" x 3/4"
Mixed media

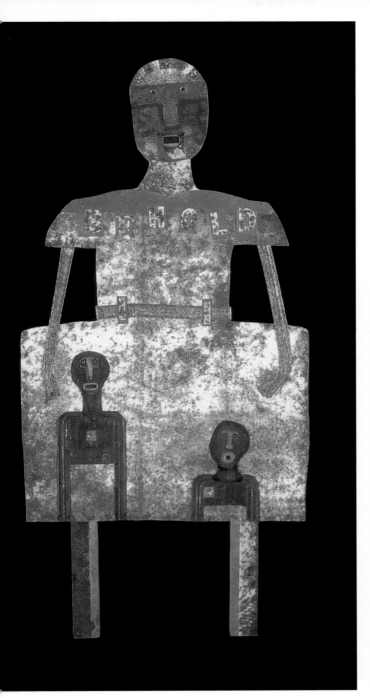

Behold, 2000
35 3/4" x 17" x 3/4"
Mixed media

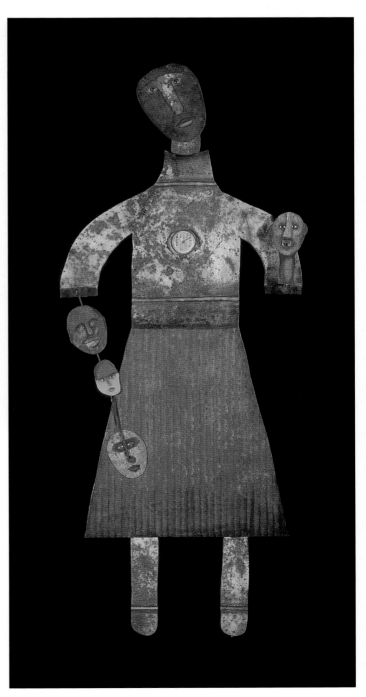

A Full Life, 2000
37" x 15" x 1 1/2"
Mixed media

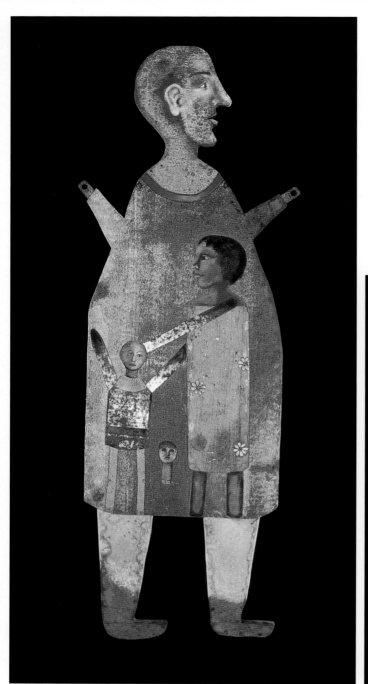

Family Scene, 1999
38" x 13 1/2" x 3/4"
Mixed media

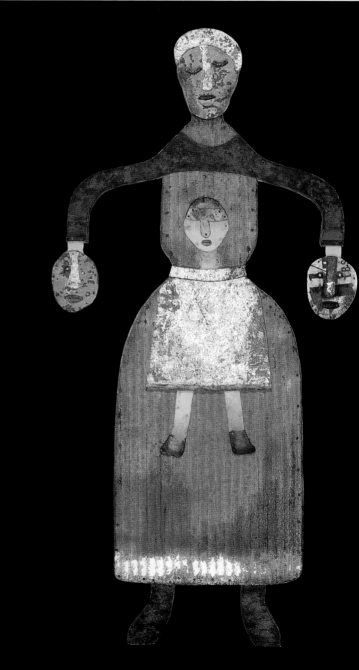

Generational Memories, 2000
30" x 14 1/2" x 3/4"
Mixed media

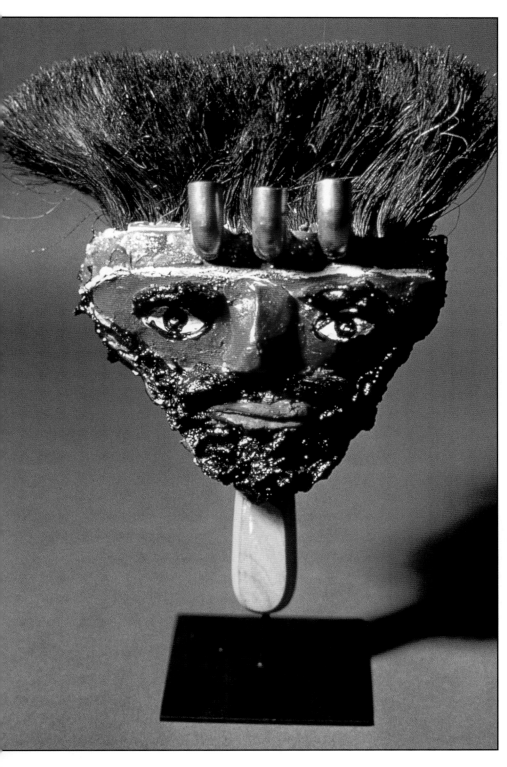

"If you can use your imagination, you can work with anything. Where I live, I'm saving lots of garbage that I find in the alley. When I walk down the alley, I hear a sound like 'Psst!' and I say, 'Where's that sound coming from?' It's coming from a trash can. And the trash can says, 'Psst!' and I stop and I look inside and I find this paintbrush and the paintbrush says, 'Hey you!' and I take this paintbrush home and make it into a man."

Mr. Imagination is a self-taught street artist who has known his calling since 1978, taking his new name and beginning his vocation after recovering from serious gun-shot wounds. His art always speaks of his intense pride in his African heritage. He lives in Chicago, Illinois.

Paintbrush Portrait, 1993
12" x 6" x 3"
Paintbrush and other found materials
Courtesy Carl Hammer Gallery, Chicago, Illinois

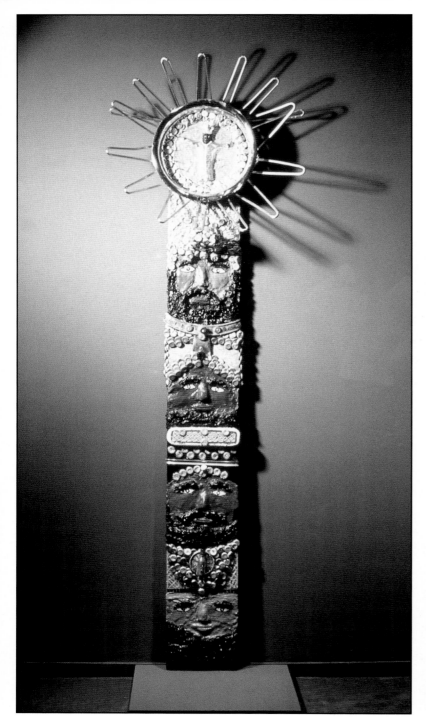

Totem, 1992
98" x 32" x 10"
Mixed media
*Courtesy Carl Hammer Gallery, Chicago,
Illinois*

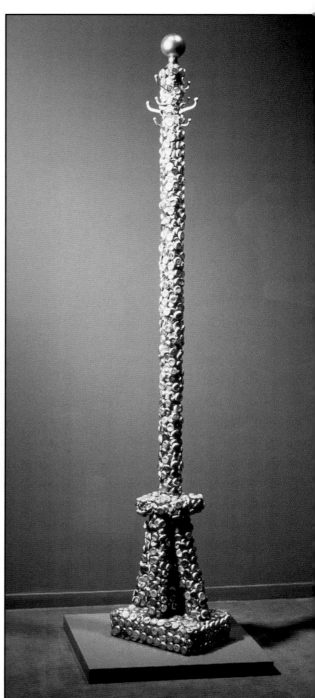

Coat Tree, 1993
82" x 10" x 14"
Mixed media
Courtesy Carl Hammer Gallery, Chicago, Illinois

Robert F. Justin

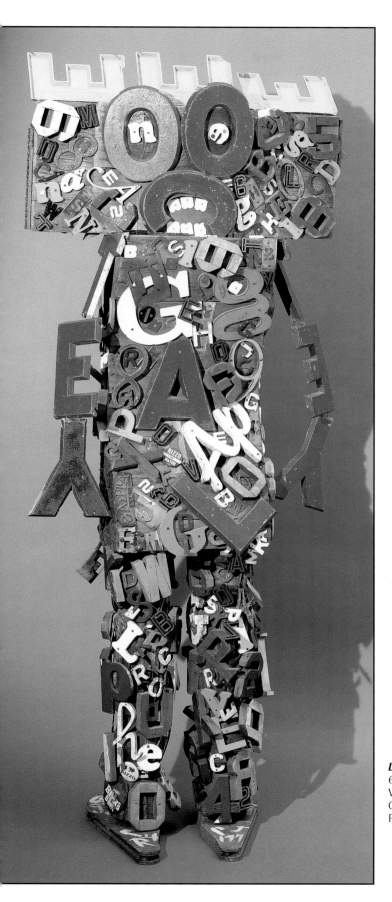

"As a boy I roamed the town dump seeking the scraps of society, which were made into toys, such as boats or pop guns. Now my workshop is located in a junkyard/flea market where the unusual reusables abound. These are chosen because of their texture, shape, numbers or novelty and the mystery they exude when combined together and are reborn.

"In 1991, after suffering a heart attack and becoming idled, I seemed to re-enter my childhood when making my first 'critter' in 1993. I never intend to create art nor efficacy, but to give form and substance to the many visions I have always seen in all things. All things have another life awaiting discovery, an essence imbuing each 'critter' with a personality and spirit unique to themselves. I would never attempt to clone them for it would destroy the magic. Unfortunately I have to sell some to survive—if I could buy them all back I surely would."

Robert Justin estimates he worked two hundred jobs in his life, everything from picking strawberries to truck driving to real estate sales. He lives in Plainsboro, New Jersey.

Letterman, 1996
65" x 26" x 15"
Wood, metal, plastic letters
Courtesy American Primitive Gallery, New York City
Photo by August Bandal

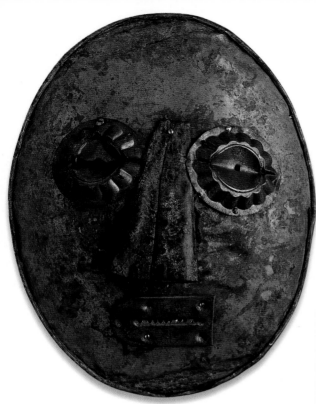

Alchemist, 1994
17" x 13"
Mask from the brass pan of a scale, torte tins, funnel,
and scrap metal

Strain, 1993
15 1/2" x 11"
Mask from old wood, sieves, other found materials

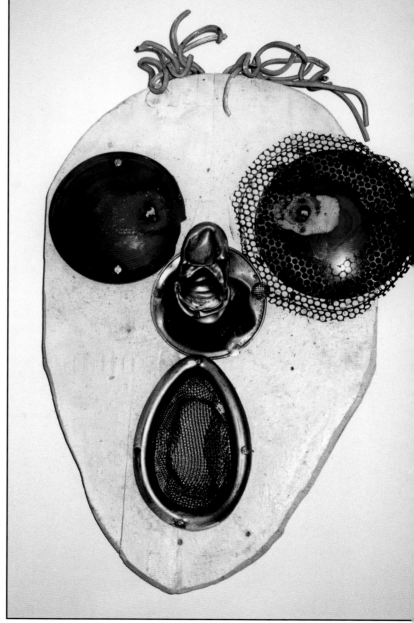

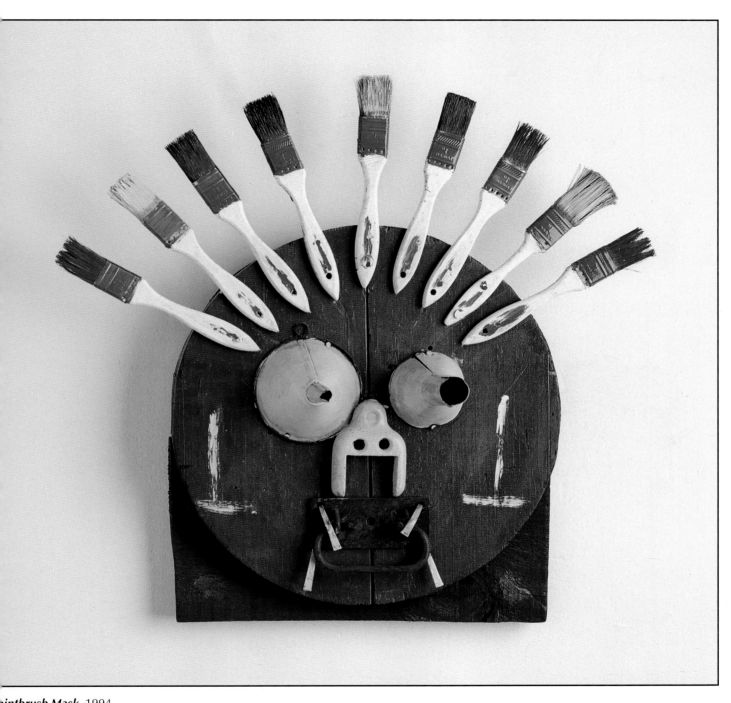

Paintbrush Mask, 1994
5" x 12"
Old barn wood, discarded paintbrushes, funnels, other found
materials

"I create in boxes using found objects as well as organic matter. The history inherent in the original use of materials enriches the work. Objects and scraps of paper are combined, losing their identity after being dragged through my own personal history. This delicate balance of storytelling and visual poetry is sometimes humorous—sometimes dramatic. The ultimate goal, hopefully, is truth, our Truth and the accessibility to it."

"Poetry has played a strong role in my art making The marriage of the visual and literary has long been a struggle in my work until one day, they just settled in together."

Shari Kadison divides her time between Boston and Cape Cod.

Cantata, 198•
5" x 8" x 1 1/2
Music box parts, scrap brass, jeweler's saw blade

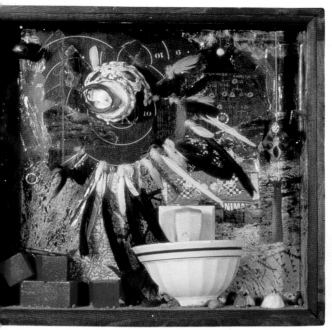

Dreamshield, 1989
15 1/2" x 16 1/2" x 4 1/2"
Feathers, ceramic, wood, thread,
metal, nightlight, finger pots

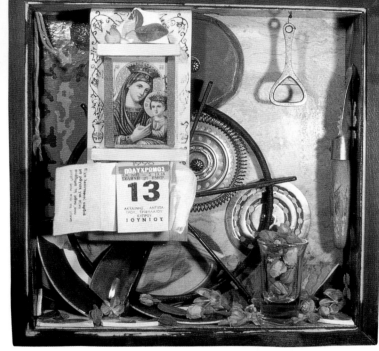

For Madeline, 1995
12" x 12" x 4 1/2"
Metal, paper, ceramic, glass, flowers

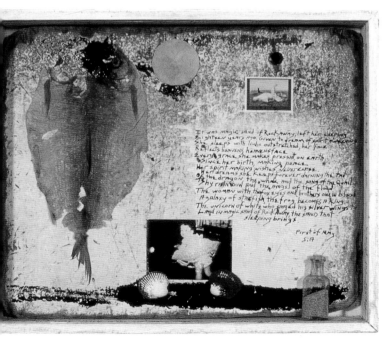

Rockaway, 1997
17" x 14" x 2 1/2"
Fish, shells, wood, ink, stamp, glass, stone

"My work is my statement, and hopefully, will be perceived in a different way by each individual. Explanations by me only narrow the viewer's perception.

"As I do art work, my past dictates the direction a particular piece will take. The viewer brings a different set of past experiences and an interaction takes place which is unique to each spectator. To explain my reasons for doing the piece does not allow for personal interpretations. A worthwhile piece of art should evoke or provoke in a way to cause a different reaction from each person. Consequently, the artist effectively creates pieces equal to the number of people who view the work.

"This is essentially true with non-objective art, and applies to representational work when it depicts subject matter with psychological implications. The figurative sculpture I am currently producing seems to arouse a variety of emotions from people—a fact I attribute to their past experiences. In my opinion the work should speak for itself. Many ask, 'What does it mean?' I have yet to say."

Grady Kimsey lives in Florida.

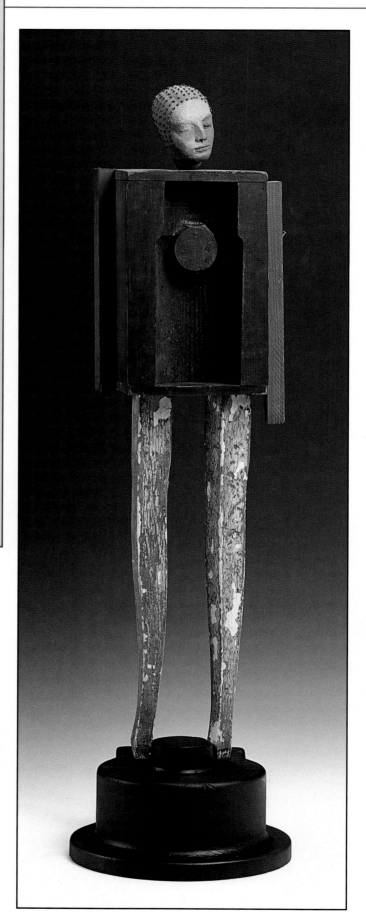

The Pragmatist
35" x 8" x 11"
Mixed media
Courtesy Connell Gallery, Atlanta, Georgia

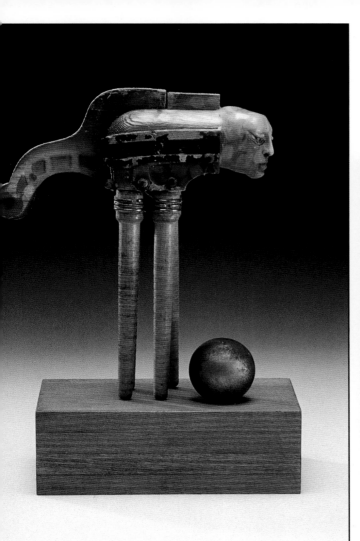

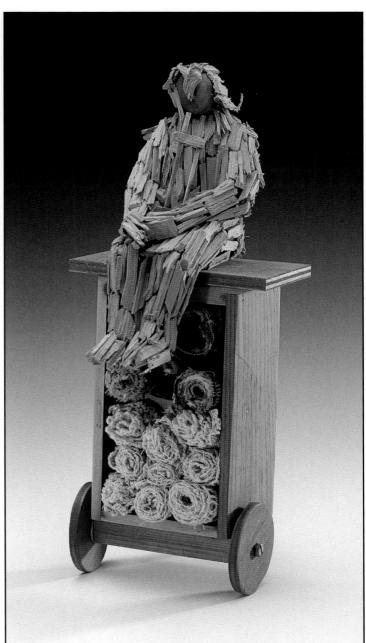

Ashland Image
15" x 11" x 5 1/2"
Mixed media
Courtesy Connell Gallery, Atlanta, Georgia

The Tender
14" x 5" x 8"
Mixed media
Courtesy Connell Gallery, Atlanta Georgia

Keepers & Seekers
23" x 23 1/2" x 13"
Mixed media
Courtesy Connell Gallery, Atlanta, Georgia

"Through my work I search for a universal language. My hope is that the work I create has the ability to communicate with all people regardless of their different social, racial, and cultural backgrounds.

"I have based the forms I use on a universal vocabulary inspired by shapes and notions that are common to all people. The work is therefore fundamentally comfortable to the viewer and the wearer. Inspired by the human figure and simple hand tools, such as the axe and the arrow, my pieces elicit a response that originates from a deeply personal level.

"My process of creation is one of development, reduction and embellishment. Tin cans are my media. The pieces are all die-formed, painted tin cans, and then set into silver bezels with either acetate or silver backs. I have found painted tin cans to be a wonderful alternative to enamels"

Shana Kroiz lives in Baltimore, Maryland.

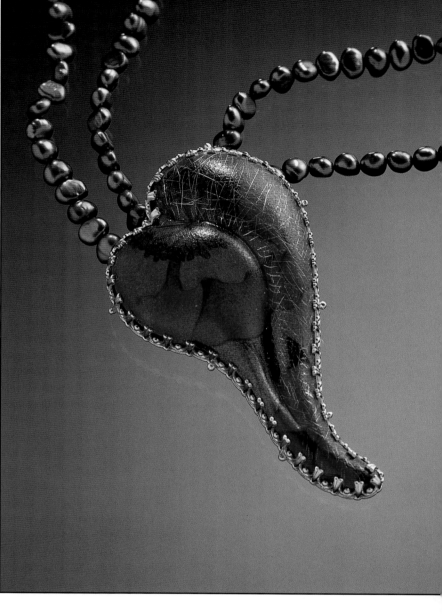

Floral Heart Pendant
Tin cans, silver, acetate, pearls

Whole Tomatoes Brooch
Tin cans, silver

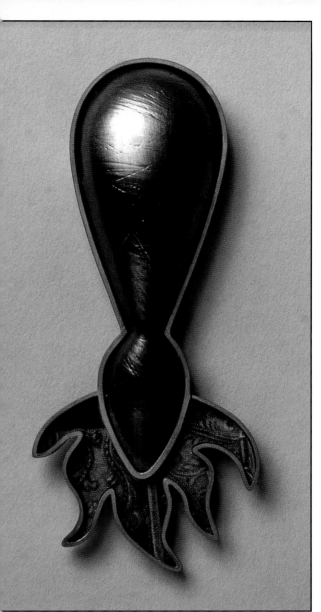

Hot Iron Brooch
Tin cans, silver, copper

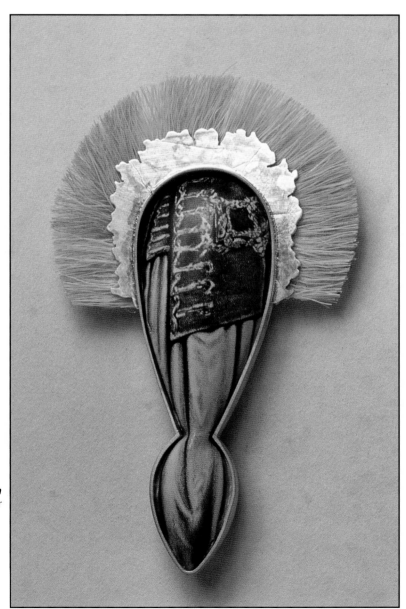

Hair Cuts Brooch
Tin cans, bronze, silver hair

"'I have always loved containers. From my youth, through graduate study, to the present, I have made containers to hold things, sometimes real, sometimes imaginary. The making of these forms and their resultant utility seem to give me a sense of order and well being. In an effort to create unique forms, I have studied the architecture, tools and objects of indigenous peoples of Africa and the Americas. I am fascinated by the sensitive use of materials, ingenious construction techniques, and the 'rightness' of the form of tribal objects.

"My current work, figurative or functional, is an effort to capture some of the spirit of these native forms. In an effort to make the work as personal as possible, I have incorporated objects from my environment. Wood—natural, milled and weathered in a variety of shapes and textures—has been selected for aesthetic, structural and associative purposes. Metals—rod, bar, sheet, cut objects, new old, rusted, deteriorating—are incorporated. Objects and materials, taken from my arenas of interest (bikes, cars, furniture, antique machines) further personalize and add accessible meanings."

Charles Kumnick lives in Ewing, New Jersey.

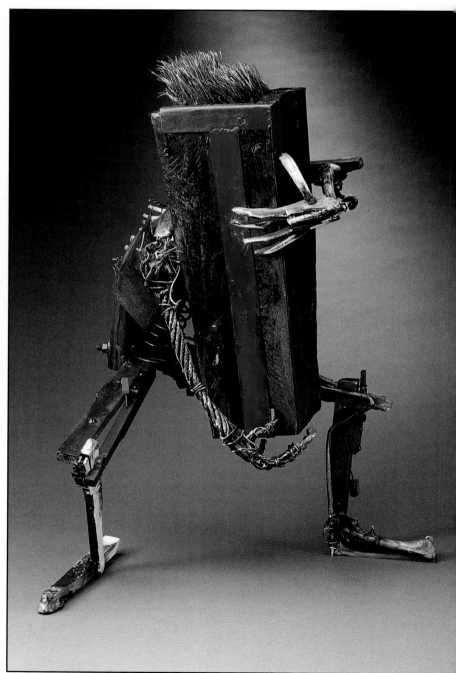

Errr…Right
27" x 18" x 16"
Steel, wood, bone, brush
Photo by Philip Smith Photography

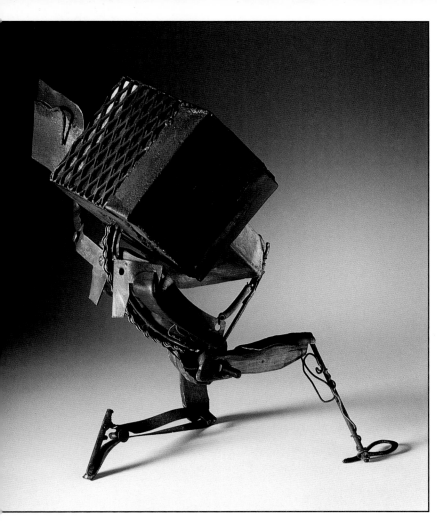

Juggler, 1997
6" x 10" x 12"
Steel, wood
Photo by Philip Smith Photography

Wheels…I'm OK
19" x 28" x 24"
Photo by Philip Smith Photography

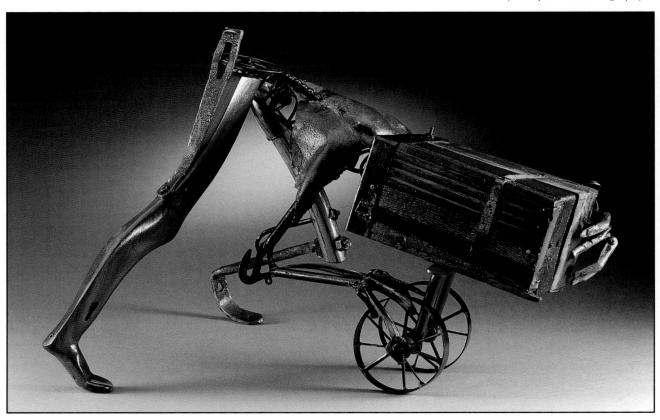

"I often see beauty in the everyday things, crackled weathered paint on an old door, a flattened beer can lying in the street, and the simple perfection of a discarded bottle cap. I have found inspiration in many things, including folk and outsider art, grottos, sculptured environments, and Burmese temples. I am drawn to forms that I would describe as obsessive, accumulative, whimsical, and overly ornamental.

"My bottle cap furniture came as a result of much time and invention and a strong desire to transform my existing conventional furniture into a new, fantastic sculptural form. With the help of a local bar, I have recycled thousands of bottle caps into very unique works: my personal expression as a celebration of life."

Rick Ladd also produces "prisoner art," using a folded-paper technique historically practiced by convicts to make intricate purses, frames, and boxes by interlocking empty cigarette packs. He learned the art by corresponding with an inmate at the New Jersey State Prison in Trenton. Ladd lives and works in Brooklyn, New York.

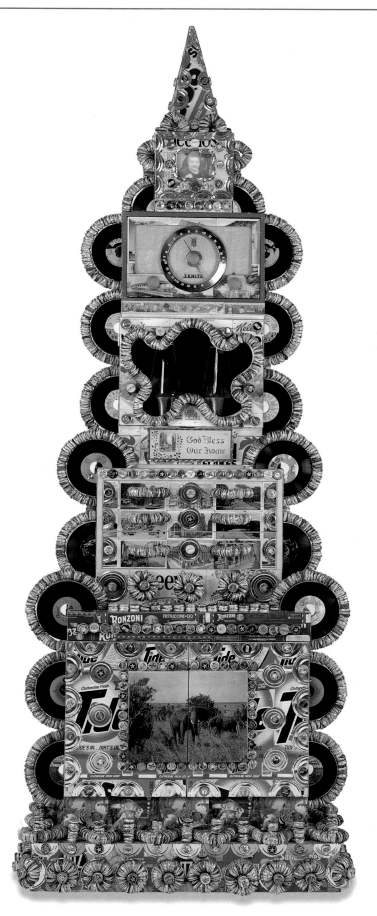

Metropolis
Mixed media

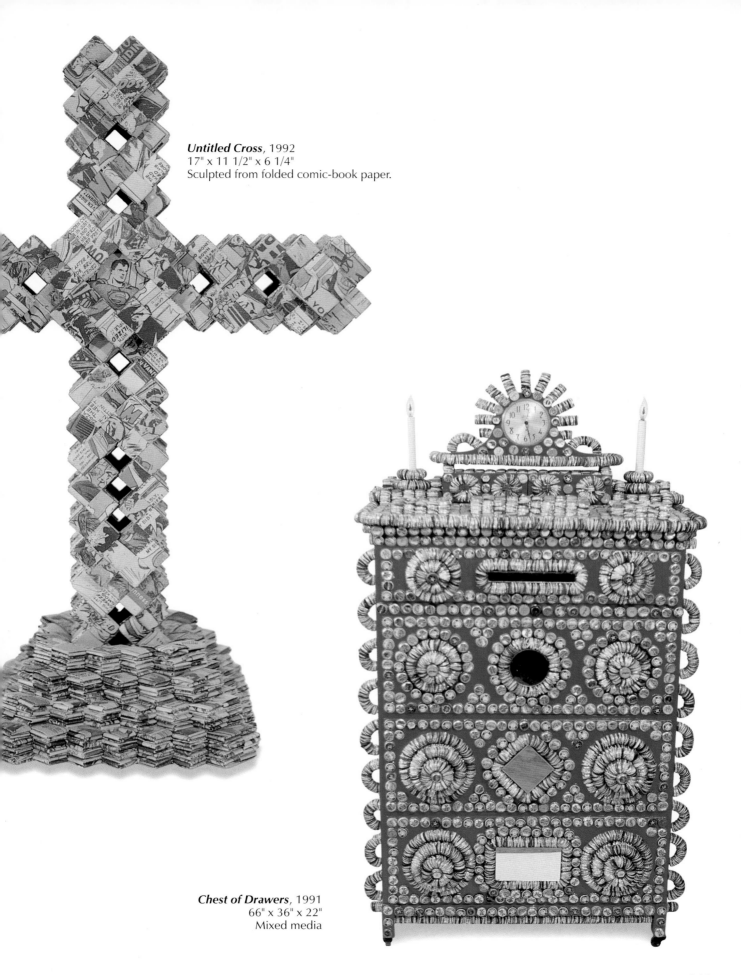

Untitled Cross, 1992
17" x 11 1/2" x 6 1/4"
Sculpted from folded comic-book paper.

Chest of Drawers, 1991
66" x 36" x 22"
Mixed media

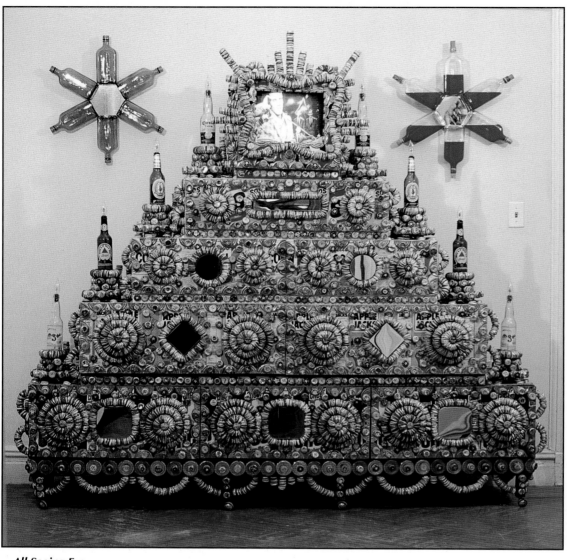

All Seeing Eye
Room size
Mixed media

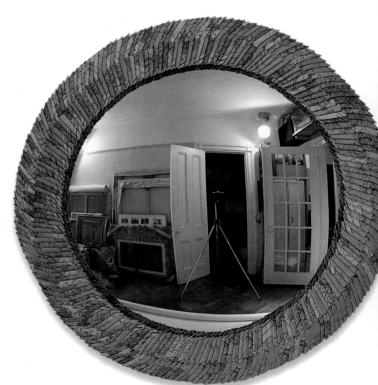

Bulls Eye Mirror
Mixed Media
Photo by Karen Bell

yöngy Laky

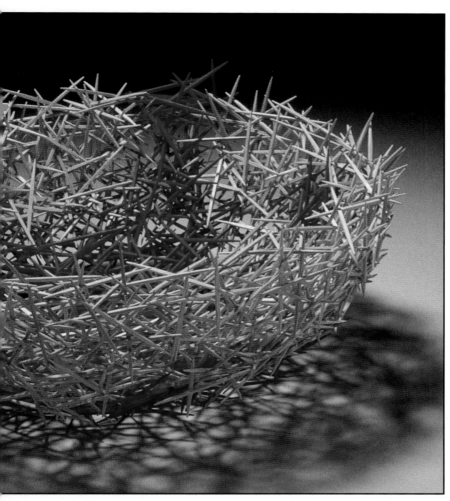

in, 2000
x 16" diameter
othpicks, paint

"Because of my childhood, I learned early on to make do. I gather local materials for my work. In land-based, agrarian settings I harvest such agricultural leftovers as prunings from fruit and nut trees, grasses, and twigs. From the industrial banks, I reap the by-products of modern technologies: scrap metal, wire, plastics—whatever presents itself becomes my medium for both my site specific installations or for the objects I exhibit."

Laky and her family fled Hungary when the Soviets took over, finally immigrating to the US. "We were so poor, we had to make do. My mother was a master at making something from nothing. Many nights we had cream of wheat with a small dollop of something wonderful in the middle—strawberry jam, chocolate—that was dinner. My guess is that my sense of preciousness of materials came from that time."

Putting herself through college at UC Berkley, where she received both a BA and MA, she continued to recognize the need for "making do while making art." "Because I was a poor student putting myself through school, some of my earliest works were made with what I could harvest from the urban life around me including cafe supplies. I made a piece from the plastic bags which contained the Styrofoam cups."

Gyöngy Laky lives in San Francisco, California.

Of Course, 1988
55" x 55" x 2"
Apple prunings, vinyl-coated steel nails
Photo by Lee Fatherree

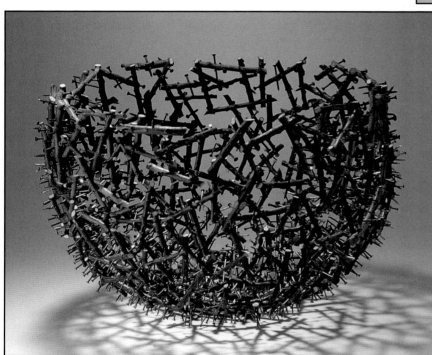

Typical Application, 1999
19" x 28" x 28"
Apricot prunings, vinyl-coated steel
nails, concrete screws
Photo by Lee Fatherree

Negative, 1998
29" x 60" x 8"
Apple prunings doweled, vinyl-
coated steel nails
Photo by Lee Fatherree

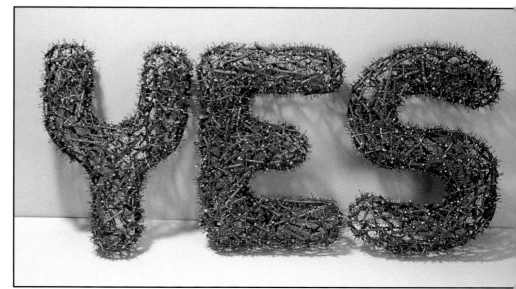

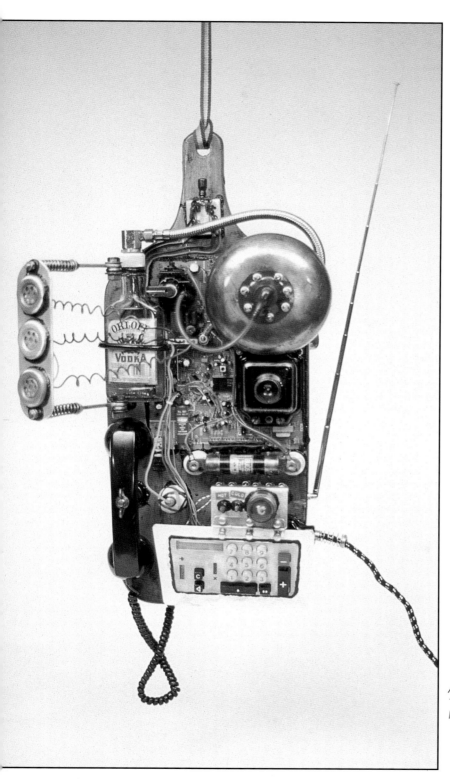

"Through my sculptures I explore my attraction and deutilization of both durable and consumable goods, their aesthetic and how it relates to an anxious consumer-driven society. Inspired by the Futurist, Pop and Fluxist movements, I attempt to bring forth my own aesthetic, spatial and sociocultural ideals. The primary intention of my art is to provide a 'refreshing kick in the eye' while at the same time unfurling a subversive tentacle in order to provoke question and reaction.

"Sheets of metal, machine innards, lost and found objects, the banal, disparate, and obsolete—systematically I gather, dissect, combine and reinvent them to find new meanings and aesthetics through mediums of sculpture, assemblage, and installation."

Eric Legacy lives in Hampton, New Hampshire.

Art Detector, 2000
18" high
Mixed media

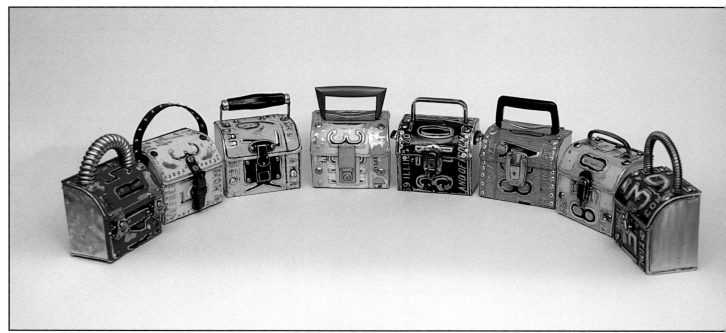

Travel Sculpture *(set)*, 2000
6" x 8" each
Mixed media

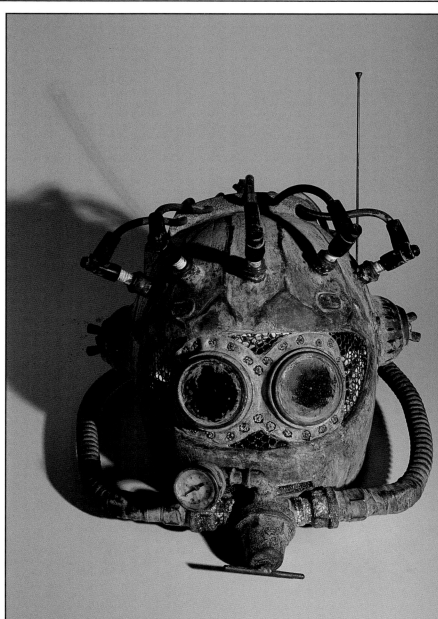

Lifeguard, 1999
14" high
Mixed media

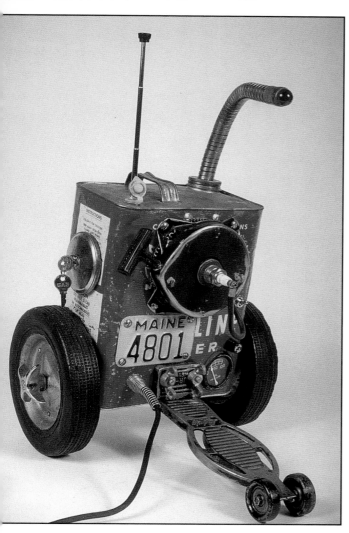

Americana
16" high
Gas can, radio, mower wheels

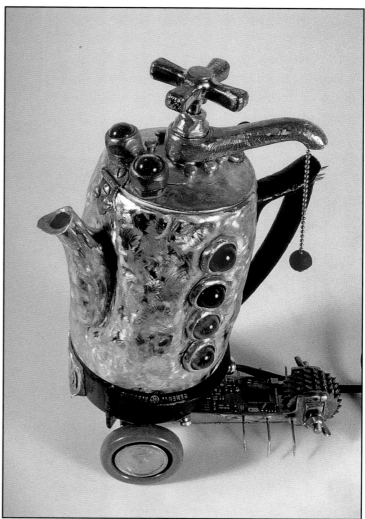

Perk-o-Lator #2
12" high
Perkolator, marbles, light bulb,
Hoover wheels

"REVISED STANDARD VERSIONS is a series of salvaged chairs that have been disassembled and then used as raw material for a newly crafted object—a revised version of the mass-produced original. The objects chosen for alteration are conventional in form. They are pieces of furniture that have some degree of redundancy within our culture, in part because they display a structural honesty and clarity sufficient to clearly denote their primary function, and in part because that rational design has served as a prototype for mass-production and a subsequent proliferation of similar forms.

"The result is that these pieces have become icons of our material culture. When such pieces are altered—when they deviate from that iconic form—they activate a certain perceptual dialogue between a sensory/utilitarian perception, and an intellectual/aesthetic perception of the object.

"The dimensional alterations render the pieces non-functional, a direct negation of their denoted primary function. Other defining characteristics such as height, posture, and surface quality have been preserved in order to maintain a close referential relationship with the original. The forms produced in this manner are enigmatic in that they simultaneously evoke and negate their own denotative meaning while their ability to function on a connotative level remains undiminished. In provoking this sort of reassessment of a familiar object-of-use, these pieces raise questions concerning the nature of craft. Although the originals were mass-produced, it is through the act of 'crafting' that they are revised."

Stephen Litchfield lives in Ravenna, Ohio.

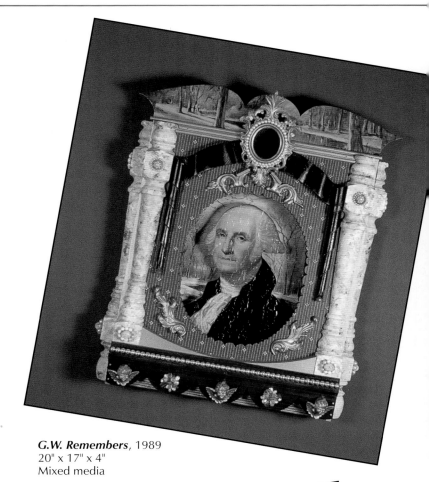

G.W. Remembers, 1989
20" x 17" x 4"
Mixed media

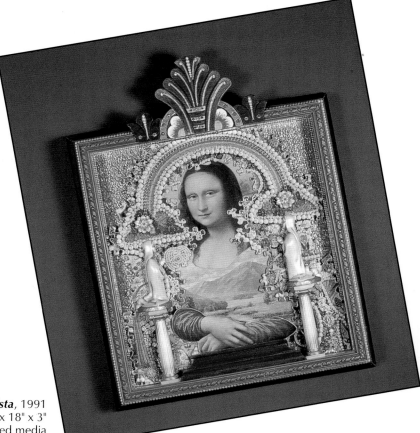

Mona Vista, 1991
24" x 18" x 3"
Mixed media

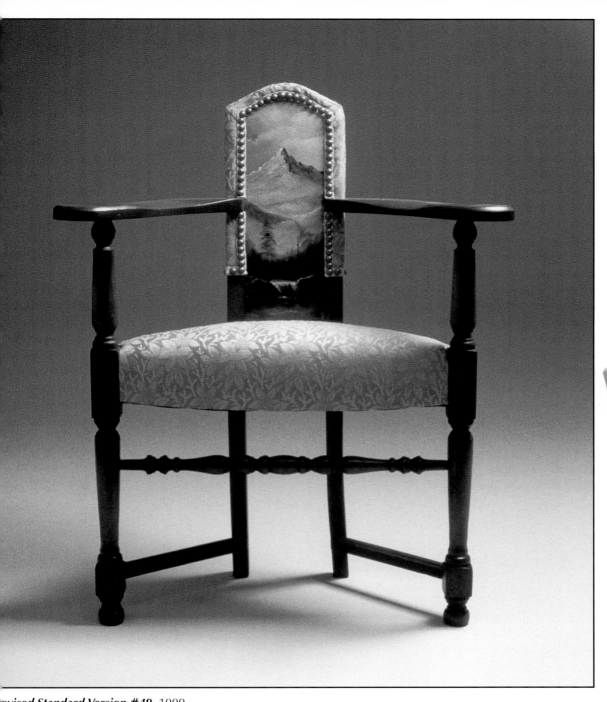

Revised Standard Version #49, 1999
3" x 26" x 12"
Mixed media, altered chair

Revised Standard Version #50, 1999
36" x 6" x 8"
Mixed media, altered chair

"What more resonant, more precious material could inhabit my constructions than the ubiquitous tin can? How many utilitarian objects shelter their cargo with such vulnerability? Could any other icon dare to trumpet our culture's achievements and limitations with such a small voice? "

Keith Lo Bue lives in Westport, Connecticut and Australia.

Condundrums, 199
8 1/2" x 13 1/2" x
Reconstructed chair with mixed med

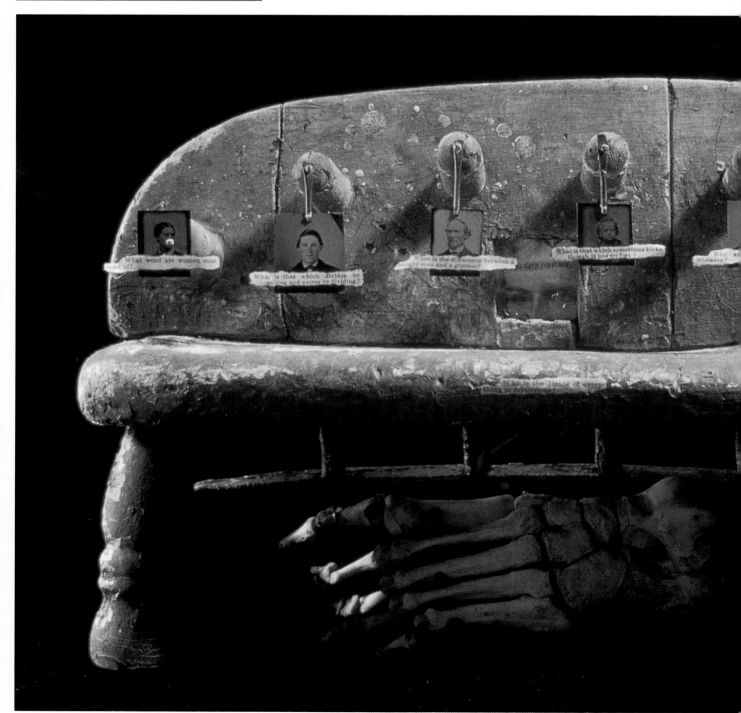

What the Sun Has Seen
Bolo tie
Horseshoe crab carapace, horseshoe crab claws, text, glass marbles, watch hands, iron key, leather

Angel of the Rain
Brooch
Pocket watch case, wood, engraving, text, glass, crushed glass, deer fur, steel wool, peacock feathers, red gravel

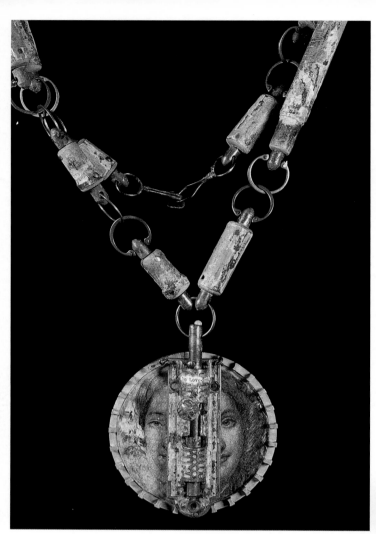

Two Love Songs
Neckpiece
Dead bolt, brass ring, glass, engravings, copper, nails, brass, steel, sterling, text, dichroic glass, lens, blasting sand, glass beads, leather

The Chamber of Silence
Brooch
Pocket watch case, bone, text, engraving, bonsai leaves, book leather, paint, brass screw, vine, tintype, coral, coat hanger wire, sterling

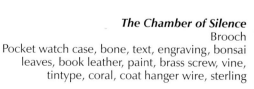

Daniel Mack

"In 1989, I began the process of including commonplace objects into my natural form chairs. The first was a cast iron cherry pitter which topped a cherry side chair, and the first 'Tool Chair' followed soon after. One important part of this series is the repetition. As the trees repeat, as the tools are mass produced, so too the amalgam chairs echo this process, but they also reflect the infinite variety of the trees and the different history of each tool as it has passed from user to user. Just as a tree is a tree and a tool is a tool, so too no two trees are the same and no two tools ever get used in the same manner.

"Another focus of this process is the use of common tools and common trees. A large part of the beauty of my natural form work comes from the careful choice and combination of common, almost forgettable trees. It is similar with the tools. I use everyday, almost culturally invisible tools and in the choice and placement, they take on a beauty and a transcendence. It is a statement that beauty, grace, harmony can be found in unexpected juxtapositions in the tilted frame. And most importantly, this is not a unique event, a fortuitous accident.

"Another aspect of this work is the opportunity to scoop into history by using tools and other material objects from history. I am respecting time and borrowing on the longevity of these objects for contemporary work."

Daniel Mack lives in Warwick, New York.

Driftwood Armchair, *1993*
Found objects

153

"I grew up in a working class family in rural Vermont during the depression. My mother was a great saver and recycler long before that word became popular. I am sure my interest in using non-precious materials has something to do with this early background. When you're working class and pass through a depression, you tend to get resourceful with materials.

"I was in the army for five years during World War II and when I got out I was eligible for 48 chronological months of education. Being in the army for five years was one of the worst things that has happened to me in my life and going to the Boston Museum School of Fine Art for four years to study painting was one of the best things that has happened to me. But right from the start at school, I was interested in construction, especially in how it related to furniture. I ran a custom woodworking shop for 30 years, making high end furniture out of precious hard woods. But as these woods became more scarce and the business less satisfying (and my children grown and less dependent) I was able to push my ideas for non-conventional structures and joinery and develop a completely new approach which made use of alternative materials. In a way, it was like returning to very early influences but with the advantage of the art school education.

"It was while I was on vacation around 1989 that I began to build furniture from newspapers and soon after that with cans. These are perfect vacation building materials, plenty of them pour into the house every day and they can be worked with a few simple tools. When I began working with cans I realized the enormous color range that can be found and that the paint on most cans is so incredibly durable that it can be put through a lot of bending and shaping, even pounding, without disturbing the paint at all. I began with small sculptures, then I got more adventurous and never looked back."

John Marcoux lives in Providence, Rhode Island.

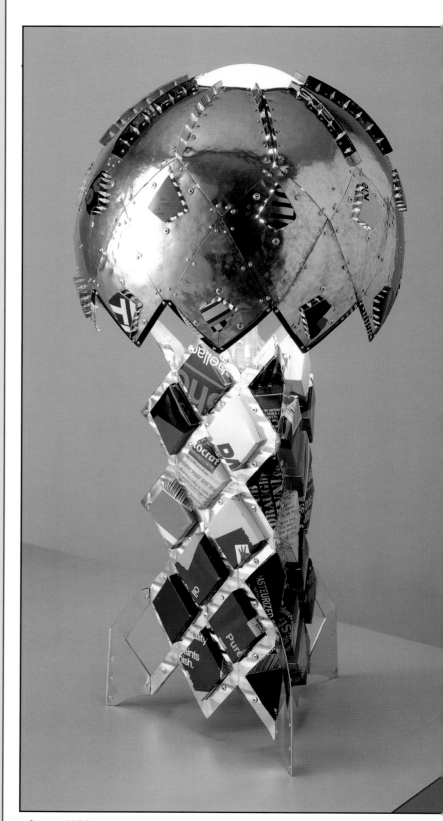

Lamp, 1998
10" diameter, 21" high
Steel, aluminum

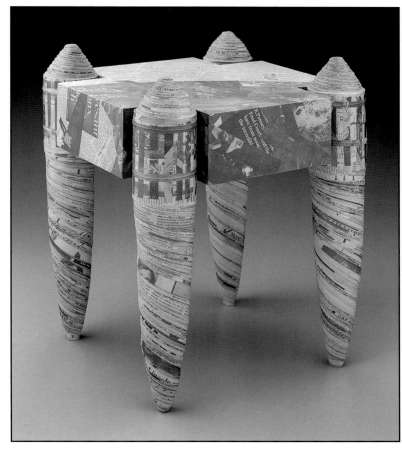

Item, 1989
15" x 15" x 18"
Newspaper, wood, wood dowels

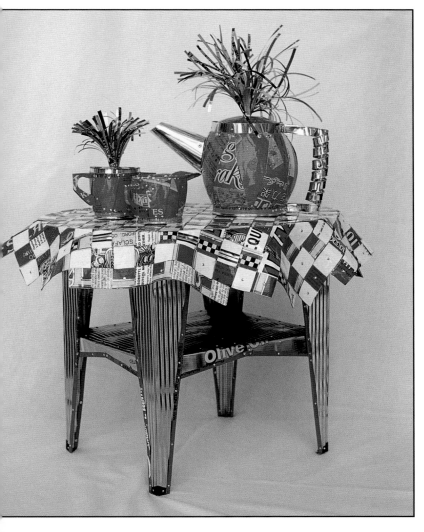

Tea Ceremony
21" x 19" x 16"
Steel, aluminum cans, wood

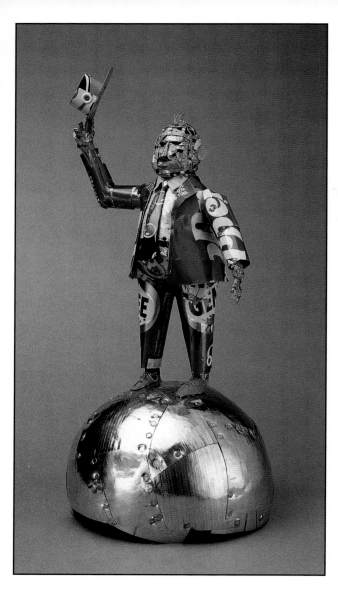

Insider
11" x 6"
Aluminum cans, steel

PTA
14" x 14" x 5"
Aluminum cans, steel

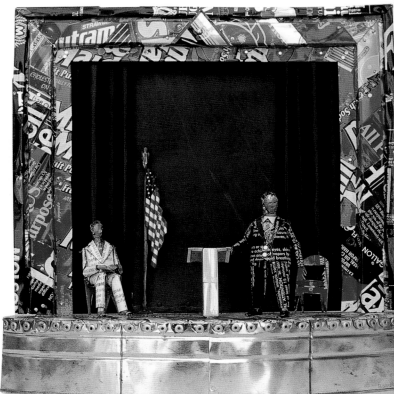

m's Obsession, 1996
3/4" x 8 1/2" x 8 1/2"
ood, wax, Plexiglas, birdseed
urtesy the Sybaris Gallery, Royal Oak, Michigan

"The most important thing to me when I'm making something is an intense sense of joy or gladness. Emerson writes about being 'glad to the brink of fear,' That kind of glad."

"I remember walking into the Tate Gallery in London to see the Turner paintings. Instead I found myself in a room with paintings by Marc Rothko, then I walked into another room filled with what seemed like hundreds of figures by Alberto Giacometti. My feelings after being in those rooms with that work has never left me. I was moved to be and to make things. How else did I feel? I felt full and wanted more simultaneously. But the more is not describable.

"Some other (but not all) artists I admire are Eva Hesse, Richard Serra, Louise Bourgeois, Ree Morton and Robert Smithson.

"I work with many different kinds of materials—wax, plaster, steel, wood, cardboard and I use found objects—recognizing something that is more than interesting, usually and less significant, initially.

"Found objects facilitate for me an experience James Joyce refers to as epiphanies. An epiphany was the 'sudden revelation of the whatness of a thing,' the moment in which 'the soul of the commonest object' seems to us radiant.' Using rusted objects that I incorporate in my work suggests a process still occurring."

Heads & Tails, 1997
7 1/4" x 8 1/2" x 8 1/2"
Wood, plaster, wax, dimes
*Courtesy the Sybaris Gallery, Royal Oak,
Michigan*

Brushes, 1994
9" x 8 1/2" x 8 1/2"
Wood, steel, wax, brushes
*Courtesy the Sybaris Gallery, Royal Oak,
Michigan*

sion of Paradise, 1996
1/4" x 2 3/4"
hreads of unraveled socks
ourtesy American Primitive Gallery, New York City

Raymond Materson is a self-taught artist known for miniature pictures that he sews from threads of unraveled socks. He came upon this approach to making art while serving a period of seven years in prison. Faced with seemingly endless time, he remembered his childhood and how he watched his grandmother sewing. His initial sewing efforts required colored threads that he got from pulling apart his socks. He fashioned a round plastic stretcher by cutting off the top ring of a plastic jar with a toenail clipper and stretched cotton fabric from boxer shorts or handkerchiefs to sew on. He began by sewing sports patches for himself and other inmates.

As he developed his skills, he began to sew pictures drawn from his life experiences. Some were raw images of his days of reckless abandon, other pictures were inspired by his former involvement with theater, by his sports heroes, and some of his dreams, demons, and aspirations.

All of this was done with the fine nylon or orlon spun from a bag of socks that he would turn into his palette wound around pens and pencils. The pictures remained small enough to hold in one hand and increasingly more intricate with up to 1200 stitches per square inch. The picture served as a healing mirror to Raymond's troubled life. His prison time saved his life from a destructive drug addiction and led to the discovery of his artistic abilities. He has continued creating art since his release from prison a few years ago.

Metamorphosis, 1997
2" x 2 1/2"
Threads of unraveled socks
Courtesy American Primitive Gallery, New York City

Yesterday at Grandma's, 1998
2 1/2" x 2"
Threads from unraveled socks
Courtesy American Primitive Gallery, New York City

Jackson Artist, 2000
4 1/2" x 3"
threads from unraveled socks
Courtesy American Primitive Gallery, New York City

Marianne McCann

ttle Cap Cloth, 1988
" x 50"
ttle caps and paper clips

Backyard Waterpump Rocketship, 1989
82" x 82"
Bed sheet, onion bags, kwik-loks, bias tape scraps

"I've been called a 'Martha Stewart-gone-environmentalist' because of my passion for recycling along with my pursuit of a simple, self-reliant lifestyle.

"Sewing [McCann is considered a fiber artist, however] is really low-tech, all you need is a needle and thread. There's such power to that. Anyone can do it. That universality is something I'm interested in. I like the fact that people can look at a quilt and think, I can do that. Not: Well, if I had this gigantic welding unit and a big loft in SoHo...'

"I work in my home-based studio with a half-dozen sewing machines (some dating back to the turn of the century) that compete for space with stacks of books about food toxins and other modern-day hazards." Most of McCann's quilts address these same environmental/health concerns in one way or another.

Sometimes she gets her point across metaphorically—but with a refreshing dose of humor. One such piece refers to the glamorization/commercialization of junk food by sandwiching brightly colored, snappily designed candy wrappers between layers of polyester chiffon.

Other times her message is more direct, as in the pieces constructed from stuff usually reserved for landfills: produce-bag mesh, plastic bag "kwik loks," discarded panty hose, and even worn out pot-scrubbing dishrags.

"I'm interested in changing the culture of suburbia. So how can I do that? Can I do that just by making pieces of artwork that people hang over their couches? No, that's not it. I want to see how far I can take the idea of an individual making a difference in the suburban context of changing the culture and trying to use their property in a really responsible way—to think about the connection with nature and the life cycle."

Marianne McCann lives in Bloomfield Hills, Michigan.

Household Leachate, 1989
134" x 104.5"
Socks, cotton, fabrics

Look Mom, 1994
Book, front cover and open book
19.5" x 13.5" x 3.5"
Felt, cotton feed sack, string, pota[...]
chip bags, safety belts, fabrics

Sunni Mercer

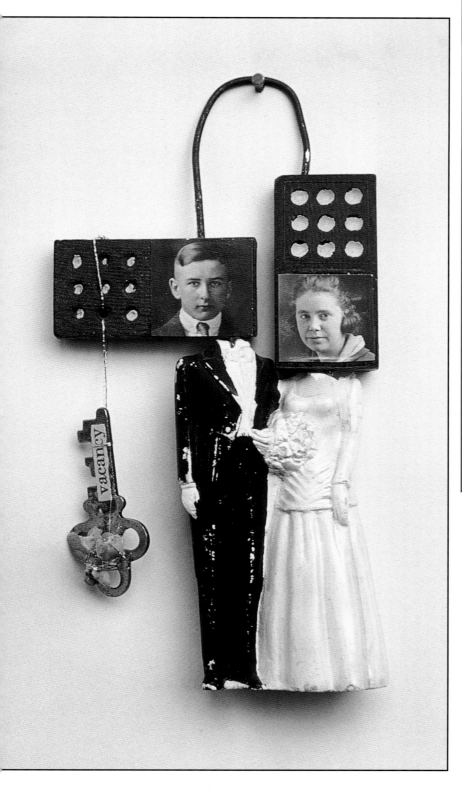

"Each object is unique and is constructed from found materials. The metals that are used are refuse found along country roads, aside railroad tracks, or, in many cases, on the grounds of abandoned farms. Some of the metals used in fabrication are useless pieces of farm equipment. I believe these metals give the objects a unique sense of place. In addition to the metals, each object may also include found bones, old photographs, old text, antique game pieces, and other aged materials. I refer to the latter materials as 'borrowed bits of history.'

"The objects suggest the similarities between the way we refer to people corporately and the uniqueness that becomes apparent when we become involved with the individual. When seen as a body of work, the pieces appear similar to one another, the way people in a crowd do. Yet because of their size and curious details, these works demand to be viewed from close range.

"The result is that the viewer is ultimately drawn into the intimate world of the object. It is at this range that the objects begin to reveal their secrets, tell their story, show their 'metal.'"

Sunni Mercer lives in Oklahoma City, Oklahoma.

Vacancy, 1993
3 1/2" x 5"
Found objects, photo, bone

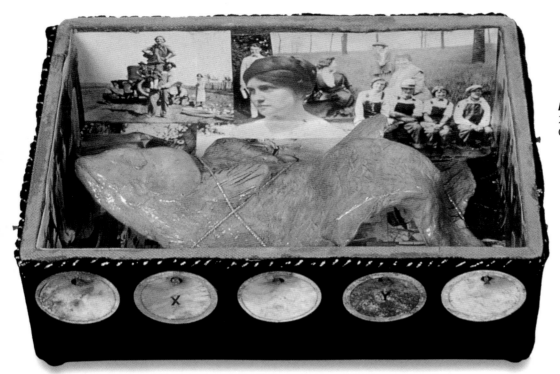

Doctrine of Memory, 1996
2" x 8" x 5"
Ceramic, found objects

Cords of Freedom, 1996
15" x 9" x 9"
Ceramic, bones

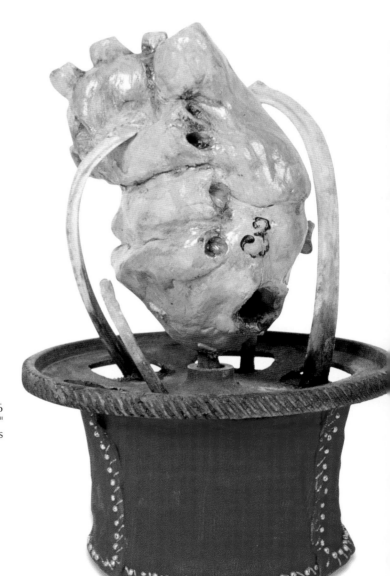

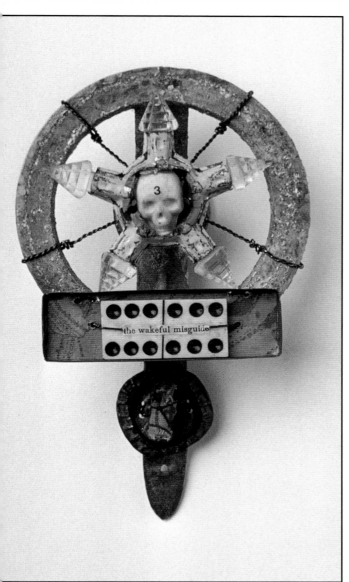

The Wakeful Misguide, 1994
6" x 3 1/2" x 1"
Mixed media assemblage

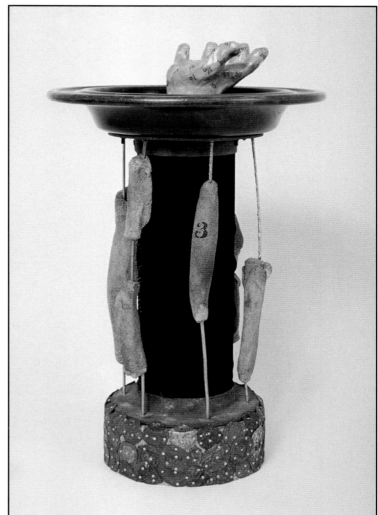

Offeratory, 1995
24" x 18" x 18"
Bone, ceramic, metal

"I have worked with found objects for years and initially began exploring the use of newspaper because I liked the bright colors of the Sunday comics. I then was introduced to the *Wall Street Journal* by my mother who discarded it after reading it each day. I began juxtaposing the rich texture of the stock listings with the bright colors of the Sunday comics and loved the combination.

"After two years of exploring newspaper as a medium, it slowly evolved into functional art—jewelry. I have been creating newspaper jewelry since 1993. I've become picky about which newspapers I use—*The New York Times* is more prone to smudging. Half the ink rubs off on your fingers. I also work with foreign newspapers. Japanese issues have proven popular, as well as Arabic. The lettering and melon color of the Arabic papers usually combine well with color comics."

Holly Anne Mitchell lives in St. Petersburg, Florida.

Clinton Impeachment Purse
Newspapers

Japanese Newspaper Purse
Newspapers

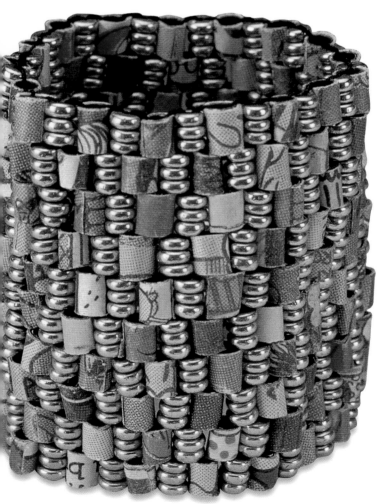

Bracelet
Newspapers

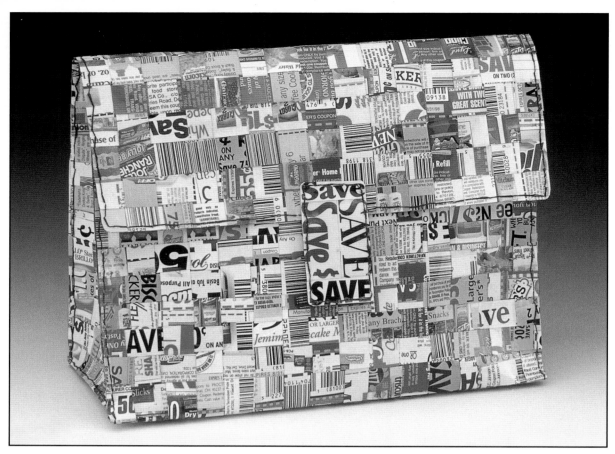

Expired Coupon Purse
Grocery store coupons

Brooch
Newspapers, gold and silver findin

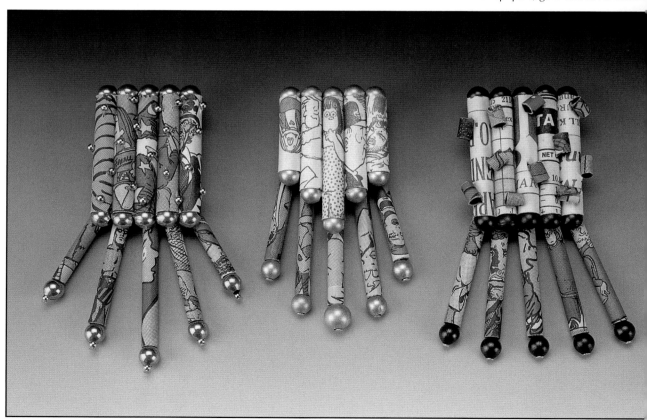

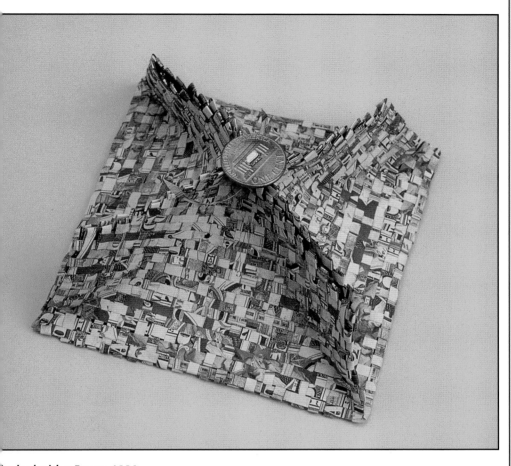

Pinched with a Penny, 1986
4" x 4 1/2" x 4 1/2"
Shredded currency
Courtesy the Sybaris Gallery, Royal Oak, Michigan

"The moment I saw my first bag of shredded money in a novelty store, a little voice in the back of my head said to me: 'Unable to spin straw into gold, she wove money instead.' The more baskets I weave, the more closely I find myself looking at my materials.

"From the patterns that each different set of strips builds up, like the layering of slices of curling leaf from the edge of a twenty-dollar bill, to the peeking out of an eye or a few tiny letters in a random weave—all have something different to show me.

"Some baskets show their material more openly than others, the bills pieced back together like a puzzle, only to be sliced again by the line of the twill weave; others require a closer look. Each basket is started by lining up a pattern of warp strips. As it is woven, each added weft weaves in its own interactions to the pattern. It is watching those interactions create new patterns that keeps weaving money fresh for me."

"I weave my baskets out of shredded money, making the material a part of my statement. I want the viewers to rethink their ideas about money—to too many it seems money is an end goal in life, not just a medium of exchange."

Zoe Morrow lives in Pennsauken, New Jersey.

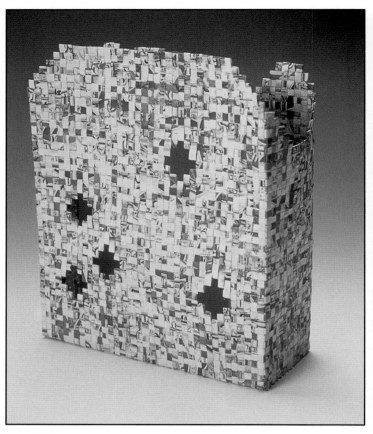

Buck-Shot, 1992
6 3/4" x 5 1/2" x 2"
Shredded currency
Courtesy the Sybaris Gallery, Royal Oak, Michigan

Capital Turnover, 1989
6" x 12" x 12"
Shredded currency
Courtesy the Sybaris Gallery, Royal Oak, Michigan

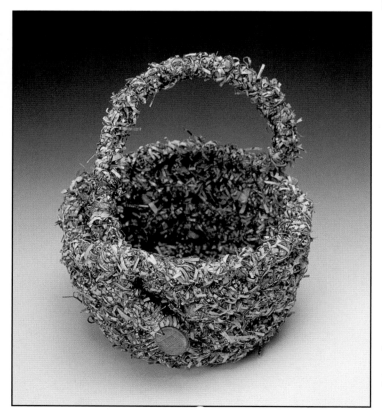

Handled Cash, 1993
7" x 6" x 6"
Shredded currency
Courtesy the Sybaris Gallery, Royal Oak, Michigan

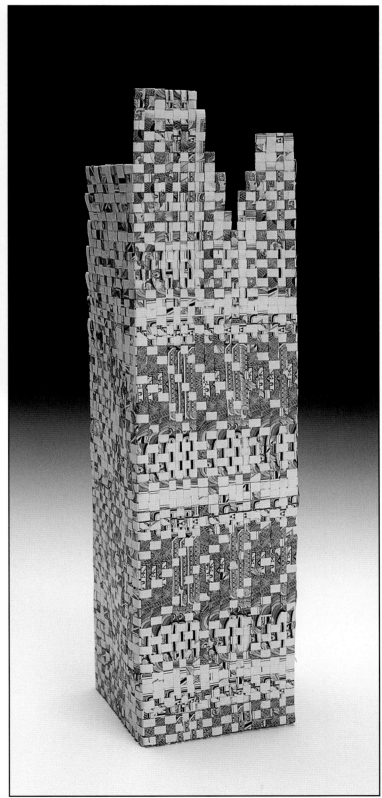

Money Monument, 1990
9" x 2 1/4" x 2 1/4"
Shredded currency
Courtesy the Sybaris Gallery, Royal Oak, Michigan

"I create new art forms out of found objects such as furniture parts, hardware and other aged metallic pieces. These I cut, sand, weld, rivet and bolt using the technique of assemblage to make figurative sculpture. Worn by time and use, the somber, earthy surfaces of the found objects remain intact and are symbolic of a former life. I am inspired by the personal experience of being a 'found' birthmother reunited with her child to guide my work."

For years Mary Deacon Opasik has been devoting her art's blood to a genre based on chance findings. Her van takes on a life of its own as she follows a subconscious map into neighborhoods where hidden treasures lie in rubbish piles beside abandoned houses. "Mixed media allow me to physically transform materials—door parts, rusted metal, furniture parts—and incorporate objects into ideas expressive of the things that fascinate me."

Mary Deacon Opasik lives in Caltonsville, Maryland.

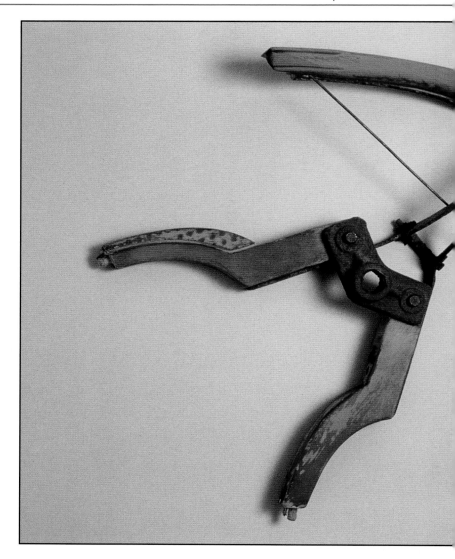

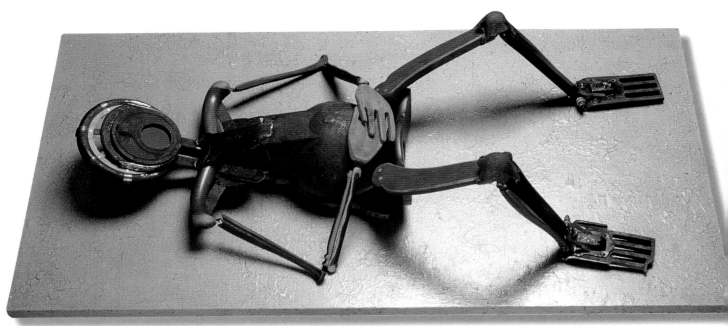

Avenger, 1992
30" x 29" x 4"
Furniture parts, aged metal

Born Anew, 1994
18" x 11" x 7"
Aged metals, wood, tortoise shell

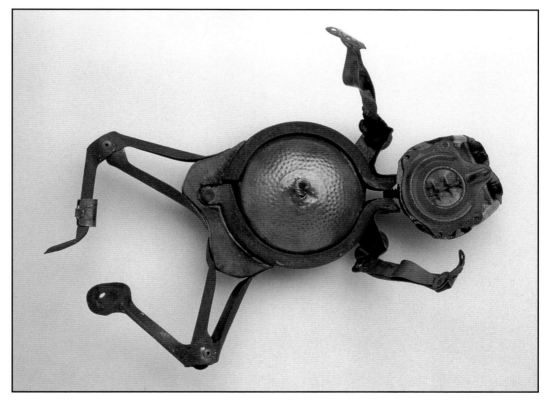

opposite page:
bor of Love, 1997
" x 57" x 30"
rniture parts, aged metals, painted door parts

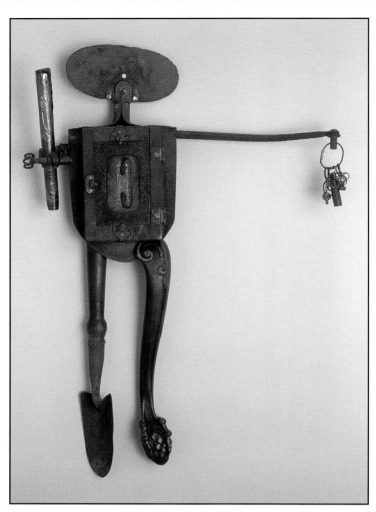

Searcher, 1994
32" x 23" x 5"
Shovels, aged metals, furniture parts

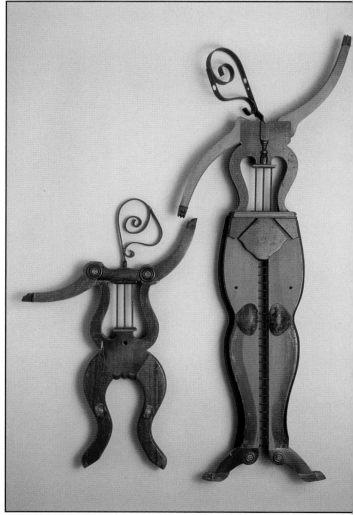

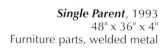

Single Parent, 1993
48" x 36" x 4"
Furniture parts, welded metal

Jim Opasik

"Recycled kitchen utensils are the domestic objects I use to create my sculpture. The utensils used in every household for preparing meals are transformed so the viewer can see and experience them in a different way. I collect old kitchen objects from flea markets, thrift stores, and donations from friends and relatives.

"My compassion and enjoyment of animals is reflected in the content of the work and I am rewarded with smiles and laughter from viewers."

Jim Opasik lives in Caltonsville, Maryland.

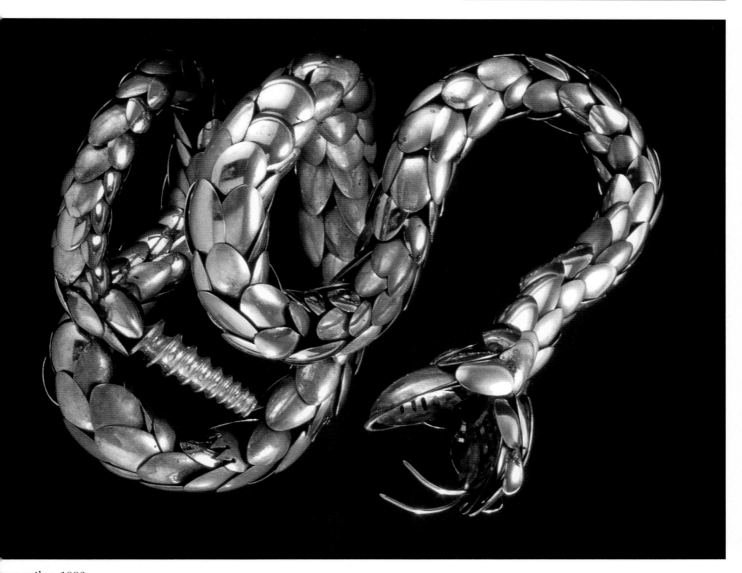

Serpentine, 1993
10" x 16" x 20"
kitchen utensils, spoons, fork

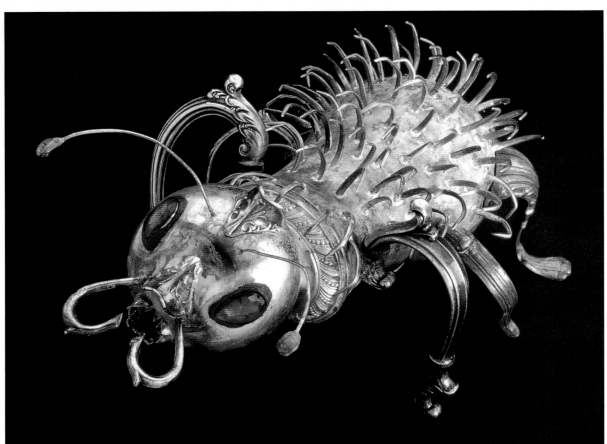

Itcher, 1997
8" x 15" x 9"
Kitchen utensils, silver
tea pot

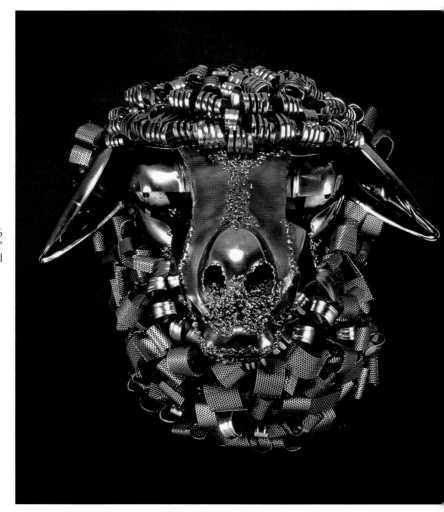

Sheepish, 1996
17" x 16" x 12"
Kitchen utensils, stainless steel

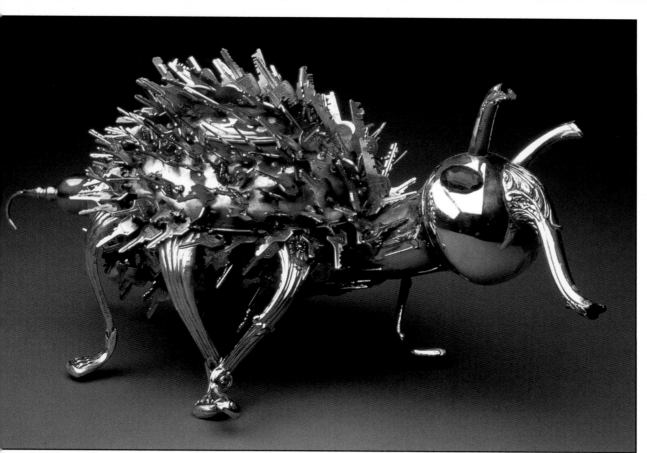

truder, 1999
x 22" x 12"
chen utensils, keys

Woking Slow, 1999
15" x 45" x 24"
Chinese woks, stainless steel spoons and knives, copper

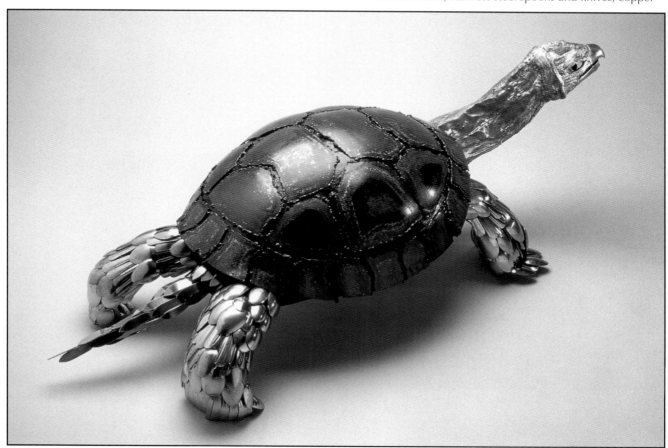

"My initial interest and exploration focus on the transitions and cycles that occur in nature. Examining, capturing and addressing both botanical and biological processes assist me in establishing a symbolic language. The characters of this language mimic forms in nature, female and male anatomy, and industrial mechanisms. Altering, dismantling, and recombining these forms allows me to discover a unity between elements that are initially disparate. I intend to create objects that provoke and challenge the viewers' intuitive response. I am interested in the duality that exists in the process of entropy, capturing both the beauty and ugliness of objects as they proceed through decay and regeneration. Furthermore, I support the object both conceptually and physically by creating a vessel in which I can exist while not being worn. My approach to making art is empirical. I incorporate alternative techniques and materials to illustrate my underlying concept. I am interested in the inherent meaning of these materials and how I can manipulate them to convey my message. At the same time, traditional processes of fabrication and electroforming permit me to cultivate forms. Finally, enameling, patination and erasure allow me to achieve surfaces and color that reference memory and a sense of passage. It is the continual investigation of new processes and mediums that stimulates, inspires and challenges my creative process.

"Many and most of my objects are assembled from materials that I collect from various places, whether it be a second hand store, the sidewalk or in nature. In many cases, the objects find their way to me from friends, acquaintances and even strangers who see my work and relate to the objects. There is nothing more exciting than receiving an unexpected package or having a viewer approach me with a little something that is special to them. As a visual artist I am constantly 'scanning' my immediate environment for little bits and pieces of inspiration. I include found metals, toys and natural objects in most everything I make. I combine them with one another to alter their original purpose or meaning, in turn creating a new and curious object for the viewer to absorb and process. Many of my objects are wearable and/or challenge traditional notions of wearability. I have chosen to make my objects permanent through the electroforming process, which many may know as a plating process or better yet, the process of 'bronzing baby booties.'"

Maria Phillips lives in Seattle, Washington.

Necessary?
6" x 4" x 30"
Steel, wasp's nest,
pods, string

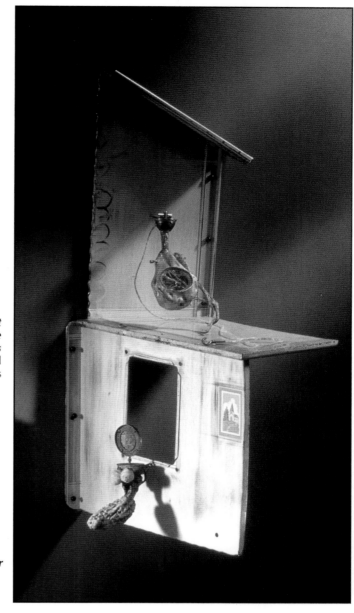

**Attic: Environment
with Removable
Wearable Objects**
Reconfigured tin doll
houses

Fern Ridge: Backdoor
Brooch
5" x 8" x 1 1/2"
Steel doll house

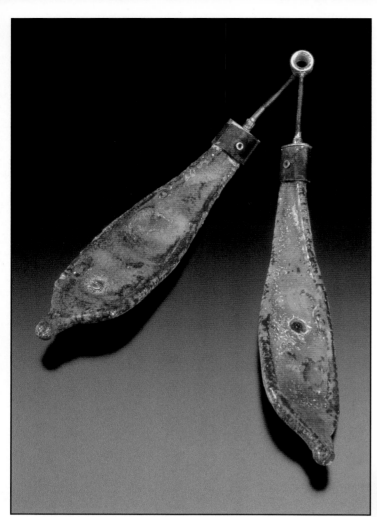

Wing Brooch
Pods: enameled and electroformed

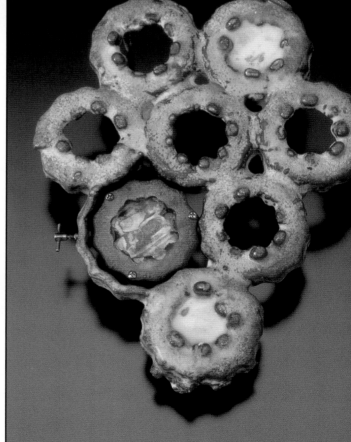

Coterie
Wall piece with removable brooch
Electroformed copper enamel

"My work had always been inspired by the things I find on street. From a broken umbrella to a wet suit washed up on shore I see possibilities beyond the trash heap. The objects have a history, a life all their own. Currently I am painting portraits from images found in the streets, thrift store and city dumps of Baltimore."

Spoon Popkin lives in Baltimore, Maryland.

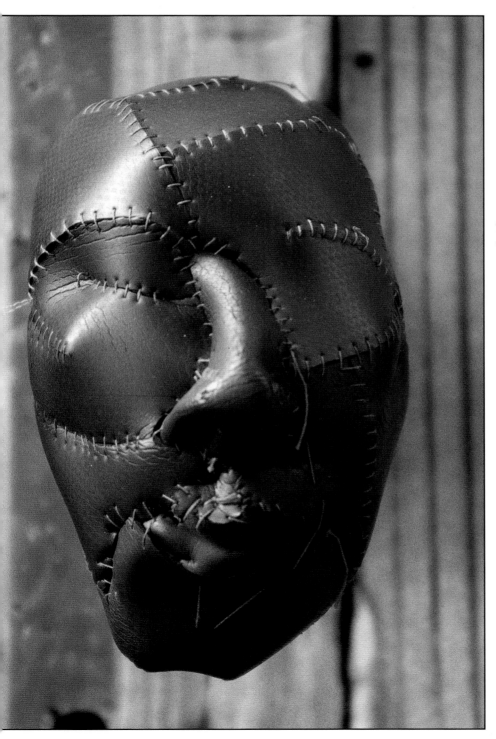

Death Mask, 1996
12" x 4" x 5"
Wet suit, thread

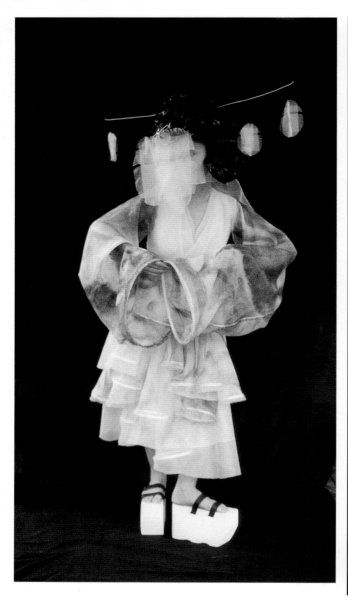

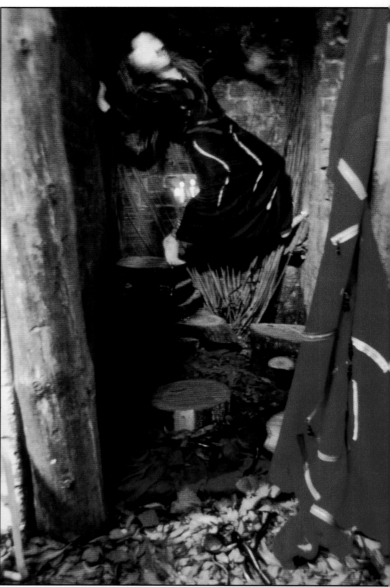

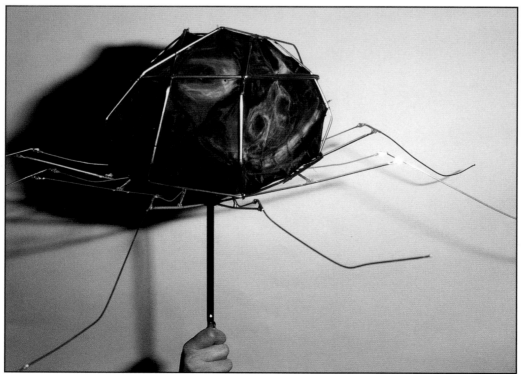

Top left: ***Yojo***, 1998
6' x 4' x 3'
Curtains, trash bag

Top right: ***Zipperwork***, 1990-91
9' x 5 1/2' x 12'
velvet, tree sections, zippers

Bottom: ***Spider Puppet***, 1989
42" x 42" x 27"
Umbrella

Bird Ross

"Problem solving, transforming, treasure hunting, manipulating, imagining, enlivening, reviving, reconstructing, deconstructing, dissecting, developing, rearranging, recuperating, regenerating, remembering, dismembering, deciding, decoding, re-coding, coating, coaxing, wondering, recharging, rigging, thinking, rethinking, assuming, reassuming, reneging, figuring, reconfiguring, wishing, connecting, digesting, assimilating, resembling, re-assembling, rewarding, but not necessarily in that order.

"I have sewn for over the past 30 years, so cloth and thread have been my primary medium. One day I looked around in my current studio and realized I didn't need to go out and buy any more supplies ever because somehow I had collected and was surrounded by a diverse and fine array of raw material. I am a true believer in and an avid fan of garage sales, second-hand stores, flea markets and the like. More than anything I value the hunt and take great pride in my booty.

"I also admire Alexander Calder's work, notably his *Circus* and Stephen Whittlesley's furniture and those who have always managed to create a lot of something out of what seems to be most like nothing."

Bird Ross lives in Madison, Wisconsin.

Little Blue Mitten, 2000
4" x 3" x 3"
Mitten, beads, threads, and metal pin box

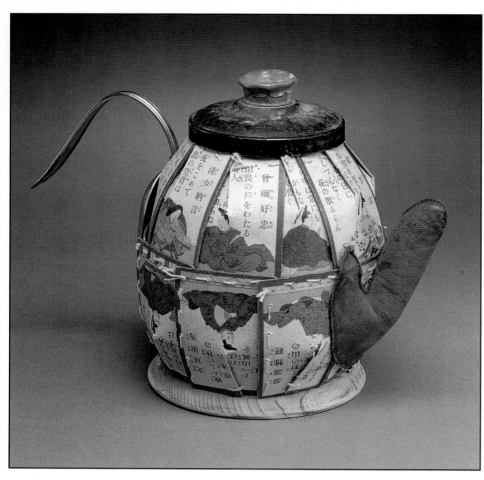

Dozo, 2000
7" x 10" x 5"
Japanese playing cards, wooden dish, paint can
lid, button, glove part, thread
Collection of Dorothy and Sonny Kamm

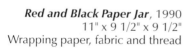

Red and Black Paper Jar, 1990
11" x 9 1/2" x 9 1/2"
Wrapping paper, fabric and thread

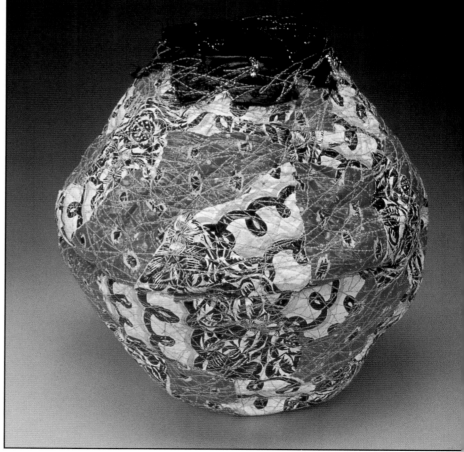

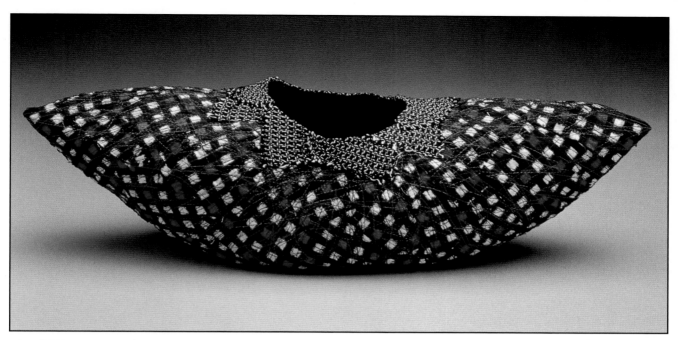

Coming and Going, 1993
8" x 8" x 15"
Antique silk kimono, rayon fabric
and thread

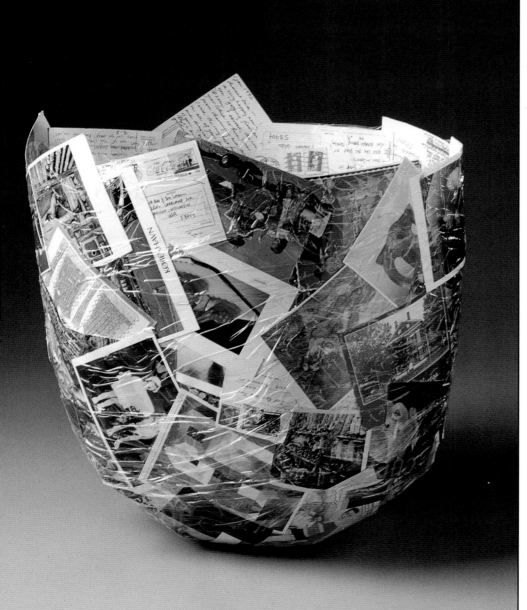

Shipping and Receiving, 1995
20" x 17" x 13"
Postcards, staples and packing tape

"I just happen to like plastic, partly because other people don't like it. It has no history. It is bad taste. It is a cheap substitute. I also love the ease of newspaper. I like the idea that at the same time that I was working with the finest silk that I could get, I like that contradictory sort of thing."

For more than forty years Ed Rossbach has been the most influential force in the United States in the development of fiber arts as an art form. Through his art, his teaching, and his writing, he is responsible for much of the interest in nontraditional baskets, the use of weaving techniques that do not involve a loom, and the use of found materials such as plastic and newspaper to create works of art.

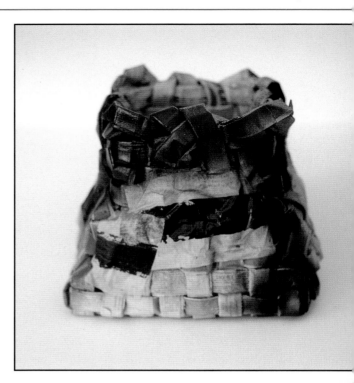

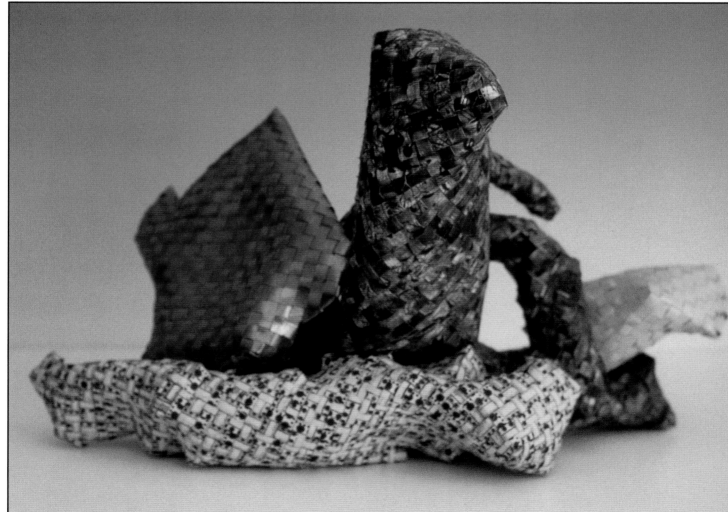

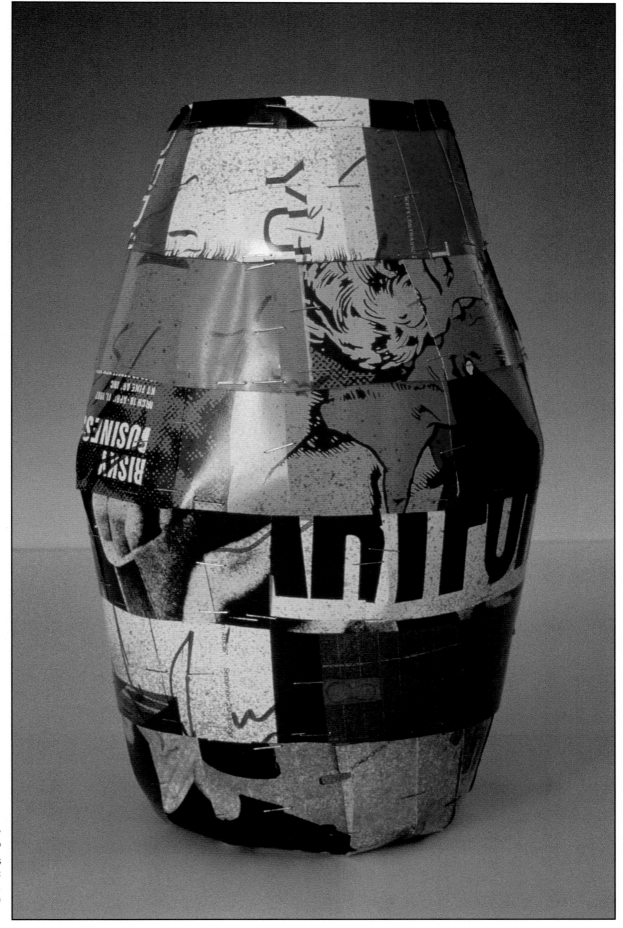

Art Forum, 1987
13" x 7" x 7"
Magazine covers
Courtesy the Sybaris
Gallery, Royal Oak,
Michigan

"The incorporation of re-used street signs in our artwork began in 1992, by sparked dual inspiration with Boris Bally. Since, we have continued the series individually: Boris working with large scale sign vessels and I work by transforming the signs into small wearable or functional pieces. The signs mimic the look of traditional enameling, causing the viewer to question the material."

ROY lives in Pittsburgh, Pennsylvania.

Greek Rhythm, 199
Tambourine and bracel
5" diameter x 1 3/8" diamet
Oxidized silver, re-used Greek Island bottle ca
Courtesy the Sybaris Gallery, Royal Oak, Michiga
Photo by David L. Smi

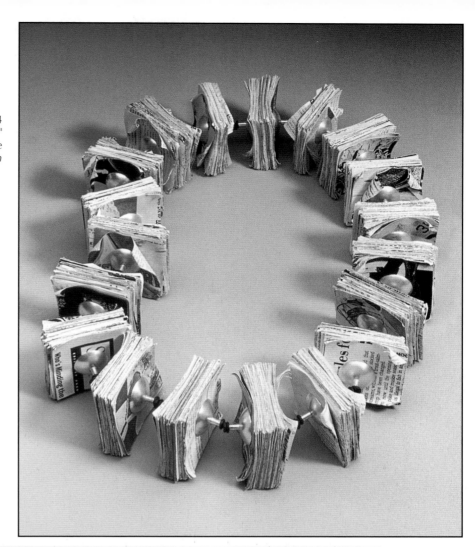

Sports Page Necklace, 1994
2" x 1" x 11"
Sterling silver, copied sports page
Courtesy the Sybaris Gallery, Royal Oak, Michigan

Dragon Stout, 1992
sculptural tambourine
' x 7 1/2" x 1 1/2"
oxidized brass, Jamaican bottle caps, homeless sign
Courtesy the Sybaris Gallery, Royal Oak, Michigan

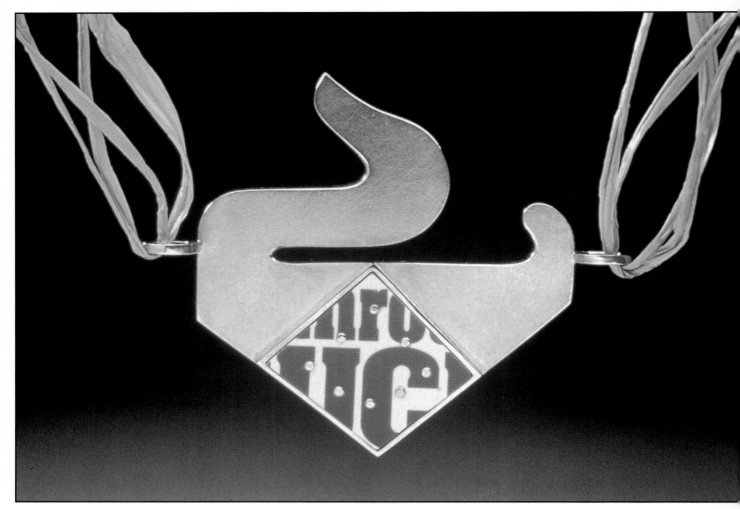

Paradise Neckpiece
3" x 3 1/2" x 3/8"
Re-used bathroom duck bottle, fabricated silver, raffia
Courtesy the Sybaris Gallery, Royal Oak, Michigan

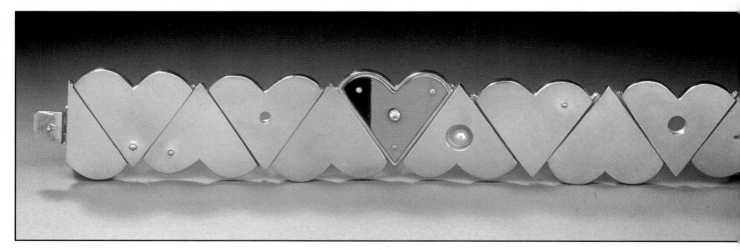

Love Bracelet, 199
1 1/4" x 8" x 1 1/4
Sterling silver, pearl, diamonds, street sig
Courtesy the Sybaris Gallery, Royal Oak, Michiga

"I love things that have been flattened. As long as it's been run over a couple of times, metal gets sort of an imprint from the contours of the ground. Everything can be reused and turned into something you treasure. Things aren't meant to be thrown away and forgotten; they are transformable."

Remi Rubel has transformed discarded bottle caps, flattened cans, keys, faucet handles, watch gears, radiator hose clamps, and scores of other assorted objects into innovative pieces of jewelry and sculpture.

Remi Rubel was an Artist-in-Residence at San Francisco's Sanitary Fill, where she was given the opportunity to comb through San Francisco's refuse before it was taken off to the landfill. She lives in Albany, California.

ut #1, 1998
6" x 8' x 8'
llboard paper and wire

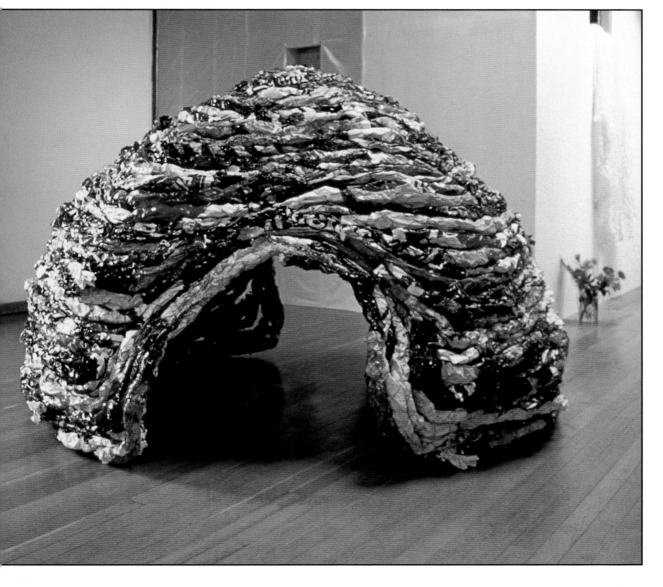

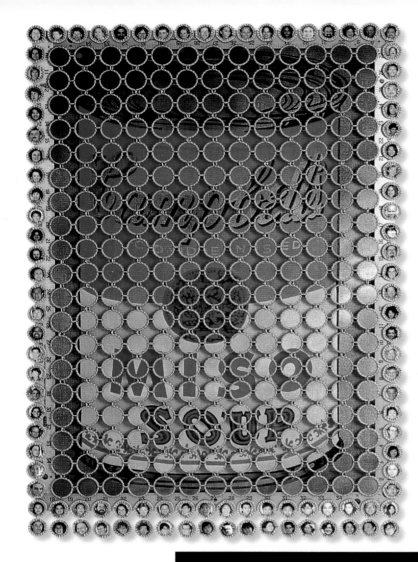

Miso Soup
29" x 20"
Bottle caps, photos, aluminum ruler

Scottie, 1993
13" x 18"
Road kill materials

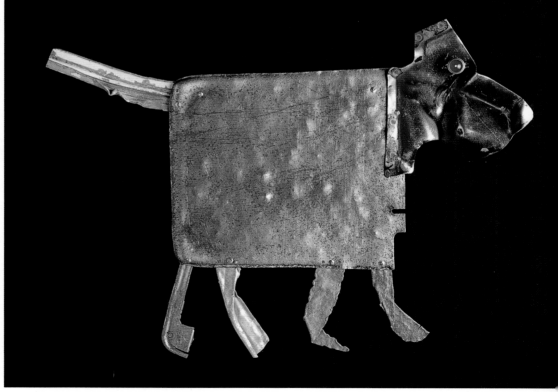

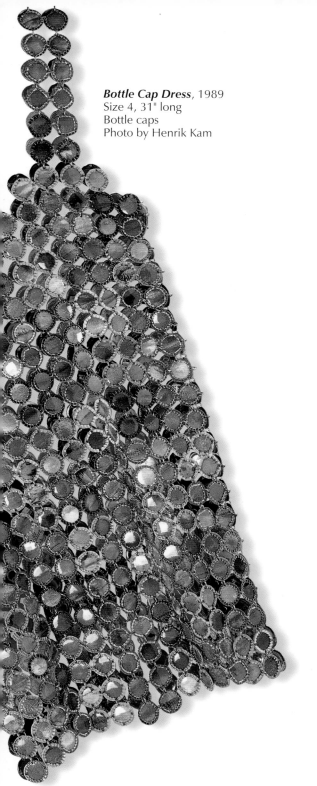

Bottle Cap Dress, 1989
Size 4, 31" long
Bottle caps
Photo by Henrik Kam

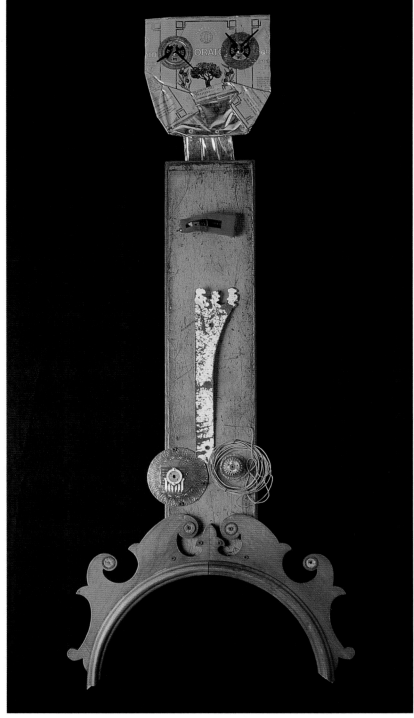

Gwenevere, 1992
Wooden box, bracket, stapler, door bells, road-kill
can, mirror frame, working clocks

"Furniture appeals to me because it is approachable. I am especially drawn to certain old pieces that have been used for years and that reflect the lives and personalities of their users as well as their makers. When I create a new piece, it is often influenced by something similar that I have lived with or have imagined living with. I use color, playful arrangements, historical references and anything else I can think of to make furniture that I hope is irresistibly inviting and reasonably functional."

For Ryerson, function works as a container for form—transforming tennis rackets into mirrors and milk crates into end tables—clocks from brass doorknobs, old timecard slots, and gears from an old machine.

Mitch Ryerson lives in Cambridge, Massachusetts.

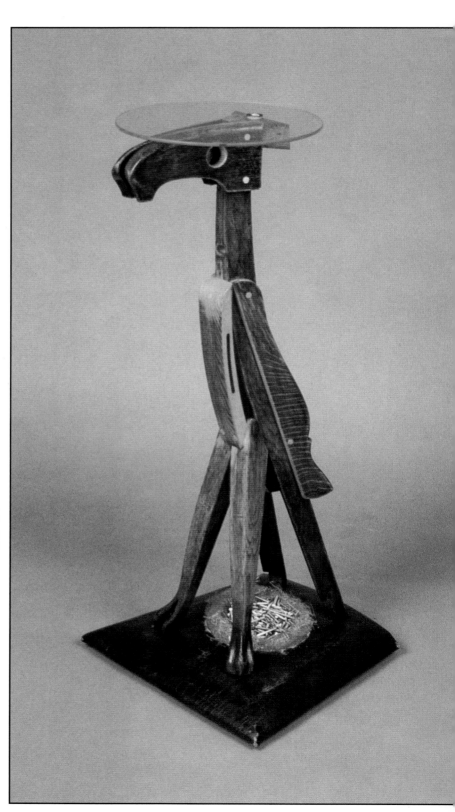

Chairadactyl Table, 1995
38 1/4" x 17 1/2" x16"
Recycled chair, glass
Courtesy the Sybaris Gallery, Royal Oak, Michigan

Milk Crate Table, 1995
29 1/2" x 14" x 14"
Milk crate, curly maple
Courtesy the Sybaris Gallery, Royal Oak,
Michigan

Dresser, 1984
Polychromed maple with produce shipping crate labels
Courtesy the Sybaris Gallery, Royal Oak, Michigan

Baroque Racket, 1997
35" x 10" x 5"
Tennis racket, found objects, ebony, pearwood, ivory
Courtesy the Sybaris Gallery, Royal Oak, Michigan

Washboard High Chair, 1986
Curly maple, cherry, washboard, soap box labels, clothespins
Courtesy the Sybaris Gallery, Royal Oak, Michigan

"American culture is just about at the top of the heap when it comes to consumption of energy, raw materials, and consumer goods. We have a wealth of material at our disposal, but as a culture, we are oblivious to this.

"As consumer products change at an increasingly faster rate, it is hard to place these objects into some kind of context. By deconstructing these products and then reconstructing them, I hope to enable the viewer to take note of the material that the product was made of.

"During reconstruction of the new object, patterns change and re-emerge as new variations. Recognizable images are lost but reappear as totally new. The material that has had a previous life is given a new life after having been discarded and yet reconstruction of the new carries with it the past."

Brian Sauve lives in Chicago, Illinois.

Copper Top
24" x 36"
Mixed media
Courtesy Ann Nathan Gallery, Chicago, Illinois

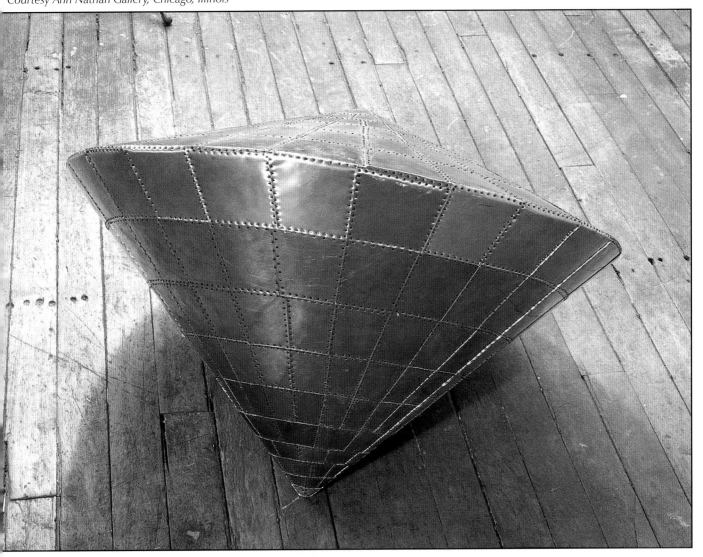

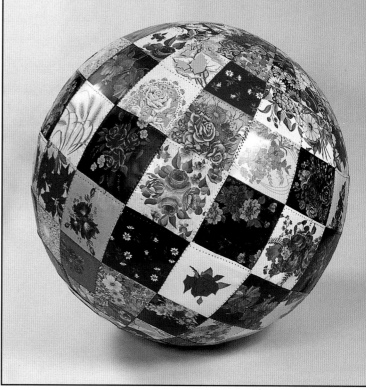

Sphere, 1989
4' diameter
TV trays from the 1950s
Collection the Rayovac Corp.
Courtesy Ann Nathan Gallery, Chicago, Illinois

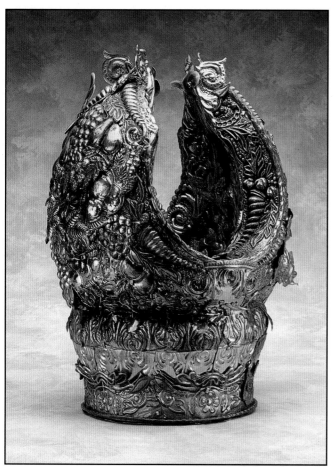

Crown
17" x 11"
Antique English serving trays and wood
Courtesy Ann Nathan Gallery, Chicago, Illinois

Barbell
4" x 16" x 4"
Brass trays
Courtesy Ann Nathan Gallery,
Chicago, Illinois

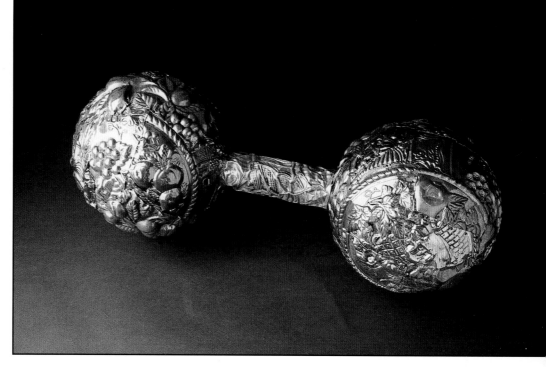

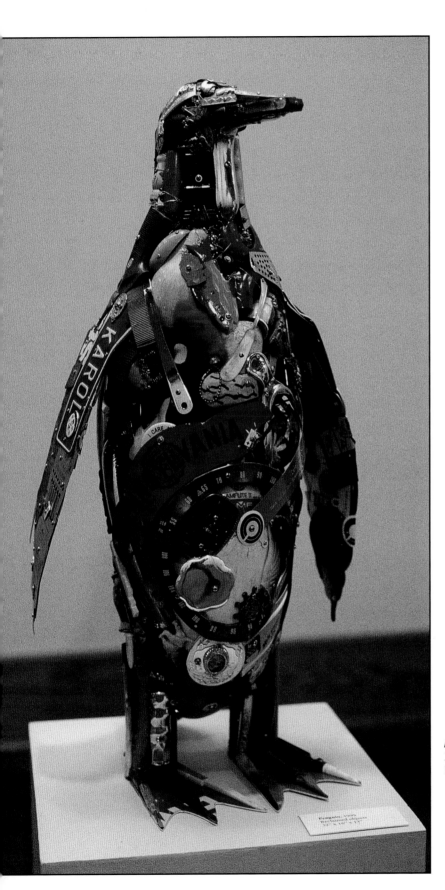

"My work is made up entirely of what Philadelphia throws away, assembled into shapes and forms that intrigue and give me pleasure.

"I grew up near a dump and began collecting objects very early. My father had a large shop and taught me to use tools to shape and assemble those industrial discards that I treasured. I had little awareness of what art was or its relevance to my work until I met art history. For years I read all I could on the subject, ultimately receiving an MA in the field from the University of Delaware. I never had a studio course but still my naiveté had been removed and I related my work to that of such 20th century masters as Rauschenberg, Duchamp and Cornell.

"I soon realized that this academic inquiry was a pursuit not to be allowed to interfere with whatever individual statement I had to make. I traded my *Art in America* for *Scientific American* and my MOMA membership for one in the Dumpster Divers.

"For the last 20 years I have been a high culture hermit, steeping myself deeply into my trash and TV. I scavenge trash nearly every day and use it for fuel, clothes, furnishings, amusement and assemblages that are my life work."

Leo Sewell lives in Philadelphia, Pennsylvania.

Penguin, 1997
32" x 16" x 13"
Found objects

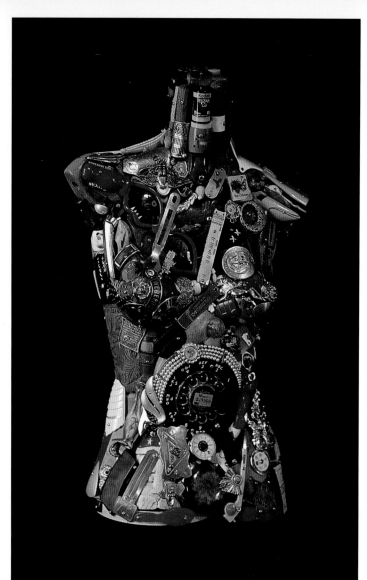

Torso, 2000
24" x 13" x 9"
Found objects

Red Lobster, 1999
36" x 16" x 4"
Found objects

Jesus Christ on the Cross, 1996
118" x 66" x 14"
Found objects

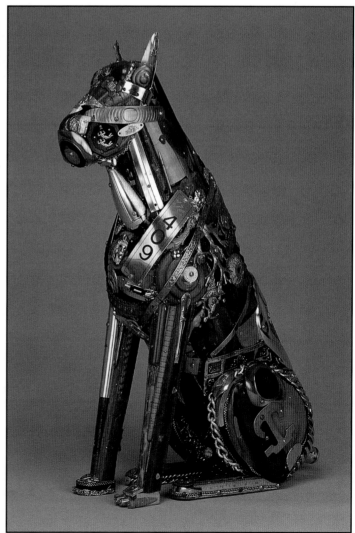

Gold Boxer, 1998
31" x 11" x 22"
Found objects

"With a simple knot, repeated over and over, I am able to create a multitude of shapes and textures. I feel my most successful pieces are those that don't refer to anything specific; questions suggested by the forms and textures are more intriguing than answers. As each knot is tied, it is as though a pulse is added to the form, as though I am breathing life into the weave. They seem to grow as I work on them, forming baskets or containers of potential life in symbolic form. I am pursuing modern Romanticism influenced by the dreams of plants and animals and giving them form with fiber. They are completed with the plugged and knotted and incorporating of found objects."

Norman Sherfield lives in Michigan.

Caterpillar Rattle, 1992
2 3/4" x 8" x 2 1/2"
Knotted wax linen and found objects
Courtesy the Sybaris Gallery, Royal Oak, Michigan

Hammer, 1996
5" x 10" x 6"
Knotted wax linen, stone, found objects
Courtesy the Sybaris Gallery, Royal Oak, Michigan

Fakir, 1995
4" x 6" x 2 1/2"
Waxed linen, stone, nails, bone
Courtesy the Sybaris Gallery, Royal Oak, Michigan

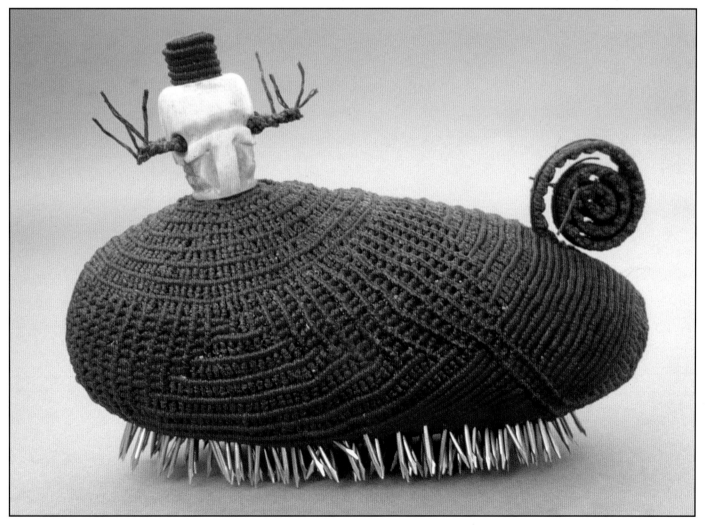

"For years I have rummaged through junk stores and scoured flea markets, salvaging cloth, sewing notions and related elements from domestic life. These collectibles trigger the inspiration for my work and serve as building materials for my forms. Transforming familiar objects is an important aspect of my work, as is the study of inside/outside and how each reveals, conceals or complements the other.

"The Faux Pots series, inspired by turn-of-the-century plastic dresser sets, uses old cloth tape measures to create vessel forms. Since the tape measure is double-sided, the exposed edge determines the interior and exterior patterning. The edge, with its physical and metaphorical implications, is of deep interest to me. Some Faux Pots have removable multi-button lids. All the buttons are plastic (celluloid and bakelite) and most were manufactured between 1920 and 1950. To maintain their integrity, I stitch together rather than glue the buttons. (I also collect buttons. My drawers and containers are filled with a twenty-five year accumulation of finds.)"

Karyl Sisson lives in Los Angeles, California.

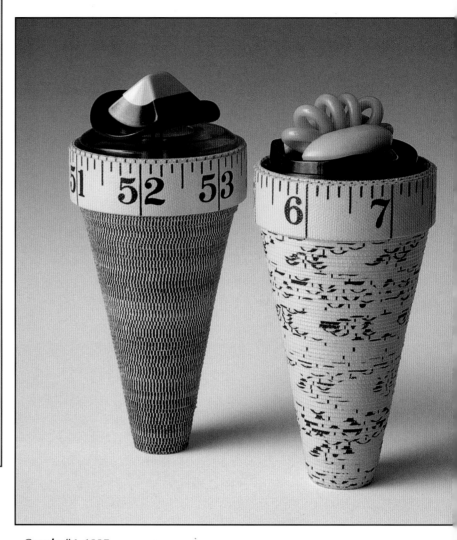

Couple #1, 1997
4 3/4" x 2 1/4" diameter
Old cloth tape measures, polymer, vintage plastic buttons, thread

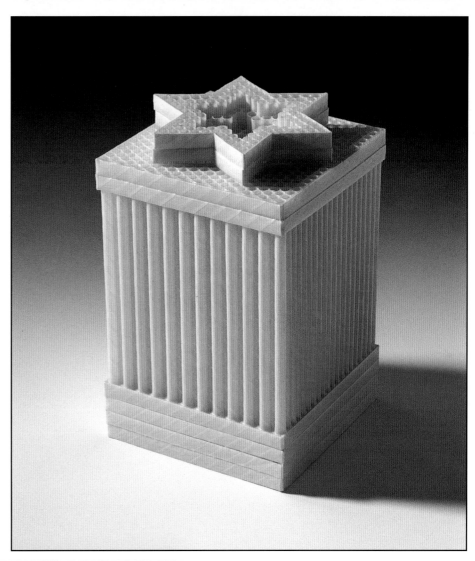

Tzedakah Box (Jewish RitualObject), 1999
5 3/4" x 3 1/2" x 3 1/2"
Old paper drinking straws and polymer

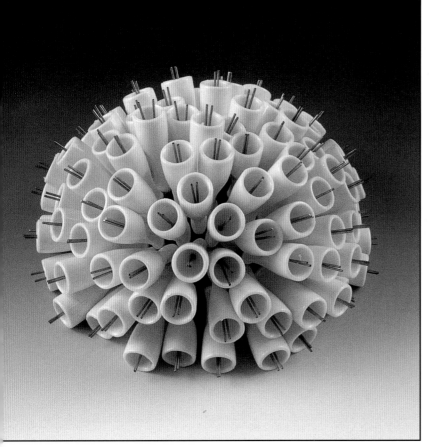

Holy Smoke, 1999
2" x 4 1/2" diameter
Old plastic cigarette holders, old hair pins, ball chain
Photo by Susan Einstein

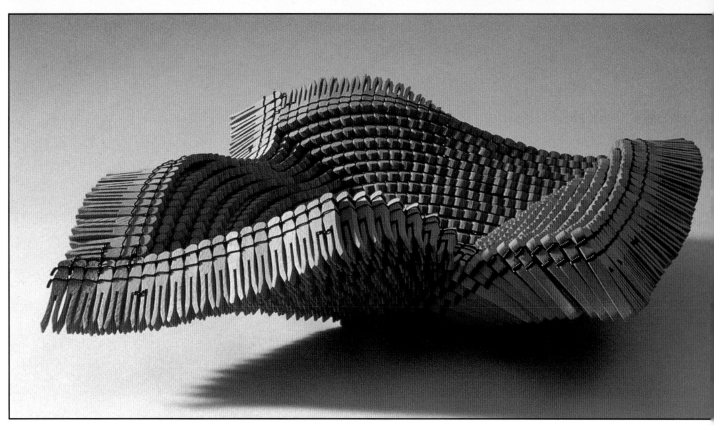

The Wave, 1991
6" x 18" x 18"
Miniature wood clothespins, wire
Courtesy the Sybaris Gallery, Royal Oak, Michigan

Slumped, 199
6" x 12" x 1
Old upholstery fabric and mini wood spring clothespir
Courtesy the Sybaris Gallery, Royal Oak, Michiga

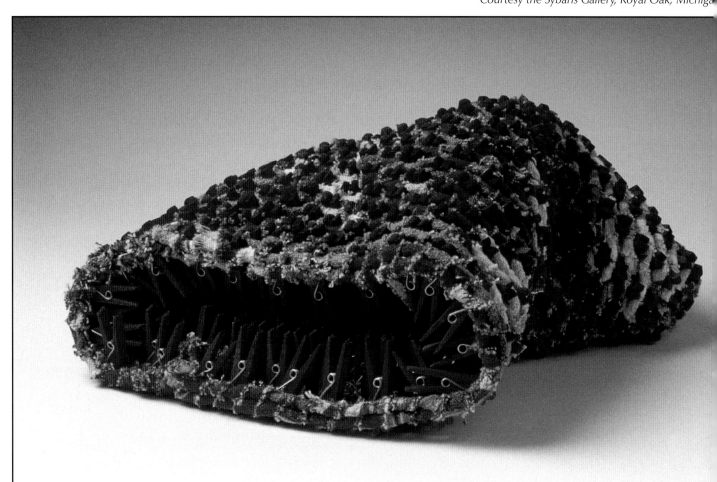

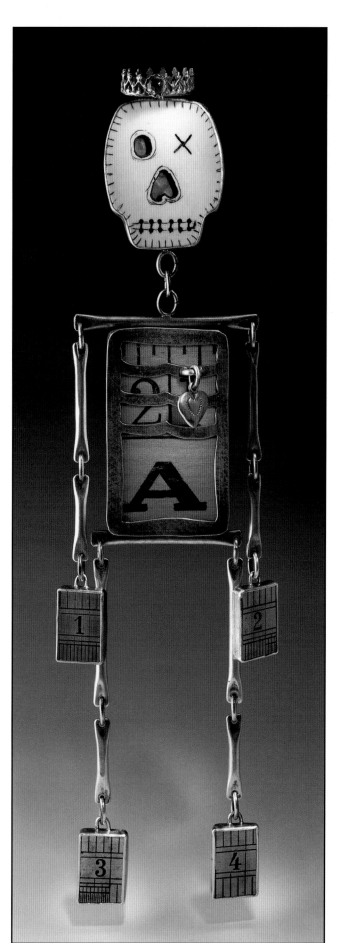

**Skelly Man Pin/
Sculpture**
6 1/2" x 1 1/2"
Hand fabricated
ing silver, wood
nd metal rulers,
ecycled antique
ivory, amethyst

"Though I did not begin making jewelry until I was in my late twenties, I have been interested in ethnic adornment for most of my life. As a child, I traveled often with my family to the American Southwest in the 1950's where I was fortunate to observe the customs and rituals of many native peoples.

I was also fascinated by the Northwest Coast Indians' use of buttons as emblems of social standing. What was originally an early trade item became a status symbol for the Indians, who would sew buttons on blankets in order to display them as a show of wealth. This use of an object out of its original context has been an ongoing theme in my work.

"As a self-taught jeweler I have combined my long time interest in buttons and found objects, such as safety pins, charms, beads and stones, to create work that is influenced by my studies in anthropology and global folk art.

"As an avid flea market and yard sale collector, I have amassed a great deal of found object materials: rulers, buttons, postcards, cans, game pieces, cards, etc. Slowly these items are working their way into the pieces I make. Not only am I following an old tradition of jewelry making, but I am also doing my part to recycle materials that might end up in the land fill.

"Since moving to the Southwest, I have been reminded almost daily of the long history of Native American silversmithing, a tradition which I greatly admire. I am discovering that my work reflects some of the attributions of this traditional simplicity of style and technique, respect for materials and a search for harmony in one's work rather than for perfection."

Susan Skinner is the owner/designer with Chris DeNoon of Fibula, a metals studio specializing in hand-fabricated and cast sterling silver jewelry and hand-fabricated copper home accessories. Established in 1987, it is located in Albuquerque, New Mexico.

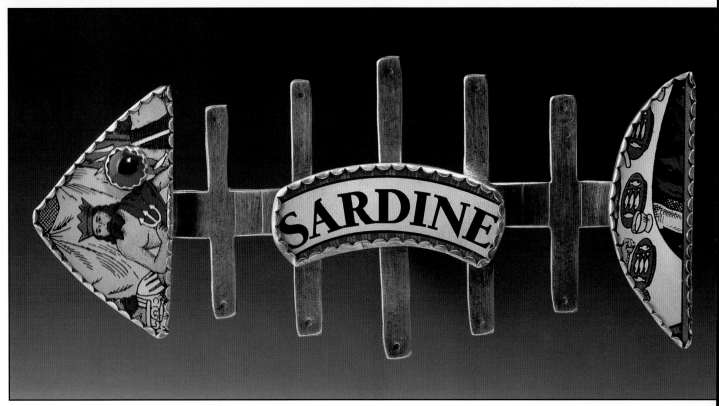

Sardine Pin
2" x 4"
Hand fabricated sterling silver and Portuguese sardine can

Keyhole Necklace
1 3/4" diameter
Hand fabricated sterling silver, antique mother-of-pearl
escutcheon plate

Postcard Bracelets
7" long
Cast sterling silver,
Lucite, postcard scans

Dragonfly and Wasp Pins
3" x 2"
d fabricated sterling silver
brass, various rulers, glass
eyes

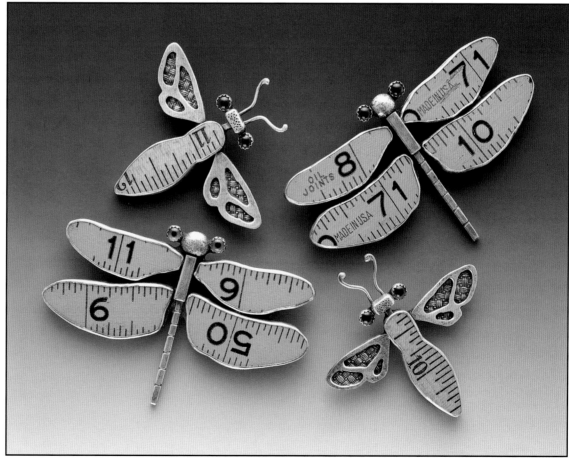

"I've always been a relatively quiet person, facing somewhat inward— much of the art I make is the embodiment of internal conversation and thought. Like a dream retold upon waking, my artwork is only an interpretation of occurrence, thought, or feeling and is formed more by the unconscious than by logic or reality."

William Skrips lives in Blairstown, New Jersey.

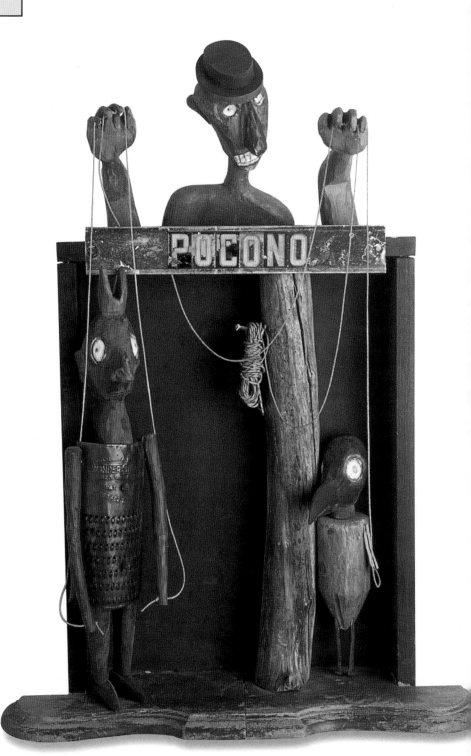

Pocono, 1999
30" high
Mixed media

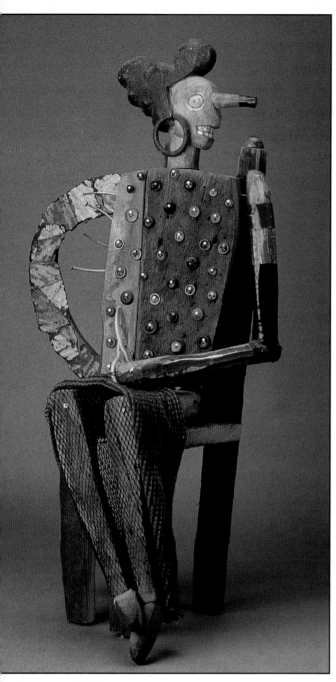

he Seamstress, 1997
4" high
ixed media

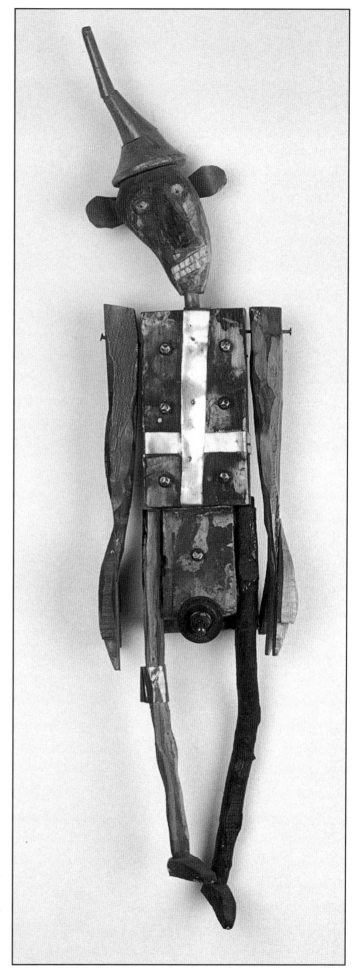

Funnelhead, 1997
24" high
Mixed media

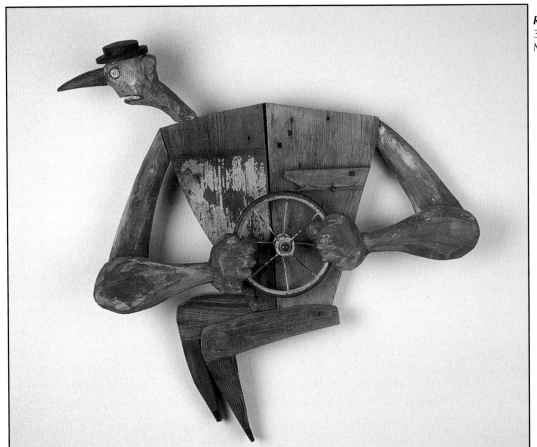

Road Hawg, 1999
32" high
Mixed media

Nick, 1998
22" high
Mixed media

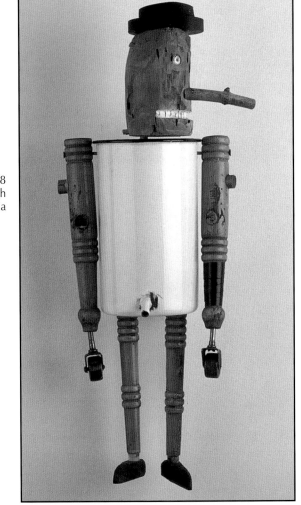

Digital Tool Box #2, 1995
1/2" x 3" x 1 1/2"
Protractor, pencil, two erasers, ruler, sterling silver
Courtesy Susan Cummins Gallery, Mill Valley, California

"I grew up in an environment jammed with old stuff. And here, in my studio, I work with it all the time. I put things together in different ways and I look at them for a while, kind of studying how they work—the textures, the colors, what happens when they're juxtaposed."

Many of Kiff Slemmons's pieces involve the thoughtful recombination of found objects—a pottery shard, an old typewriter key, a pencil stub, an inch or two cut from a ruler. From Masi flat-beaded neck disks to Sioux breastplates, her jewelry suggests the tribal art of numerous primitive cultures. Some pieces are instantly recognizable, while others are subtler in their allusions to ancient civilizations, as if they were remnants of obscure societies, totems of their rituals and religions.

Closer inspection provides startling revelations. These necklaces, pins, and assorted body adornments reflect the ritual art of a more complex, contemporary society. Made from a wide range of both precious and common metals in combination with discarded and found objects, they suggest multiple meanings, whose affiliations are not with antiquity but with the more recent past.

Kiff Slemmons lives in Seattle, Washington.

Toy, Brooch, 1997
2" x 3"
Sterling silver, mica, cloc[
piece
Courtesy Susan Cummin[
Gallery, Mill Valley,
California

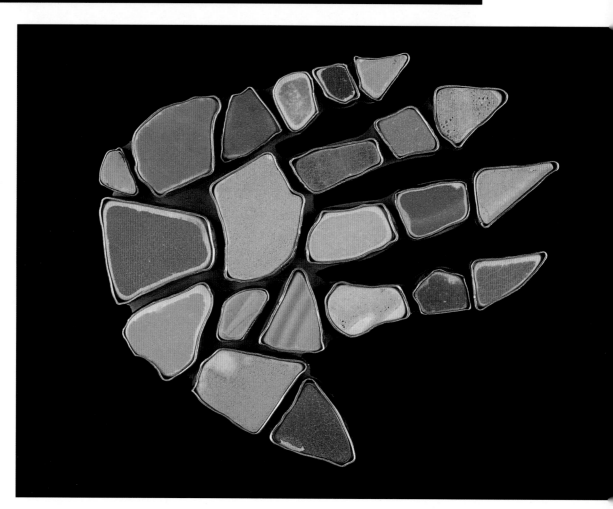

China Bone, 1989
Sterling silver, china shards
Courtesy Susan Cummins Gallery, Mill Valley, California

214

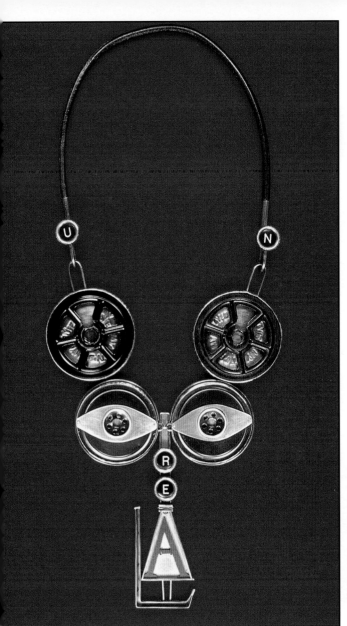

Unreal Neckpiece, 1993
8" x 6" x 1 1/4"
Silver, typewriter spools and keys, Formica, leather
Courtesy Susan Cummins Gallery, Mill Valley, California

Domino Effects, Necklace, 2000
silver, photographs, mica, leather
Courtesy Susan Cummins Gallery, Mill Valley, California

"I grew up in the old part of Philadelphia. That city, its shapes, energy and battered surfaces led me to many of the ideas I use in my work. I am an observer. I'm interested in the objects that form a city rather than the functions of its structures. My line of sight is directed at the common and everyday that is passed on the street. I'm also fascinated by the way decay spawns color and surface richness, creating a new visual life for discarded things separated from their former utility. I want my work to examine those ideas."

Evan Snyderman lives in Brooklyn, New York.

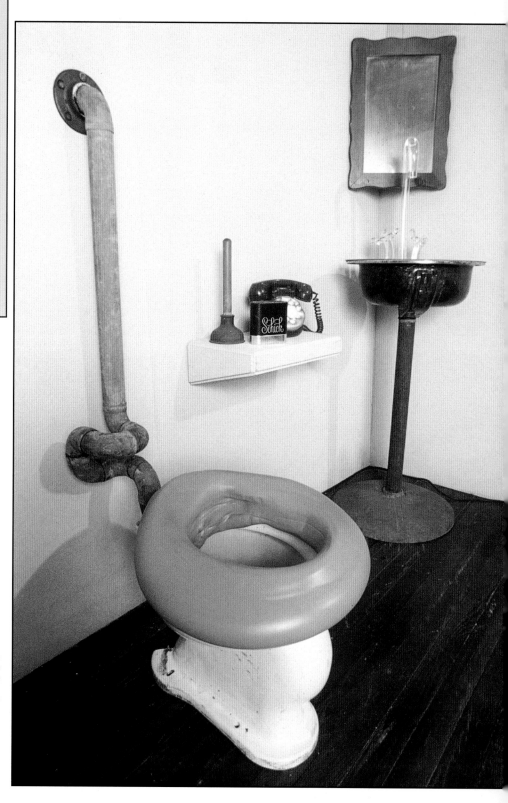

The Thrown, 1996
Installation view
54" x 18" x 28"
Mixed media

Glass Fan, 1996
22" x 16" x 12"
Mixed media

Installation: Glass Meters, Phone and Hydrant
Mixed media

Room with a Skew, 1996
Installation view
120" x 144" x 144"
Mixed media

"My current mixed media works on wood are icon-like serial constructions, which are intended to represent our relationship to the natural and spiritual worlds. Incorporating images of the landscape which are layered, wrapped, bandaged, stained, and scarred, they may also bear assembled objects of bent sticks and vines that are also wrapped and bound. Containing mnemonic traces of private loss, these somewhat fragile crusts of signification are open to a broad range of interpretations and meanings.

"My work, characterized as mixed painting, crosses disciplines, while incorporating various process and materials. In addition to painting, I stitch, cobble, burn, draw, and fasten an assortment of disparate images together. My studio is an accumulation of objects: battered fabrics, found and rusted metals, assorted sticks and tree fragments, driftwood, books, damaged canvases and paintings, and photographs. These fleeting scraps of cloth, paper, wood and metal when fused together become indicators of both a natural world and human presence.

"While employing disruptive formal techniques such as distressed fragmentation, collage, appropriated imagery, sewn, nailed and burnt surfaces, these multipaneled constructions comment on the genre of landscape painting while presenting conflicting issues of beauty and foreboding."

Dawn Southworth lives in Gloucester, Massachusetts.

Sticks and Stones Break Your Bones
21" x 108" x 4 1/2"
Linen napkin, bandages, canvas, thread, newspaper, nails, metal, sticks, wood burning, wax and mixed media on wood

Labryrinth
21" x 64" x 4 1/2"
Canvas, newspaper, thread, cotton pillowcase, buttons, nails, metal, wax, and mixed media

Opposite page, bottom
Throw Death into the Water
28" x 56" x 5
Linen, canvas, cotton bandages, thread, twine, nails, sticks, metal, glass, wax, and mixed media on wood

Tree Man
21" x 64" x 4 1/2"
Linen napkin, bandages, canvas, thread,, newspaper, nails, metal, sticks, wood burning, wax and mixed media on wood

"Growing up in the Midwest post-WWII, I was instilled with a sense of frugality. We saved our pennies, returned empty bottles for the two-cent deposit, and sent our used clothing to less fortunate relatives and friends in Eastern Europe. Today I still save pennies and return bottles, but clothing that has been worn and loved sees life anew through use in my quilts.

"I learned to quilt using traditional methods of drafting and designing, and teach my students techniques requiring meticulous attention to detail. However, I often approach my art quilts by cutting fabric into random pieces which I puzzle together into sewn forms whose final lines are unknown to me until they occur."

Judy Speezak lives in Brooklyn, New York.

Selected Shorts, 1991
88" x 100"
Vintage cotton boxer shorts

String-Pieced, 2000
16" x 16" and 18" x 18"
Patchwork pillows

String Squares #1, 1998
86" x 106"
Old shirts, fabric scraps, men's hankies, shirts, cotton bathrobe

"My work is playing with found objects and finding ways to animate them into toy-like figurative sculptures. I attempt to offer my viewing audience a playful experience of looking, discovering and interacting with the moveable parts of the sculptures.

"In my studio I enjoy the starting point that the found objects give me and the problem solving that follows."

Michael Stasiuk lives in Portsmouth, New Hampshire.

Bird # 2, Marionette, 1999
40" x 29" x 14
Mixed media
Photo by Andrew Edga

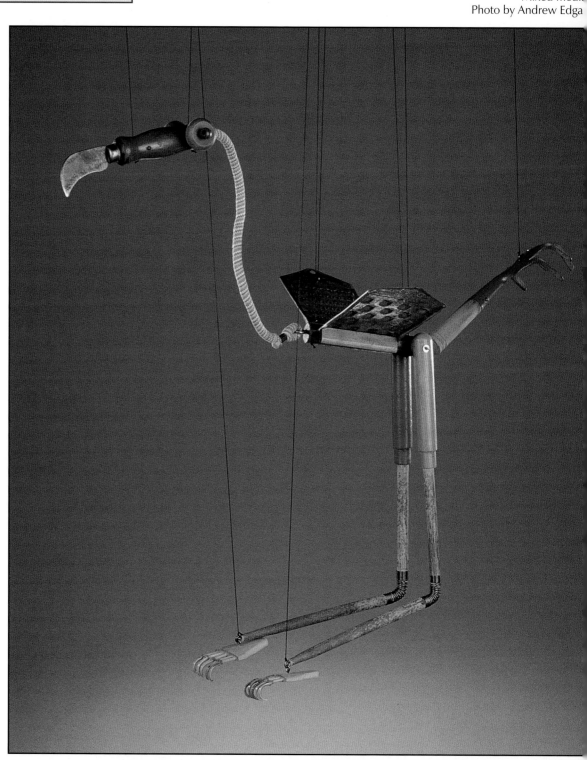

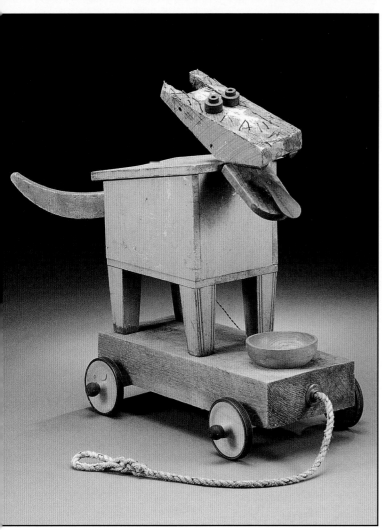

Hungry Dog Pull-Toy and Storage Bin, 1996
28" x 28" x 12"
Mixed media
Photo by Andrew Edgar

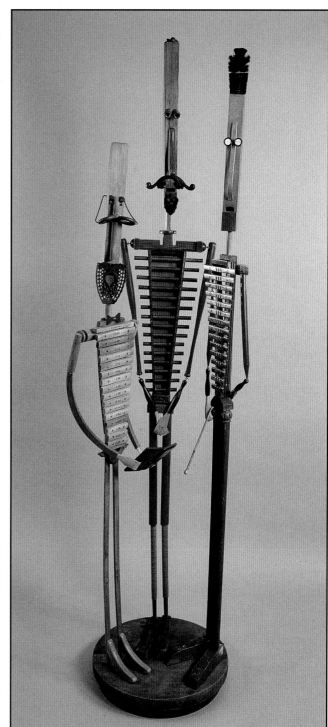

3 Singers, 2000
101" x 28" x 26"
mixed media
Photo by Andrew Edgar

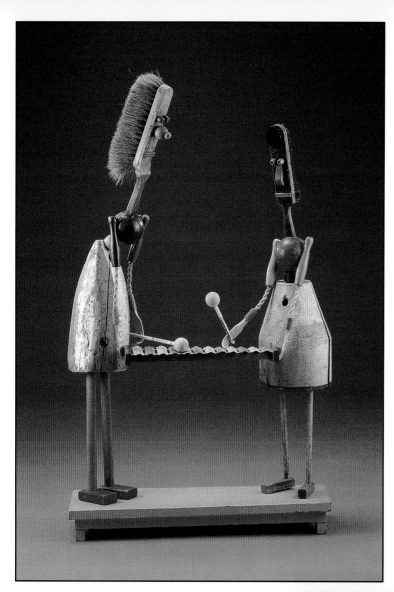

The Xylophone Ladies, 1999
41" x 24" x 8"
mixed media
Photo by Andrew Edgar

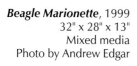

Beagle Marionette, 1999
32" x 28" x 13"
Mixed media
Photo by Andrew Edgar

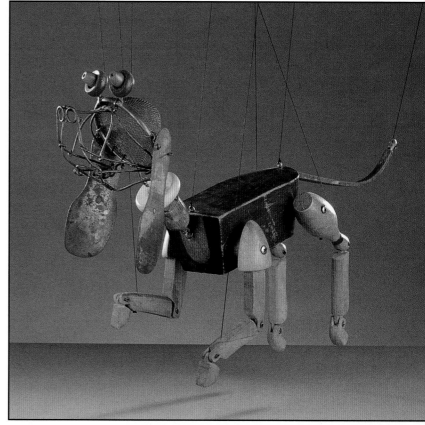

Barbara Stork

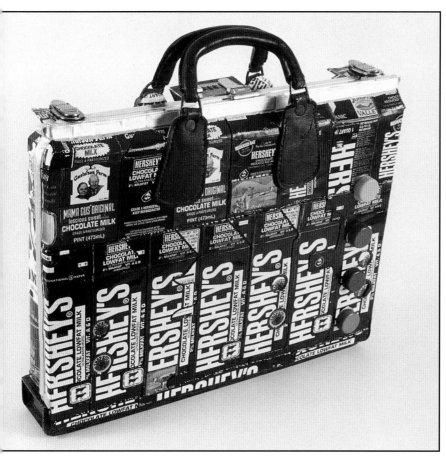

Milk Carton Leather Briefcase, 1999
15" x 19" x 3 1/4"
disposable milk packaging, found lock and handle

"For me, the recycling habit started with paper bags. At first, it was Mom's re-use of bags for my lunches instead of the fresh, perfectly new ones other kids got. Mom was a Depression child. But after a while those paper bag holders started showing up in everybody's house and it became a sign of prissiness to buy fresh clean new lunch bags.

Then, in the 1970s the tone changed. It became an ecology thing to refuse any paper bag at a store for purchases of one or two items. In fact, there was a new nationally sanctioned ecology movement that was taking the nation by storm. Then came the 1980s and the memories of gas rationing had subsided. Everyone seemed generally aware that hideous waste of natural resources was bad but the government had begun to take steps to take care of pollution and waste.

"In the 1980s, after graduating from college, I was also spending a lot of time on an Amish farm in Lancaster, Pennsylvania. I got to see how they burned all their trash to create heat and hot water. How they grew and prepared everything to eat. How to make rugs out of scrap cloth.

"Renovating raw space in Jersey City also taught me a great deal about the need to be self sufficient. I went on to create art objects to ease, or at least entertain myself during the process of recycling. And then I began to experience the Amish effect in the repetitive discipline of methodically cleaning and saving material from going into the landfill. In time I had to remember my original impulse was saving my own hide through mastery of free materials, not solving the landfill indulgence. So I have settled down to study one type of trash at a time and try to figure out how to use it effectively, with some validity and actual applicable function."

Barbara Stork lives in Jersey City, New Jersey.

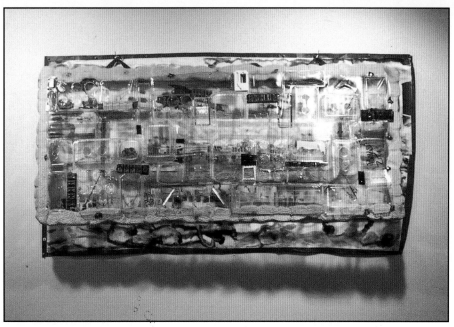

Construction Site Wallpaper with Vitrine, 1995
48" x 71"
Wallpaper: acrylic on paper
Vitrine: wood with plastic container assemblage

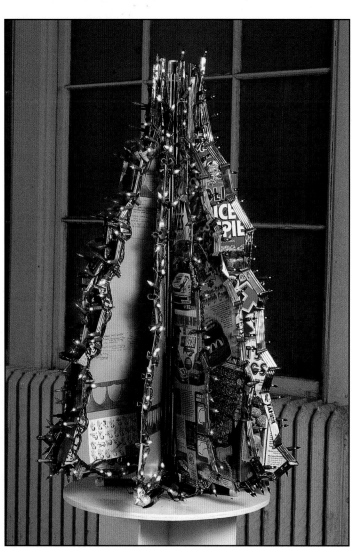

Cereal Safety Tree, 1999
39" x 22" x 22"
Steel cans and cereal box with lights on rotating central support

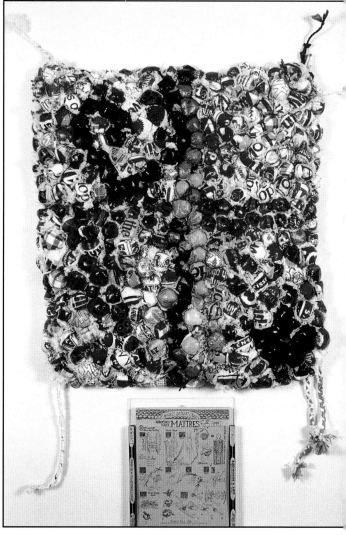

Grocery Sack Mattress with Instructions Dispenser, 1999
28" x 25" x 4"
Mattress: plastic grocery bags, thread
Dispenser: Plexiglas and wood with offset edition of paper

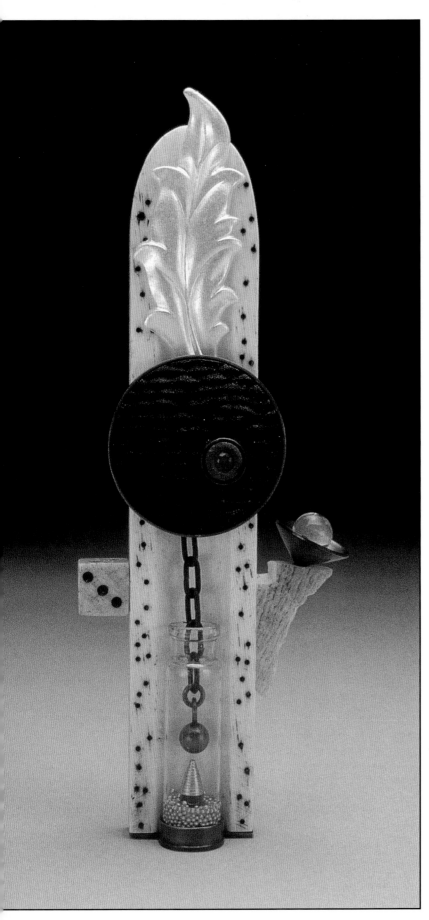

"I am someone who loves to repair, to rescue, to revive objects from the oblivion of our distracted attentions. We are bombarded and overwhelmed with information and objects while being underwhelmed with meaning and scrutiny. The artist, Paul Klee, once stated: 'The object expands beyond the bounds of experience by our knowledge that the thing is more than its exterior present to our eyes.'

"My pieces are a kind of narrative vignette—they act as a surrealist allegorical film still—the moment is frozen in actual time while implying movement, action, interaction and story. There are many ways jewelry is used. Some select pieces of jewelry are worn every day, but most reside in boxes, on dressers, in drawers and safes. I am interested in jewelry that is held and inspected, handed to another to be shared like a boy showing the most beautiful marbles in his collection to a friend. Often jewelry spends much of its existence off the body acting as a repository of wealth, memory and narrative. My work is meant to be held and inspected as much as it is to be worn. My hope is that the viewer/holder will recognize some of what lies within.

Alan Burton Thompson lives in Massachusetts.

Shelf Life Brooch
4 3/4" x 1 3/4" x 1/2"
antique whale bone, copper, plastic, found objects

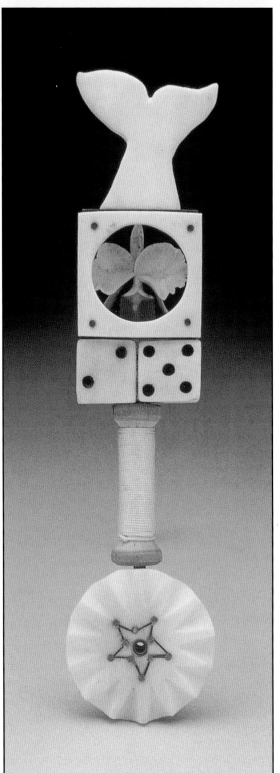

Last Look Brooch, 1993
5 1/2" x 1" x 1/2"
Antique whale bone, found objects, wool thread, plastic

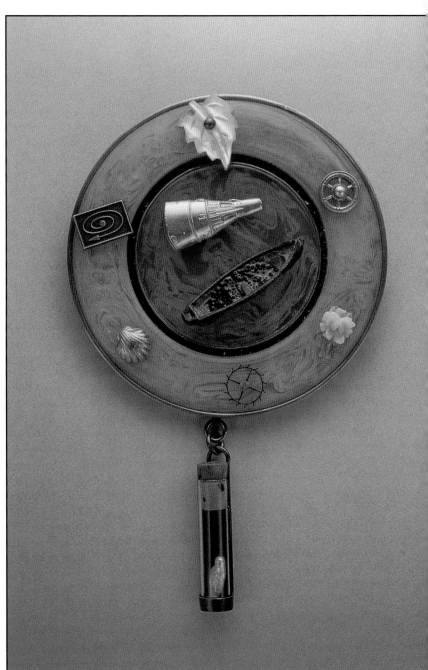

Round House Brooch
4 1/4" x 2 1/2" x 1/4"
Bakelite plastic, copper, brass, fresh water pearl, found objects

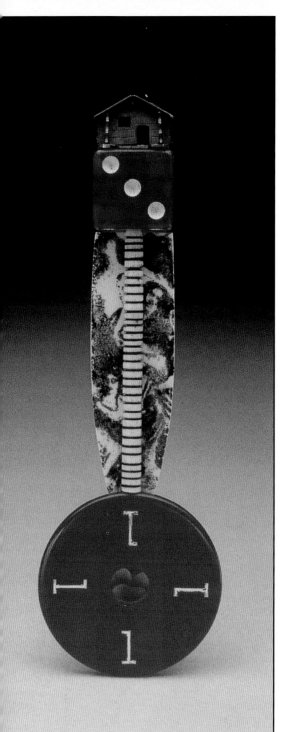

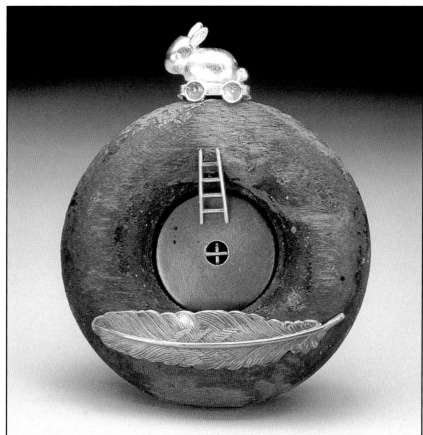

Shadow Box Brooch, 1993
4 1/2" x 1 1/2" x 3/4"
Bakelite plastic, antique whale bone, plastic, sterling

Rabbit Hole Brooch, 1997
3" x 2 1/2" x 1"
Antique door knob, sterling silver, copper, brass

"My work comes from a wide variety of sources. In my sculptural pieces a couple of recurring themes are that of discarded toys and icons (i.e., objects of healing, shaman figures). I never intentionally set out to make statements of any type and the outcome of my work is usually as new to me as is the viewer."

Terry Turrell is a self-taught artist who has developed a personal imagery that often uses simple images with an intuitive strength and directness. He experiments with materials and mediums in a variety of ways. He utilizes found materials such as paneled doors and tin to achieve unusual surfaces in both paintings and sculpture.

Terry Turrell lives in Seattle, Washington.

Untitled, 1999
40" x 13" x 11"
Wire, wood, tin, magnifying glass
Courtesy American Primitive Gallery, New York City

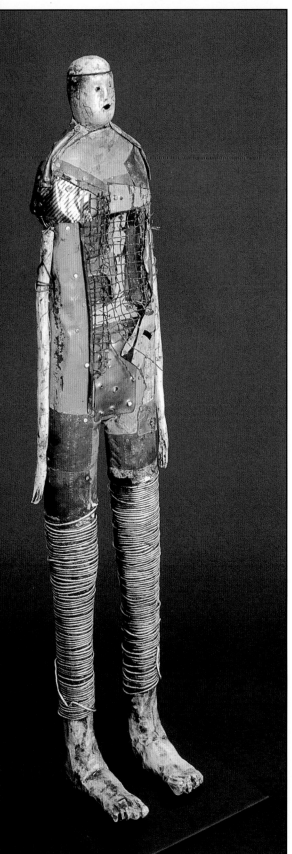

Nickel and Dime, 1998
29" x 8" x 9"
Mixed media
Courtesy American Primitive Gallery, New York City

No Shoes, 1997
22 1/2" x 5" x 2"
Metal, wood, wire, paint
Courtesy American Primitive Gallery, New York City

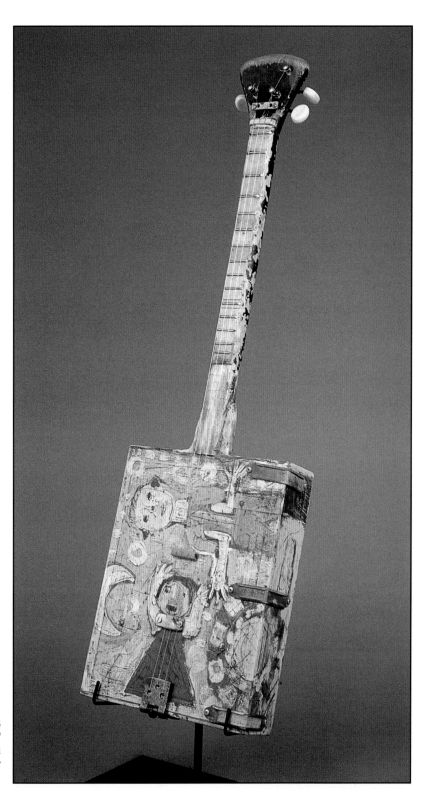

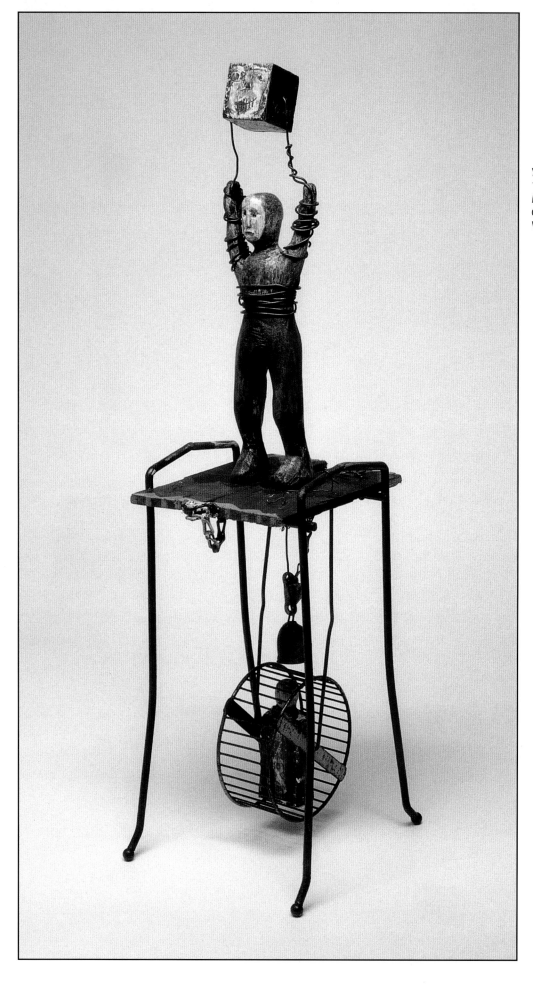

You Win, You Lose, 1993
18" x 6" x 6"
Mixed media
Courtesy Susan Cummins Gallery, Mill Valley, California

Daniel Van Allen

"Modern man seems to be drowning in material goods. A restorer by trade and a devotee to natural harmony, I create sculpture using the bounty of found objects. My work explores ancient and non-Western themes, seeking a connection to a universal imagery of the unconscious and instinctual needs of an emerging modern culture.

"Can an urn made from an old tire or a cup made from a toilet float be as important as a marble vase or a silver chalice? There is an urgency to recognize the importance of our interconnectedness to our planet as well as a spiritual or primal satisfaction gained from truly creating something from nothing."

Daniel Van Allen lives in Baltimore, Maryland.

African Tire Pot, 1987
24" x 36" x 24"
Rubber tire, enamel

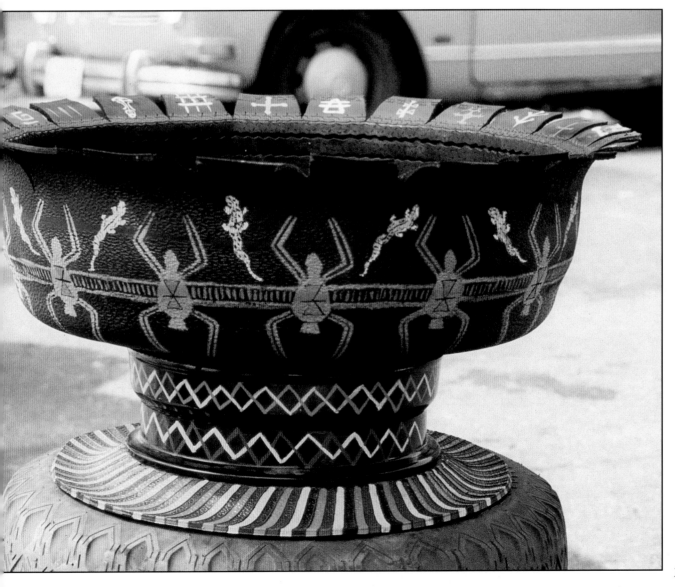

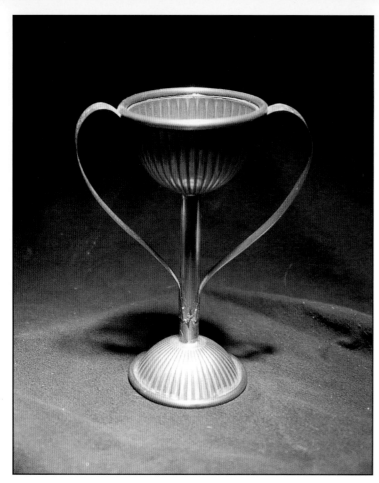

Chalice, 1997
Toilet float, copper pipe

Spinning Girl, Doll, 1993
24" x 6" x 6"
Turbine vent, found objects

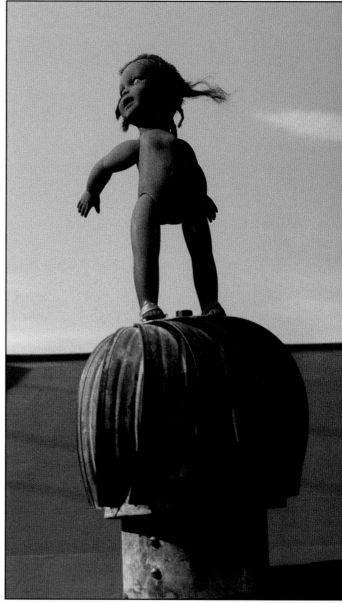

Stephen Whittlesey

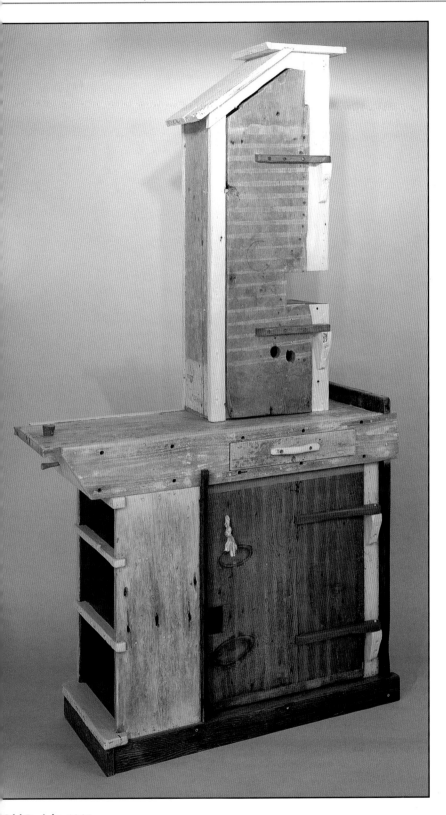

Old Dwight, 1967
Cabinet
88" x 52" x 16"
Salvage wood, metal

"The environment I grew up in was full of materials which were used over and over again, whether it was canning jars or hand-me-down clothes or old lumber. My father built a cottage for our family in 1950 using wood salvaged from a factory which had been torn down. Piles of heavy wooden skids from a paper mill became a rugged floor and room dividers. I spent summers as a kid finding derelict boats on the marsh, dragging them home, and restoring them to use. My first jobs were on farms where things were fixed, not thrown away, and frequently they were fixed by re-using 'stuff' that was piled up behind some shed. Most of us had a lot of time and little money, so there was definitely a 'waste-not-want-not' philosophy, and an 'if it breaks, fix it' attitude.

"My creations in salvaged wood have grown out of that 'making do with what you have' kind of living. There is both humor and hardship in that kind of life, as well as an ongoing need to solve little and big problems, indoors and out, without making a big deal of it all—without missing too many beats. I hope to express some of that sensibility and process in my work. It is a great pleasure to me to find a craggy piece of century-old wood, and find some way to rescue it and give it a new purpose before it is orphaned in a landfill. I feel like I am partly an archaeologist searching through the ruins of New England, and partly an artist trying to, among other things, make sense out of the disappearance of rural life. It is no small irony that years ago, when I took wood out of the dump to build things with, people were amused, but now, when recycling is really necessary, I'd be arrested if I tried to dump-pick."

Stephen Whittlesey lives in W. Barnstable, Massachusetts.

Sloop, 2000
Table
30" x 112" x 48"
Salvage wood, metal

Reach, 2000
Side table
35" x 99" x 14"
Salvage wood, metal

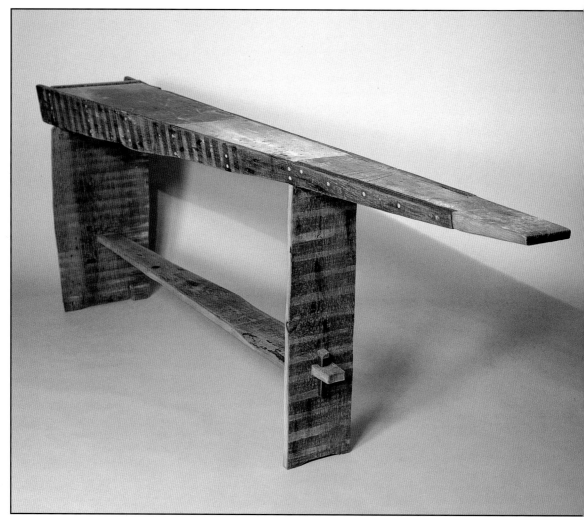

Pillar, 1997
Cabinet
96" x 36" x 22"
Salvage wood, metal

Wings, 1999
Wall cabinet
62" x 31" x 9"
Salvage wood, metal

"I can remember back to the Fall of 1965 visiting New York City to see if I could find a gallery to represent my jewelry work. I was in a show at the Museum of Contemporary Crafts at the time, entitled: 'The Art of Personal Adornment.' I thought that this might give me some credibility for representation in a good craft gallery in the city. What I found was that there really weren't any good craft galleries in New York City at that time. I was also told by some metal artists I met that if I wanted to be selling in New York City I would have to be working in gold, not silver, which was my metal of choice. This was because the George Jensen Gallery was marketing very attractive and affordable silver jewelry at this time and pretty much had a corner on that market.

"I had been working with what I thought were rather unusual patinas on silver and knew I could not do this with gold. It made me rather mad to think that I would have to change the metal I was using just to market my work. It was something of a repeat of another incident in my life, when my college professor told me that if I would include a gemstone in my jewelry, I could up the price of it considerably. Gemstones and now the need to switch from silver to gold, just made me snap. All this crap about marketing with what the market wanted wasn't what I (as an artist) was about. I was into the thought (and still am) that it was the creative idea and execution of the idea that was important and not materials that had intrinsic value to the public. Or what was fashionable.

"I returned home to the Midwest and decided to start making jewelry out of junk. I declared a personal war on materials that had value and began my campaign to begin recycling what I found free on the streets, at the dumpsites, and in nature. I was now free to be whatever I wanted to be, because no one would want whatever I made and I didn't really care. I had also been a collector of found objects, which gave me an immediate resource.

"The strange thing about this step in my life is the fact that the response to my work was so positive. People started giving me things to use in my work and telling me I should show it. One of my former college professors recommended that I send slides of the work to Paul Smith, the director of the Museum of Contemporary Crafts. I couldn't imagine he would be interested, but did send him slides and the rest is history. Paul arranged for me to have a one-man show at the Museum of Contemporary Crafts in its Little Gallery on the second floor. This show netted me considerable exposure, including an article on this work in *Craft Horizons* magazine. My work even appeared on the *Today* show!

"The best thing about my beginning to use found objects was the fact that it 'fit.' It felt right. For the first time in my creative life, I was really being me. I found that I could make political and social statements with the things that made up my work. I could poke fun and be serious at the same time. I also found that for myself, if not for others, I could make things that had meaning and value without worrying about the intrinsic value of the materials that went into the work I created."

Como Esta? Pin, 1997
3 1/2" x 3 1/2" x 1/2"
Mixed media

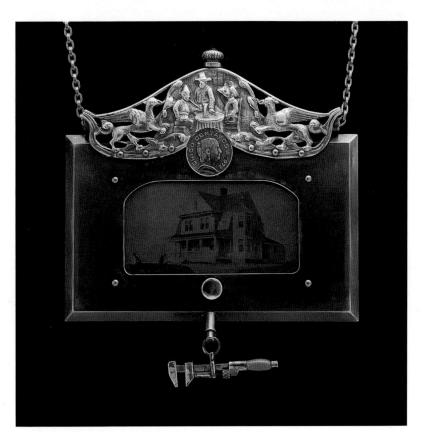

There's No Place Like Home, Pendant, 1995
4 3/4" x 4 1/2" x 5/16"
Mixed media

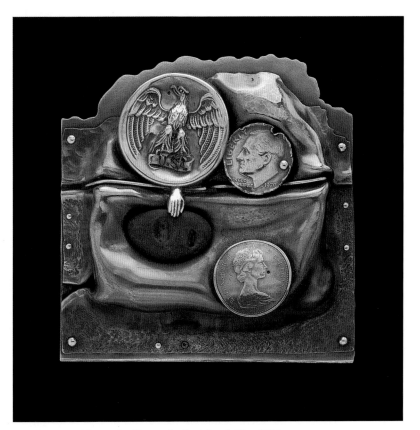

Summer Memories/Campabello Island, Pin, 1991
3" x 3" x 3/4"
Mixed media

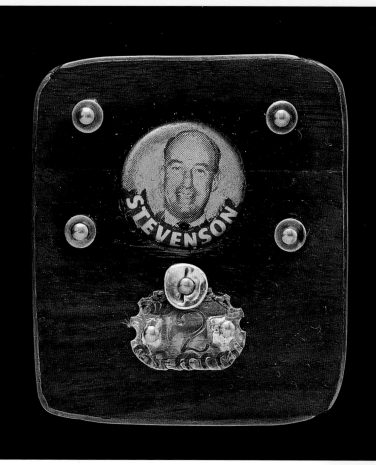

St. Elsewhere, Pin, 1986
2 1/4" x 2" x 3/8"
Mixed media

Family Icon/Father, Pendant, 1967
3 1/4" x 2 1/4" x 3/8"
Mixed media